Canon® EOS
Rebel T4i/650D

D1108810

Digital **Field Guide**

Canon® EOS
Rebel T4i/650D

Digital Field Guide

Rosh Sillars

WILEY

John Wiley & Sons, Inc.

Canon® EOS Rebel T4i/650D Digital Field Guide

Published by
John Wiley & Sons, Inc.
10475 Crosspoint Boulevard
Indianapolis, IN 46256
www.wiley.com

ISBN: 978-1-118-16913-1

Manufactured in the United States of America

10 9 8 7 6 5 4 3 2 1

For general information on our other products and services or to obtain technical support, please contact our Customer Care Department within the U.S. at (877) 762-2974, outside the U.S. at (317) 572-3993 or fax (317) 572-4002.

Wiley publishes in a variety of print and electronic formats and by print-on-demand. Some material included with standard print versions of this book may not be included in e-books or in print-on-demand. If this book refers to media such as a CD or DVD that is not included in the version you purchased, you may download this material at http://booksupport.wiley.com. For more information about Wiley products, visit www.wiley.com.

Library of Congress Control Number: 2012948920

WILEY

About the Author

Rosh Sillars is a veteran photographer with a background in photojournalism. He specializes in photographing people, food, and interiors. He earned a BFA in photography from the College of Creative Studies (CCS), Detroit. He owns the creative representation firm, The Rosh Group Inc.; works as a marketing consultant for Synectics Media; teaches photojournalism at Wayne State University in Detroit; and is a digital photography instructor at the University of Detroit Mercy. He is an active author, speaker, and consultant on the topics of photography and marketing.

Rosh's home photography studio, Octane Photographic, is located in Ferndale, Michigan, where he lives with his wife, Shirley, and their daughters, Ava and Kelly.

Credits

Acquisitions Editor
Courtney Allen

Project Editor
Amanda Gambill

Technical Editor
Haje Jan Kamps

Senior Copy Editor
Kim Heusel

Editorial Director
Robyn Siesky

Business Manager
Amy Knies

Senior Marketing Manager
Sandy Smith

Vice President and Executive Group Publisher
Richard Swadley

Vice President and Executive Publisher
Barry Pruett

Project Coordinator
Kristie Rees

Graphics and Production Specialists
Jennifer Henry
Andrea Hornberger
Jennifer Mayberry
Christin Swinford

Quality Control Technician
Lindsay Amones

Proofreading and Indexing
BIM Indexing & Proofreading Services
Penny L. Stuart

I dedicate this book to my mother, Patricia Sillars.

Acknowledgments

Many thanks to my wife, Shirley, whose ideas and editing skills always make me look good. To my children, Ava and Kelly, who demonstrated admirable patience during this process and its many deadlines. Thank you to the Synectics Media team for your unwavering support and for taking the time to model in my camera demonstrations: Jeffrey Huysentruyt, Sharon Stanton, Katy Hinz, Steve Gualtieri, Tim Kloote, Anahid Derbabian, and Ava Sillars.

Thank you to the photography social media community, without which I would have never connected with all of the great photographers who share their knowledge in this book. I'm grateful to everyone who took the time to submit tips and photos—you added a wonderful dimension to this book.

Appreciation for added support goes to Dean La Douceur, Greg Evans, Geoff McMahen, April Pochmara, Kevin Dolan, Mal Sillars, and Edith Sillars.

Thank you to Courtney Allen for the opportunity to write this book, Amanda Gambill for her guidance, and to the entire Wiley team who really make this book shine.

Contents

CHAPTER 3
Choosing the Right Settings
for Your Camera 45

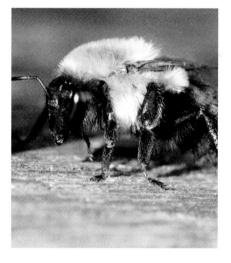

CHAPTER 4
Using Lenses with the Canon
EOS Rebel T4i/650D 77

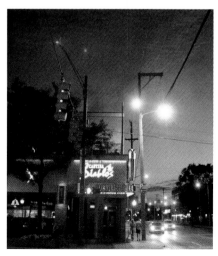

CHAPTER 5
Exploring Exposure and Composition 95

CHAPTER 6
Working with Lighting and Flash 121

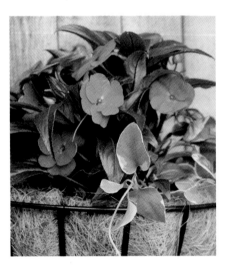

CHAPTER 7
Shooting Photos 147

CHAPTER 8

Shooting in the Live View and Movie Modes 181

CHAPTER 9

Viewing, Editing, and Sharing Your Images 207

Introduction

It's always exciting to get a new camera, even if it's a used model. Think of this book as a companion piece to your new purchase. Soon, you'll discover the wonderful features the Canon T4i/650D offers for creating both still photography and videos. Use this book to explore these features and learn how to take better photos. As I wrote this book, I reviewed every menu, pushed every button, and applied my 20-plus years of experience in photography to inform you about how this technology can benefit your photos.

This book also features tips from other photographers on everything from how to capture the best shots, to how to market your work via social media. The first part of this book covers the technical information, including how to use the camera's many menus, displays, and buttons. As you read further, you will discover more information on important topics, such as composition, lenses, light, and shooting video.

Your camera has some great features, including HDR and low-light modes. It is also the first camera to include the Movie-servo feature, which continuously maintains focus on your subject as it moves. The LCD touch screen makes selecting features and settings from your camera's menus much easier. It also makes it possible for you to review your images and videos with the swipe of a finger.

This book is not meant to replace the Owner's Manual. In fact, it was written with the assumption that you have read the Owner's Manual and know the very basic stuff, like how to put the camera strap on and how to charge the battery. Even so, I do dig into plenty of basic information that you need to get started. I also take you through some midlevel and advanced ideas that you won't find in the manual, but that are meant to improve your photographs and experience with the Canon Rebel T4i/650D.

Quick Tour

My guess is you are itching to start using your new Canon EOS Rebel T4i/650D. Maybe you picked up this book to learn how to use it or maybe you just want some advice on taking better pictures. This Quick Tour covers the basics for achieving both goals. The next few pages provide an overview about using your camera more efficiently and effectively. The in-depth information is in the chapters ahead. In those chapters, I explore all of the menus, functions, settings, and tips for getting the images you desire. Don't worry—even after you start playing around with your camera, if you find you are not happy with its settings, it's easy to reset it to the factory default settings in the Setup menu. First, let's set up your camera and get out in the field.

The Canon T4i/650D has many great new features, including an LCD touch screen, HDR capabilities, and continuous focus for video.

Getting Started

If you want to take photos right now, follow these quick steps to get going. Your camera should be unpacked from the box. The camera battery, straight out of the box, should have some power. However, I recommend fully charging the battery before you use it for the first time. If you can't wait that long, just get started.

To begin shooting, you need a fully-charged battery, a formatted memory card, and a Canon dedicated lens (or compatible lens) attached to your camera. The battery door is on the bottom of the camera. Open it and insert the battery until you hear a click indicating that the battery is locked in place. The memory card should also be formatted for your camera.

To format the memory card, place it in the card slot (with the letters facing you) on the right side of the camera, as shown in Figure QT.1. Press the Menu button (**MENU**), select Setup menu 1 (▣), select the Format option, and then press OK. The memory card is formatted within a few moments. The more memory the card has, the longer the formatting process takes. To place a lens on the camera, match the red (or white) dots found on both the camera and lens, and then turn the lens to the left. Make sure that the camera lens is set to autofocus.

QT.1 The memory card fits into the slot on the right side of the camera.

Set the camera to the Scene Intelligent Auto shooting mode (⒜) for evaluative auto-matic program control. In other words, this mode lets the camera make all of the exposure decisions. Your job is to place your index finger on the shutter button, as shown in Figure QT.2, and your eye to the viewfinder to begin shooting photos.

QT

QT.2 Place your index finger on the shutter button to begin taking photos. Make sure that you hold the camera grip securely with your other hand.

To shoot videos, flip the power button to Movie mode ('🎥). The LCD screen's Live View feature turns on, and displays the view through your lens. For quick access to many of the camera's main movie options, press the Quick Control/Print button (🔳) to get the options displayed on the screen. Use the Live View Shooting button (■) to start and stop movie recording.

Camera Controls

This section covers some of the basic controls you need to know for the everyday use of your Canon T4i/650D. Most of these are found on the top and back of the camera. Many of the same controls can also be found on the LCD touch screen. Press the Quick Control/Print button (🔳) to view them.

CROSS REF A detailed list of all of the camera controls can be found in Chapter 1. Menu options are covered in Chapter 2.

The top of the camera

The top of the camera features the following buttons and dials:

▶ **Power button.** You have three power options: Off, On, and Movie on. Turn the power button On when you want to take still photographs. Turn it to the Movie mode ('🎥) when you want to create videos.

▶ **Mode dial.** This controls the 14 exposure modes. The dial is divided into two zones: Basic and creative. The following basic zone modes offer a variety of automatic settings: Scene Intelligent Auto (▣), Flash off (🏵), Creative Auto (CA), Portrait (❀), Landscape (🏔), Close-up (🌷), Sports (🏃), Night Portrait (▣), Handheld Night Scene (▣), and HDR backlight control (▣). The following creative zone modes offer more exposure freedom for advanced users: Program (**P**), Shutter-priority AE (**Tv**), Aperture-priority AE (**Av**), and Manual (**M**).

▶ **ISO button.** ISO refers to the light sensitivity setting of your camera. The higher the ISO is, the less light you need. The lower the ISO is, the more light you need, but the less digital noise your image will contain (higher quality).

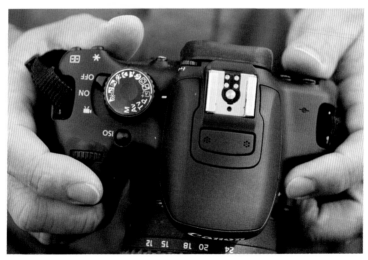

QT.3 **The controls on top of your camera.**

The back of the camera

The back of the camera features the following buttons and dials:

▶ **Menu button (MENU).** Pressing this button gives you access to the many options available to customize your camera.

CROSS REF The camera's menus are fully covered in Chapter 2.

▶ **Info button (INFO.).** Press this button to activate the information display on the LCD screen. Depending on the mode you are using, the screen displays information about the camera, the shooting mode settings, photograph, or video.

▶ **Live View Shooting button (🔲).** This button turns on the camera's LCD screen for the Live View feature. This allows you to see the scene as the lens reads it. This button is also used for starting and stopping video shooting.

▶ **Quick Control/Print button (🔳).** Press this button to quickly pull up important features on the LCD screen to use in specific modes.

▶ **Cross keys.** These four buttons offer quick access to the White balance (**WB**), Autofocus mode (**AF**), Picture Styles (⚡), and Drive modes (**DRIVE**). They also serve as direction keys to navigate through menu options. When you land on the menu option that you want, press the Set button (⑤ET).

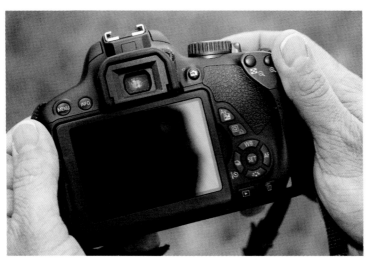

QT.4 The control center on the back of Canon Rebel T4i/650D.

Choosing Image Quality

Your camera has 10 image-quality options. The default is Large fine (◢L), which is the largest size JPEG available on your camera at 5184 × 3456 pixels. The RAW format (RAW) is the highest quality image available on your camera and Small 3 (S3) is the smallest file size. I recommend that you use the higher image-quality settings, such as the default Large fine (◢L), for regular use because you can always downsize your photos on your camera or in the Digital Photography Professional software that came with it. You cannot, however, increase a photograph's resolution without losing image quality. If you need more room for images, purchase a card with more memory, especially if you plan on shooting larger files and video.

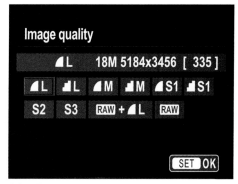

QT.5 The Image quality menu has 10 options.

Selecting a Focus Mode

To use autofocus, check the switch on the side of your lens and make sure that it is in the AF position. Next, press the shutter button halfway to focus on your subject. If you are using a basic (automatic) zone mode, the camera selects the focus points for you. If you are using a creative zone mode, you have the option of nine focus points (31 if you are using the Live View FlexiZone Auto focus method options). The default is automatic autofocus, in which the camera selects the focus point based on nine AF points, usually focusing on the closest subject to your camera. To manually adjust the autofocus points, press the Magnify button (⊕) to view the camera's AF points. Adjust the points by using the Main dial (⁂) on top of the camera.

CROSS REF For more information about the Live View and Focus options, see Chapter 8.

You also have three options related to how your camera focuses. Press the Autofocus button (**AF**) to see your autofocus operation options. The default (and first) option is One Shot (**ONE SHOT**) and it does just that. When you press the shutter button halfway in this focus mode, the camera focuses on your subject once. It stays at that focus

point until you lift your finger and press the shutter button again. AI Focus (**AI FOCUS**) takes one shot unless the camera detects motion, and then it switches to the AI Servo mode (**AI SERVO**). AI Servo (**AI SERVO**) follow-focuses as you or the subject moves.

The default focus setting for videos is Movie Servo AF (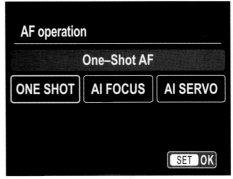). This means that the camera follow-focuses the closest object to the camera. You can turn off Movie Servo AF (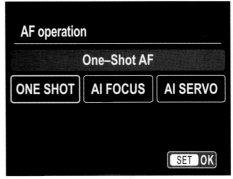) by touching the icon in the lower-left corner of the LCD screen. When Movie Servo AF mode (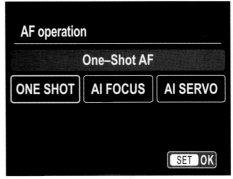) is turned off, your camera focuses once when you press the shutter button halfway. Manual focus is achieved by selecting the Manual focusing mode (**MF**) on your lens.

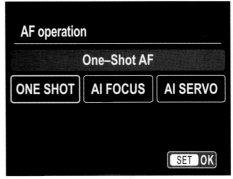

QT.6 The Autofocus (AF) operation menu offers three focus options.

Using a Flash

If you are using one of the basic zone modes, the flash pops up automatically when needed. When using one of the creative zone modes, the flash must be manually popped up by pressing the Flash button (⚡) on the front of the camera (see Figure QT.7). If you are using an external flash, place it in the hot shoe on top of the camera. Flashes that are compatible with Evaluative Through-the-Lens (E-TTL) technology (that is, Canon's version of Through-the-Lens metering) sync seamlessly with your camera. This means that the flash and camera work together to create the best exposure using your camera's evaluative metering sensor. This type of metering is helpful for more accurate readings, especially if you have a filter on your lens, because the flash knows how to adjust.

QT.7 The Flash button is on the left side of the camera.

Reviewing Images or Video

Once you have taken some pictures, you will want to review them. To see your photos, press the Playback button (▶) while keeping the camera power on. You can use the left and right Cross keys to move forward and back between images. This is where the LCD touch screen is very convenient—you can also swipe your finger back and forth across the screen to review images. If you want to skip through a large number of images, use the Main dial (🔄) to scroll through ten or more at a time.

To play a video, press the Set button (SET) located in the middle of the Cross keys twice. The first time you press it, the camera displays the video playback and review options on the LCD screen. The second time you press it, the video plays if the Playback button (▶) is highlighted. An even easier option is to press the Playback button (▶) on the LCD screen.

> **NOTE** Each time you press the Info button (**INFO.**), a different image display screen appears for either images or videos. There are four screen options.

Taking Better Photos

Beyond my own tips I have invited other professional photographers to share their suggestions for taking better photographs, and Chapter 7 covers this topic in depth. However, the following list includes a few tips to help you get started:

▶ **Fill the frame.** Get close to your subject. Often, too much empty space or unrelated objects can lessen the impact of a great subject. Make sure that everything in the frame is necessary and supports your concept. To help compose your images, use the Live View mode (📷) to view your scene in larger form on the LCD screen. Consider using the grid option, located under the Live View menu (📷), to support your composition.

▶ **Light.** Light is everything in photography, so always make sure that you have a good source of it for your photographs. Early morning and late evening are referred to as the *golden hours*, and are the prime times for photography. Experiment with light direction and shadows. If you turn on the Auto Lighting Optimizer located in Shooting menu 2 (📷), your camera will adjust your image automatically to optimal brightness when you are shooting in the basic modes.

► **Flash.** Don't fear the built-in or external flashes; learn how to use them. I encourage you to use Canon E-TTL II flashes to ease the learning curve of flash photography. Plus, you camera is designed to fire Canon flashes wirelessly, offering you more lighting options.

QT

► **Variety.** Every photograph doesn't have to be shot in the same way—try new angles and lenses. Use your vari-angle LCD screen to get pictures from high and low angles.

► **Experiment.** Try out all of the exposure modes and special effects, such as Picture Styles, so that you know what your camera can do.

To kick off our advice from professional photographers, here are some composition tips from artist and photographer Damien Franco:

► **Learn the Rule of Thirds and know when to use it.** Think of lines that divide your photograph into horizontal and vertical thirds, like a tic-tac-toe grid. Most people instinctively put their subject in the middle of a shot, but that often results in boring photographs. You can line up your subject on one of the intersecting points of the grid, called a *power point*, and it creates a more dynamic photo. Also, you can try placing the horizon on one of the horizontal lines to create a more pleasing balance to your photographs. Humans have a natural tendency to look for symmetry because we find it safe. When you see a scene that is a little off balance, you tend to pay more attention to it. The most important thing to do is experiment. Use the grid as a guideline but, remember, in art, all rules are made to be broken.

Image courtesy of Damien Franco

QT.8 The Rule of Thirds creates more dynamic images. (50mm lens, ISO 100, f/2.0, 1/400 second)

▶ **Take control and lead your viewer.** You will find that there are lines all around you if you practice looking for them. Use them in your composition to lead the viewer across your photographs. Maybe there are lines in the background that can point toward your subject. Perhaps you're photographing a person who is looking off to the right of the camera. Leave room in the photograph in the direction in which your subject is looking. This gives the viewer space to follow your subject's gaze.

▶ **Use different perspectives and angles.** As you make your way through your daily life, you spend most of your time looking at the world from a standing position. It's all too familiar to see photographs taken from that same perspective and think, "I could have shot that." Change your perspective by getting down on the floor or up on a ladder—shoot subjects from weird angles. It's fun, and you can create images that are different from your normal visual frame of reference. Doing this also makes people stop and pay more attention. It's almost like viewers are forced to put themselves at the level of the photographer—that's called engagement!

▶ **Break all of the rules and have fun.** I discovered, early on in my studies, that learning the rules was essential to becoming a consistently better artist. Then I learned an even better lesson: rules are made to be broken. You can create visually compelling images by purposefully (and sometimes, forcefully) breaking the rules. When done correctly, this can create tension in a photograph that carries the mood in a dramatic fashion. This is also about learning, experimentation, and fun. Take tons of photographs all of the time. Study them and study the photographs of some of the great photographers, past and present. Dissect them to see which rules and guidelines they follow and which they break. Don't forget to play with your camera and its settings to try new stuff. This is photography, after all, not rocket surgery.

Damien Franco is a photographer, artist, and writer based in Houston. He is well known for sharing quality photography information online. You can view his work at: http://damienfranco.com.

Exploring the Canon EOS Rebel T4i/650D

Chances are you wondered what all of the buttons and dials do as you unpacked your new camera. Even professional photographers have to take the time to review the function of each button on a new camera. Think of this chapter as a virtual tour of the outside of the Canon EOS Rebel T4i/650D. It will help you understand the lens controls, the display in the viewfinder, the LCD touch screen, and the display options. This chapter also offers guidance on camera setup and which defaults to use. Once you understand the camera's controls, you can focus on taking great photographs.

This photo of Devils Tower was photographed using a 50mm lens.

The Top of the Camera

The top of the camera houses the power switch, exposure modes, Main dial, and the ISO and shutter buttons. All of these play an integral role in creating photographs.

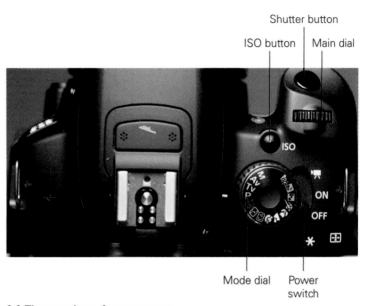

1.1 The top view of your camera.

The following list explains what the each of these switches and buttons do:

▶ **ISO button (ISO).** The ISO setting represents the camera's sensitivity to light. Your camera has a range of ISO 100 to ISO 12800. You also have the option of H, which if engaged increases the camera light sensitivity to ISO 25600. To turn this option on, use the Custom function 1 ISO expansion.

▶ **Shutter button.** This is the button that triggers the camera to take a photograph. Pressing the button halfway activates the focusing and exposure system.

▶ **Main dial.** Use this to move through different menus and options on your camera. For example, if you press the Menu button (**MENU**) and turn the Main dial either left or right, you scroll across the menu screen. If you select Shutter-priority AE mode (**Tv**), you use the Main dial to increase and decrease your shutter speed.

▶ **Power switch.** You have three options on the power switch: On, Off, and Movie (**'🎥**). On is for photographing still images; Movie (**'🎥**) is for creating videos.

▶ **Mode dial.** This dial has 14 options for selecting exposure modes. The white line next to the Mode dial tells you which option is in use.

Table 1.1 lists the fourteen exposure modes available on your Canon T4i/650D. There are four creative zone modes that offer greater flexibility. The remaining ten modes are automatic exposure options located in the basic zone.

Table 1.1 The Exposure Modes

Mode	Description
Manual (**M**)	You set the shutter speed and aperture.
Aperture-priority AE (**Av**)	You set the aperture and the camera sets the shutter speed for proper exposure.
Shutter-priority AE (**Tv**)	You set the shutter speed and the camera sets the aperture for proper exposure.
Program AE (**P**)	The camera automatically sets the shutter speed and aperture.
Scene Intelligent Auto (▣)	The camera analyzes the scene and chooses the proper settings, such as shutter speed, aperture, ISO, and focus mode. It also activates the flash if needed.
Flash off (⚡)	Performs the same function as the Scene Intelligent Auto mode (▣) but does not activate the flash.
Creative Auto (CA)	The default setting is the same as Scene Intelligent Auto mode (▣), except that you have more options, such as depth-of-field adjustments, choosing the Drive mode, and deciding whether to fire the flash.
Portrait (👤)	This mode blurs the background so that your subject is the central focus.
Landscape (🏔)	Use this mode when you want a large depth of field and crisp images.
Close-up (🌷)	This mode is for photographing small subjects that are close to your lens.
Sports (🏃)	Ideal for action photography, this mode prevents the blurring of moving objects, such as active children or athletes.
Night Portrait (🌃)	Use this mode when photographing people at night. It helps you capture as much background as possible by slowing the shutter speed. Try to minimize camera shake.
Handheld Night Scene HDR (🌆)	When you don't have a tripod, this mode helps capture handheld night shots. It accomplishes this by quickly shooting and combining four different exposures.
HDR Backlight (🖼)	This mode takes three quick shots at different exposures, and then combines them to create better highlight and shadow detail.

1

13

The Bottom of the Camera

The following items are located on the bottom of your camera:

▶ **Tripod socket.** Use this threaded hole to attach tripod plates or attachments.

▶ **Battery.** Your camera uses an LP-E8 battery pack. It takes approximately 2 hours to fully charge.

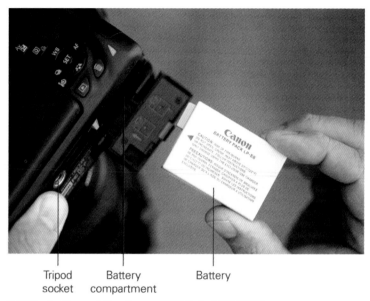

Tripod Battery Battery
socket compartment

1.2 The bottom of the Canon EOS Rebel T4i/650D.

NOTE A battery grip (BG-E8) is available for your Canon T4i/650D. This acces-
sory holds two batteries and allows for easier vertical shooting.

The Front of the Camera

The front of the camera features important things like the lens, and the flash (⚡) and Depth-of-Field Preview (▣) buttons.

The following buttons and features are found on the front of your camera:

▶ **Flash.** The built-in pop-up flash is a handy feature in low light and backlit situations. It syncs between 1/60 and 1/200 second. The effective distance of the flash

depends on the aperture and ISO settings, and the lens that you are using. I don't recommend using flash for subjects farther than 15 feet from your camera.

▶ **Flash mode button (⚡).** You have more control over your camera when using the creative zone modes because they prevent the pop-up flash from activating, even if it's dark. If you need additional light and don't have an external flash, press the Flash mode button (⚡) to activate the built-in flash.

▶ **Depth-of-Field Preview button (⬛).** It is sometimes helpful to know what the depth of field in your photo will look like in advance. The Depth-of-Field Preview button (⬛) shuts down the aperture so you can see the depth of field before you take your picture.

▶ **Lens.** To attach your Canon-dedicated lens, turn it until the red or white dots on both the camera and the lens are aligned. While pointing the camera away from you, turn the lens to the left until you hear a click and the lens stops turning. To release and change your lens, press the Lens Lock release button (when the camera is facing away from you, it's on the left side), and then turn the lens counterclockwise to release it. Remember to hold onto both the lens and the camera.

Pop-up flash Flash mode button

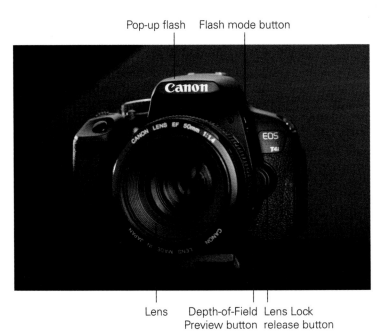

Lens Depth-of-Field Lens Lock
Preview button release button

1.3 The front of the Canon EOS Rebel T4i/650D.

The Back of the Camera

The back of your camera is where the action takes place. Most of the camera's options are here, including menus, photo information, and standard functions. The LCD touch screen adds additional functionality compared to other cameras—many standard functions are available just by touching an icon on the screen.

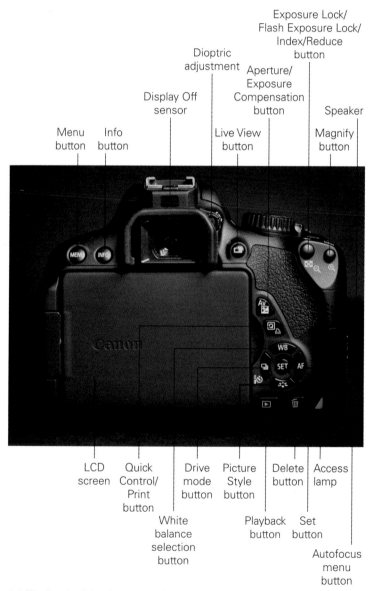

Exposure Lock/
Flash Exposure Lock/
Index/Reduce
button

Dioptric
adjustment

Aperture/
Exposure
Compensation
button

Display Off
sensor

Speaker

Menu
button

Info
button

Live View
button

Magnify
button

LCD
screen

Quick
Control/
Print
button

Drive
mode
button

Picture
Style
button

Delete
button

Access
lamp

White
balance
selection
button

Playback
button

Set
button

Autofocus
menu
button

1.4 The back of the Canon EOS Rebel T4i/650D.

NOTE You have fewer menu options when you use the basic zone modes, which are: Scene Intelligent Auto (⊡), Flash off (⊡), Creative Auto (CA), Portrait (☻), Landscape (▲), Close-up (♣), Sports (⚄), Night Portrait (⊡), Handheld Night Scene (⊡), and HDR backlight (⊡).

The following buttons and options are available on the back of your camera:

▶ **Menu button (MENU).** This button takes you to the menu screen. There are six menu groups: The Shooting menu (📷) includes options related to taking photographs; the Movie shooting menu ('🎥) has options for creating videos; the Live View shooting menu (📺) is for setting the Live View functions; the Playback menu (▶) is for reviewing images and postproduction; the Setup menu (🔧) is full of camera operation functions; and My Menu (★) is for you to set up your own menu of favorite settings.

CROSS REF Chapter 2 explains all of the menu options in detail.

▶ **Info button (INFO.).** Press the Playback button (▶), select an image using the Cross keys, and then press the Info button (INFO.). It offers four informational display options about your photographs, including two with histograms. When you press the Info button (INFO.) when the LCD screen is blank, a display appears with statistics about your camera, including how much free space is on the memory card and which color space you are using. When using the Live View Shooting (📺) or Movie ('🎥) modes, press the Info button (INFO.) to display the available functions and mode options.

▶ **Display Off sensor.** This sensor detects your eye moving toward the viewfinder and turns off the LCD screen. When you move your eye away from the camera, the LCD screen turns back on. This helps prevent glare from hitting your eye when trying to look through the viewfinder. This feature does not work in the Live View Shooting mode (📺). You can turn the sensor off in Setup menu 2 (🔧).

▶ **Dioptric adjustment.** Use the dial located above and to the right of the viewfinder to adjust the viewfinder's clarity. Focus on the nine AF focus points in the viewfinder and move the dial left or right until the points are sharp.

▶ **Live View Shooting button (📺).** This button activates the Live View shooting mode (📺) on the LCD screen. This option allows you to watch what's happening live through the lens. It is also used for starting and stopping movie capture when shooting in Movie mode ('🎥).

▶ **Aperture/Exposure Compensation button (⚙).** This button has two options when you are shooting in a creative zone mode (Manual (**M**), Aperture-priority AE (**Av**), Shutter-priority AE (**Tv**), or Program AE (**P**). When in Manual mode (**M**), it serves as the Main dial for adjusting the shutter speed. When you press the Aperture/Exposure Compensation button (⚙), the Main dial switches to aperture control. When you are shooting in the Program AE (**P**), Shutter-priority AE (**Tv**), or Aperture-priority AE (**Av**) modes, this button is used for exposure compensation for as many as 5 stops.

▶ **Exposure Lock/Flash Exposure Lock/Index/Reduce button (✳·⊖).** This button has four uses. It allows you to lock exposures while recomposing your shot, which is helpful in high-contrast or backlit situations. It is also serves as the Flash Exposure Lock, preventing your flash from readjusting its exposure. This allows you to recompose your image without worrying that the flash will under- or over-expose your image. When you are viewing your images in Playback mode (▶), this button serves as the Index Display and shows multiple photographs at one time on the LCD screen. Lastly, this button reduces magnified images in Playback mode (▶).

▶ **Magnify button (⊕).** This button has two uses. First, it magnifies your photos when you review them in the Playback mode (▶). You also can magnify the scene on the LCD screen (when not in Face Tracking mode (AF☺)). If you are in a creative zone mode (and the Live View shooting mode (◼) is turned off), this button can be used in conjunction with the Main dial (⚙) to select auto-focus points.

> TIP You can also tap the Magnify button (⊕) in the Live View shooting mode (◼) to magnify a scene.

1.5 The Exposure Lock/Flash Exposure Lock/Index/Reduce and Magnify buttons are located on the back of your camera on the upper-right side.

▶ **Speaker.** The speaker plays the sound from videos and slide shows.

▶ **Set button (⊛).** This button works like a return or input button on a computer. It affirms the highlighted setting you want to engage on a menu, or an option or function.

▶ **Delete button (🗑).** When you want to delete an image or video during playback, press the Delete button (🗑).

▶ **Autofocus menu button (AF).** In the basic zone modes, autofocus is set according to the mode and scene, and it cannot be adjusted. In the creative zone modes, the Autofocus menu button (AF) has the following three options: One-shot AF mode (**ONE SHOT**) locks on your subject after you press the shutter button halfway; AI Servo focusing mode (**AI SERVO**) follow-focuses on your subject; and AI Focus (**AI FOCUS**) defaults to the One-shot AF mode (oneshotaf) and switches to the AI Servo focusing mode (**AI SERVO**) if the camera detects movement.

▶ **Access Lamp.** When this light is on, it means the camera is recording an image. Make sure this light is off before removing the memory card from the camera.

▶ **Picture Style button (⌁⁚⁚).** Your camera offers many options for creating stunning images. The Picture Styles are designed to enhance your photographs depending on the type of scene you are photographing. For example, if you are shooting a landscape, using the Picture Style Landscape enhances the blues and greens, and increases the sharpness of your image. The Portrait Picture Style softens the image. You can also make your own Picture Styles in the Picture Style Editor software that is included with your camera.

CROSS REF Full descriptions of the Picture Style options can be found in Chapter 3.

▶ **Playback button (▶).** This option allows you to review your images. You can use the Main dial (⌁) or a finger swipe on the LCD screen to advance to the next image.

▶ **Drive mode button (⌁).** This button can be used in any exposure mode. It allows you to shoot one image at a time or take continuous shots of up to 5 frames per second (fps). You also have the following three self-timer options: 2 seconds, 10 seconds, and multiple shots with 10-second countdowns.

▶ **White balance selection button (WB).** This is the top Cross key button. It lets you change color tones in your photographs when the camera is in a creative zone mode. Use it to adjust the color of the environment to appear more natural. For example, if you are photographing in a room with tungsten bulbs as the main light source, your photographs will have a yellow cast. If you select the Tungsten white balance setting (⁕), the camera adds a blue filter to the scene to neutralize the yellow.

CROSS REF For more about white balance, see Chapter 3.

▶ **Quick Control/Print button (⊡).** When using either the creative or basic zone modes, use the Quick Control/Print button (⊡) to make active options available for that specific mode. For example, if you wish to change your shutter speed while shooting in Shutter-priority AE mode (**Tv**), press the Quick Control/Print button (⊡). The shutter speed options activate on the LCD screen. The Print function allows you to print directly to your home printer when the camera is connected to it with the supplied USB cable.

▶ **LCD screen.** The screen on the back of your camera is a vari-angle LCD touch screen. It is explained in detail later in this chapter.

The Sides of the Camera

The features on the sides of your camera are dedicated to electronic and computer functions. The memory card slot is on the right side of your camera, and the input and output terminals are on the left. You insert the memory card on the right side of the camera. I recommend using memory cards with as much space as possible, especially if you plan on shooting a lot of video. You may also want to pick up an Eye-Fi card, which wirelessly transfers your photos to your computer. After you install an Eye-Fi card, you can find the Eye-Fi settings under the Setup menu 1 (⚑).

1.6 The memory card is stored on the right side of the camera.

The following terminals are located on the left side of the camera:

▶ **A/V Out Digital.** This terminal is for connecting your camera to a non-HD television or monitor.

▶ **HDMI out.** Use this socket to connect the camera to an HD television or monitor. You will also need an HDMI cable.

CROSS REF The A/V and HDMI outputs are discussed in more detail in Chapter 9.

▶ **Remote terminal.** This is where you plug in a remote control, which allows you to keep the shutter open for long exposures. It is located on the left side of the camera (as the camera faces away from you) above the microphone terminal.

▶ **External microphone terminal.** If you plan to produce professional-quality videos, you need an external microphone. Your camera has one built in, but it also picks up camera noise, which is unacceptable for a good presentation.

Lens Controls

Each lens has its own set of controls, depending on what it is designed for and the manufacturer. You must use a lens with a dedicated Canon lens mount.

1.7 The connection terminals are located under the two covers on the left side of your camera.

Here are a few common features and controls you find on lenses:

▶ **Focus mode.** The focus mode lets you switch back and forth between manual and autofocus.

▶ **Focus range.** Some lenses, especially those with long focal-length ranges, have a switch to limit the focal length for faster focusing. Each lens approaches this option differently.

▶ **Focus ring.** If you switch your lens to Manual focusing, you use this ring to focus.

▶ **Image Stabilization switch.** Some lenses have Image Stabilization built in to help prevent unwanted blurring in images when using slow shutter speeds. This switch turns the option on or off.

Image courtesy of Canon

1.8 This Canon 55-250mm lens has Image Stabilization and Manual focus switches on the left.

▶ **Distance scale.** Many lenses have a distance scale on top that can be used to estimate focus based on feet or meters. The low number represents the closest your lens can be to an object to properly focus. Infinity is used when you want everything in focus, such as when shooting a landscape.

▶ **Zoom ring.** If you are using a zoom lens, turning the zoom ring sets your desired lens focal length.

The Viewfinder Display

The viewfinder is your photographic dashboard. It lets you know if your subject is in focus, if the exposure is correct, and if the flash is ready to fire. The display only shows information relevant to the scene or your choice of options.

The following are the indicators you see in the viewfinder (the options that are displayed depend on the mode you are using):

▶ **Focusing screen.** The electronic screen that you see when you look through the viewfinder to focus the camera.

▶ **Spot metering circle.** This is the area the Spot metering mode (⊡) reads to determine the proper exposure.

▶ **AF point activation indicator.** Each of the nine autofocus points light up as indicators as they are activated.

▶ **AF points.** There are nine autofocus points on the focus screen that can be used to focus the camera.

▶ **ISO speed (ISO).** This setting displays the camera's ISO setting.

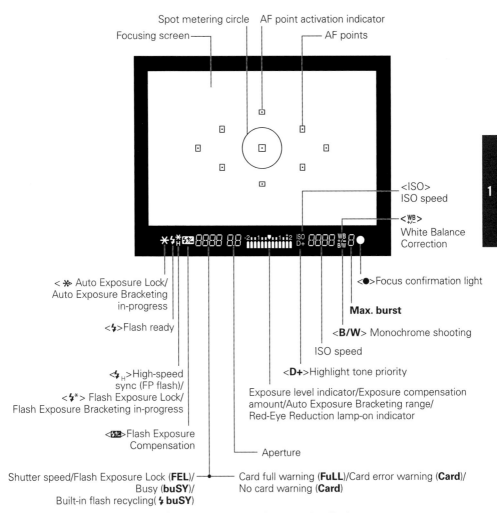

Spot metering circle AF point activation indicator

Focusing screen AF points

<ISO>
ISO speed

<WB>
White Balance
Correction

< ✹ > Auto Exposure Lock/
Auto Exposure Bracketing
in-progress

<●>Focus confirmation light

Max. burst

<⚡>Flash ready

<B/W> Monochrome shooting

ISO speed

<⚡H>High-speed
sync (FP flash)/
<⚡*> Flash Exposure Lock/
Flash Exposure Bracketing in-progress

<D+>Highlight tone priority

Exposure level indicator/Exposure compensation
amount/Auto Exposure Bracketing range/
Red-Eye Reduction lamp-on indicator

<FEC>Flash Exposure
Compensation

Aperture

Shutter speed/Flash Exposure Lock (**FEL**)/
Busy (**buSY**)/
Built-in flash recycling(⚡ **buSY**)

Card full warning (**FuLL**)/Card error warning (**Card**)/
No card warning (**Card**)

1.9 This graphic shows the information you see in your viewfinder.

▶ **White Balance Correction (WB).** This lets you know that a white balance correction is being applied.

▶ **Focus confirmation light.** This light indicates that the camera believes your image is in focus.

▶ **Max. burst.** The number of photographs your camera buffer can hold before it is full.

▶ **Monochrome shooting (B/W).** This lights up if you are using a black-and-white or monochromatic option.

► **Highlight tone priority (D+).** This lets you know that the Custom Function 3 Highlight tone priority function is on. This option improves highlight detail in your photos.

► **Exposure level indicator.** This lets you know how much your image is under- or overexposed based on the camera's internal light meter.

► **Exposure compensation amount.** This indicates how much of an increase or decrease in exposure is set.

► **Auto Exposure Bracketing range.** This lets you know how many stops under- and overexposed your bracket is set.

► **Red-Eye Reduction lamp-on indicator.** This lets you know that the Red-Eye Reduction option is on.

► **Aperture.** This tells you at what aperture your camera is set.

► **Card full warning (FuLL).** When the memory card is full, this warning alerts you. You can't take any more photographs until you delete some images or replace the card.

► **Card error or no card warning (Card).** When you see this warning, your camera is experiencing an error reading or writing to the memory card, or there is no card in your camera.

► **Shutter speed.** This is the indicator that tells you at which shutter speed the camera is set.

► **Flash Exposure Lock (ϟ*).** When this icon appears, it means that the Flash Exposure Lock is engaged.

► **Busy (buSY).** When you see this, the camera is still processing images.

► **Built-in flash recycling (ϟ buSY).** This indicates that the built-in flash is recharging.

► **Flash Exposure Compensation (🔲).** This light comes on when Flash Exposure Compensation is in use.

► **High-speed sync (ϟH).** This indicates that High-speed sync is engaged on your speedlite.

► **Flash Exposure Lock/Flash Exposure Bracketing in-progress (ϟ*).** This icon indicates that the Flash Exposure Lock and Flash Exposure Bracketing are in use.

► **Flash-ready (ϟ).** When your flash is ready to fire, this icon lights up.

► **Auto Exposure Lock/Auto Exposure Bracketing in progress (✲).** This indicates that the Auto Exposure Lock or Auto Exposure Bracketing is in use.

The LCD Touch Screen and Live View Mode

The Canon EOS Rebel T4i/650D LCD touch screen adds another dimension to your camera. Not only do you have a large, flexible screen to use while taking photos or shooting video, but it is also a tool for making feature selections fast and easy. When you use the screen to review photos, it is similar to how you navigate on a smartphone. Just swipe your fingers across the LCD screen to view the next image or spread your fingers across the LCD screen to enlarge one. These gestures come so naturally, you might soon find yourself trying to swipe the image files on other camera screens.

1.10 Use your finger to swipe to the next image.

NOTE The software that comes with your camera allows you to connect it to a computer and take photos remotely.

The Live View shooting mode (📷) is a useful feature, particularly when you are shooting video because the touch screen menus are found on the edges of the LCD screen. To turn on Live View mode (📷), press the Live View button (📷) located to the right of your camera's eyepiece. The default focus system for Live View is Continuous view. There are options to make adjustments using the four information displays.

Each time that you press the Info button (**INFO.**) the display switches to the next option. If you don't want to use the Live View mode (◙), disable it by pressing the Menu button (**MENU**), and then select the Live View menu (◙).

CROSS REF For more information about the Live View Shooting mode (◙), see Chapter 8.

The following list covers how to navigate the options and views available in the Live View Shooting mode (◙):

▶ **Making selections.** Menu options differ from the creative to basic zone modes. You have more options in creative zone modes. When you want to make a selection, touch the icon on the LCD screen and additional options appear, if applicable.

▶ **Viewing photos.** To view your photos, press the Playback button (▶), which shows the last photograph you created. Swipe one finger across the screen to scroll to the next picture. Move your finger to the left to view the newest image, and to the right to view older photos or those with lower file numbers. If you use two fingers when you swipe, the camera jumps the number of images set in Playback menu 2 (◙). When you place two fingers in the middle of the screen and spread them apart, you zoom in to the photograph. When you pinch your fingers together, you zoom out. You can also use the Cross keys to maneuver through your photographs.

1.11 Press the Playback button to view your images.

▶ **Viewing videos.** Press the Playback button (▶). You will know which files are videos because they have a large Playback icon (▶) displayed on the LCD screen—press it and the video starts playing. There are additional options at the bottom of the LCD screen to fast-forward, rewind, turn the sound off, or edit the video. Use the Main dial (✺) to control the volume.

▶ **Still information display.** When shooting photos, there are standard informa-
tion displays for the creative and basic zone modes (note, however, that these
do not appear in the Live View shooting mode (■)). Press the Quick Control/
Print button (▣) to make adjustments to the available options.

▶ **Movie information display.** This display includes some of the same informa-
tion that the still display does, including white balance, AF method, and Picture
Styles. However, it also includes the video size and frame rate. Like the still
information, you have a few more options when you use the creative zone
modes. For example, you don't have white balance or Picture Style options avail-
able if you're using a basic zone mode.

1

Setting Up the Canon EOS Rebel T4i/650D

You may already know how to use some of the settings on your Canon camera. If you are familiar with dSLRs, you know the camera manufacturers are adding more features every year. This chapter is all about the menus found when you push the Menu button (**MENU**) on your camera, along with a quick overview of each setting. Generally, each menu has a theme. However, finding what you are looking for can quickly become confusing. Take the time to review all of the Canon Rebel T4i/650D menus and settings. Once you customize your camera and use it for a while, you can refer to this chapter as needed.

The Menu button is on the upper-left side of your camera.

The Shooting Menus

If you use the creative zone modes (Program AE (**P**), Shutter–priority AE (**Tv**), Aperture–priority AE (**Av**), and Manual (**M**)), you have three shooting menus available to you. When you use the basic zone modes (Scene Intelligent Auto (**⬛**), Flash off (**⚡**), Creative Auto (**CA**), Portrait (**♥**), Landscape (**➤▲**), Close-up (**♣**), Sports (**🏃**), Night Portrait (**Ⓝ**), Handheld Night Scene (**⊞**), and HDR backlight (**🖼**)), only Shooting menu 1 (**📷**) is available.

> **NOTE** When you are using any of the shooting modes, you can press the Info button (**INFO.**) on the back of the camera to display a screen containing many of your camera's major functions.

Shooting menu 1

The first menu is available for both creative and basic zone modes. The only option not available when using basic zone modes is flash control. When you are in Movie shooting mode (**'🎬**), red-eye reduction and flash control are no longer listed.

Settings and corrective functions

The following list of options is available in Shooting menu 1 (**📷**):

▶ **Image quality.** You have 10 options here. RAW (**RAW**) is the option with the highest quality and Small 3 (**S3**) is the smallest. The RAW (**RAW**) and Large fine (**◢L**) combination creates both image types at the same time.

▶ **Beep.** The beep sounds when the camera has achieved focus, during self-timer countdown, and when you press a button on the LCD touch screen. Select Enable or Disable to turn the beep on or off. You can also turn the beep off for the LCD touch screen only, and leave it on for both the focus and self-timer.

▶ **Release shutter without card.** This option allows you to shoot even if there is no memory card in your camera. The default is Off, which prevents you from taking a photograph without a card. I recommend leaving this

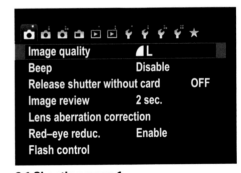

2.1 Shooting menu 1.

off. It's no fun finding out later that you took a bunch of pictures without a card to record them.

▶ **Image review.** After you take a photograph, the image displays on the LCD screen. This option gives you the choice of turning Image review off, or setting the review time to 2, 4, or 8 seconds. There is also an option called hold. This leaves the image displayed until the Auto power off timer (found under the Setup menu 2 (🔧) turns off the display or you press a button on the camera, such as the shutter-release or Menu (**MENU**) button.

▶ **Lens aberration correction.** Some lenses produce images with peripheral light falloff, which creates darker corners in your photos. This is also known as *vignetting*. Other lenses create *chromatic aberration*, which means that the color fringes along light and dark (high-contrast) lines because the colors traveling through the lens are not able to refocus on the same point. If you have these issues with your lens, this selection is an option to help correct it. If you photograph in the RAW file format, you can also make adjustments using the Canon Digital Photo Professional software that came with your camera.

▶ **Red-eye reduction.** When using flash indoors, the light from it reflects off of your subject's pupils and back into the lens of your camera, making your subject's eyes appear to be red. The closer the flash is to your lens, the greater the chance of red eye. When you enable Red-eye reduction, the camera's red-eye reduction lamp lights up to reduce the size of your subject's pupils, thereby decreasing the chance of red eye. Red-eye reduction does not work in the Flash off (🚫⚡), Landscape (🏔), Sports (🏃), or HDR backlight (🖼) modes.

Flash control

Selecting this option opens a new menu with the following flash controls:

▶ **Flash firing.** Select Disable when flash is not allowed. This prevents the flash from popping and firing while using basic zone modes.

> **NOTE** Turning flash firing to Disable does not prevent the AF-assist beam from illuminating in low-light situations.

▶ **E-TTL II Metering.** This is Through-the-Lens metering for your flash. You have two flash metering options: Evaluative and average. Evaluative is the default metering option, which sets the exposure based on the scene the camera reads. Average metering averages the light in the entire scene to determine the proper exposure.

▶ **Flash sync. speed in Av mode.** There are three flash sync options when using the creative zone mode in Aperture–priority AE mode (**Av**). Auto ranges from 1/200 second to 30 seconds; this can be an issue if you don't want any blur in your photographs caused by low light. The 1/200 second to 1/60 second auto option prevents the camera from setting the shutter speed below 1/60 second. This helps prevent camera shake and ghosting, which happens when using slower shutter speeds. The third option is a fixed 1/200 second shutter speed. In low light, this setting tends to create a dark or black background.

▶ **Built-in flash settings.** When you select this option, you are taken to another menu with more options. Normal firing is the default for most flash photography using the pop-up, built-in flash. Easy wireless lets you set the channel you want to use to trigger an external speedlite when it is set to Slave, as shown in Figure 2.2. CustWireless offers more options to set up the camera's built-in flash to your specifications.

▶ **Flash mode E-TTL II.** This option, available under CustWireless, gives you the choice of using Canon's E-TTL II flash metering system or manual metering. Manual is for controlled flash output. This option is recommended for advanced users.

▶ **Shutter sync.** Curtain sync sets the beginning of the exposure. First–curtain sync means the flash triggers immediately after the shutter button is pressed. Second–curtain sync delays the flash to the end of the shutter cycle.

▶ **Wireless func.** You have three wireless options. The first sets the built-in flash to extend only enough to trigger the external speedlight. The second is designed to trigger multiple speedlites. The third uses the internal flash and external speedlites for exposure. Each wireless function setting adds dedicated options to the menu, such as flash ratio setup and group firing options.

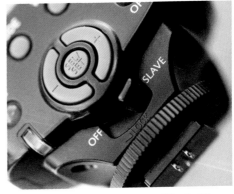

▶ **Channel.** You have four channels to choose from for wireless to trigger an external speedlite using the Slave option. Make sure that both the camera and the speedlite are set on the same channel.

2.2 The switch to turn a speedlite to Slave mode is often found at the base, as shown here on the Canon 430EX.

▶ **Exp. comp.** This gives you the opportunity to manually increase or decrease the camera's exposure by up to 2 stops.

▶ **External flash func. Setting.** You can set some of your external flash settings from your camera's menu using this setting.

▶ **External flash C.Fn Setting.** This custom function setting varies depending on your flash model.

▶ **Clear settings.** If you want to set the camera's flash settings back to the defaults, select clear settings. You have the option of clearing the built-in and external flash settings, as well as the flash Custom Functions.

Shooting menu 2

The settings under the Shooting menu 2 (◙) are only available while using creative zone modes. Most of the options in the Shooting menu 2 (◙) are related to exposure, color, and contrast.

You'll find the following options in Shooting menu 2 (◙):

▶ **Expo.comp./AEB.** This option has two settings. The first (top) is for exposure compensation, which allows you to increase the camera's exposure settings by plus or minus 5 stops. The bottom setting is the stop range between exposures for Auto Exposure Bracketing (AEB).

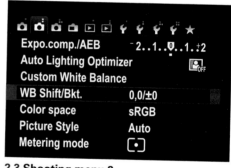

2.3 Shooting menu 2.

▶ **Auto Lighting Optimizer.** This setting automatically corrects the brightness and contrast of your image when you are creating JPEG files. You have four choices: Off, Low, Standard, and High. The default setting is standard. This feature improves underexposed images. It helps bring out shadow detail in the dark areas of an image and automatically adds contrast, without blowing out highlights.

▶ **Custom White Balance.** Use Custom White Balance when you want to set white balance based on the light of a specific environment. To do this, take a photograph of a white piece of paper in the same lighting you are balancing. Using the Custom White Balance setting, select the image of the white piece of

paper (which will reflect the color of the light in the room), and the camera sets the Custom White Balance based on the selected image.

▶ **WB Shift/Bkt.** Just like bracketing for exposure, you can bracket for white balance. This selection gives you bracketing options between blue and amber, or green and magenta. So, in one shot you create three images with different color balances.

▶ **Color space.** You have two color spaces from which to choose: sRGB (the default) and Adobe RGB. sRGB is a good choice for e-mail, digital media, and Internet use. Adobe RGB is a larger gamut of colors and is a good choice if your photographs are used for commercial print purposes.

▶ **Picture Style.** These settings are designed to enhance various photographic scenes with sharpness, contrast, saturation, and tone adjustments. The Picture Styles menu and the Picture Styles button on the back of the camera offer the same options. You may select a specific style, adjust a preset style, or create your own style to be stored in the user-defined section.

▶ **Metering mode.** The Canon T4i/650D has four metering modes—the default is Evaluative metering mode (⊡). The other three options are the Partial (⊡), Spot (⊡), and Center-weighted (⊡) metering modes.

Shooting menu 3

The third shooting menu and its settings are only available when using creative zone modes. The options are related to ISO, noise reduction, and image quality.

The following options are available in Shooting menu 3:

▶ **Dust Delete Data.** This option helps collect data on dust not removed by the self-cleaning sensor. Once you go through the data collection process, it attaches the information to your JPEG and RAW files. This option

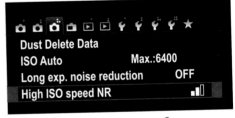

2.4 Shooting menu 3 on your Canon T4i/650D.

works in conjunction with Canon's Digital Photo Professional software to automatically remove dust from your photographs.

▶ **ISO Auto.** If you don't want your automatic settings to exceed a specific ISO setting, you can set the maximum ISO within the range of ISO 400 to ISO 6400.

▶ **Long exp. noise reduction.** Long exposures tend to create a lot of noise in photographs. When enabled, this setting can reduce the noise produced in your images by exposures of 1 second or more. When set on Auto, the camera detects and applies the setting as needed.

▶ **High ISO speed NR.** This setting is a noise reduction (NR) option. It can remove noise in shadow detail at all ISO settings, but the effect is more noticeable at higher ISO settings.

The Live View Shooting Menu

The Live View Shooting mode (◉) allows you to see the scene in front of your lens on the camera's LCD screen. The LCD screen can swivel 180 degrees horizontally from the camera. It can also swivel up or down. This is helpful when holding the camera high or low to capture new angles.

You find the following options in the Live View Shooting menu (◉):

▶ **Live View shoot.** Here, you can enable or disable the Live View option.

▶ **AF method.** This setting offers four focus modes. All of them (except the Quick focus mode (AFQuick)) use the image sensor to autofocus. The first option is the Face Tracking mode (AF⚇), in which the camera focuses on

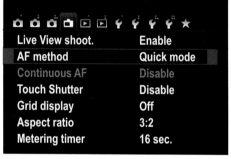

2.5 The Live View Shooting menu.

and follows any face it detects. The second is the FlexiZone-Multi mode (AF◖), which uses 31 focal points that also may be manually divided (using the LCD touch screen or the Set button (⊛)) into one of nine zones. The third is the FlexiZone-Single mode (AF□), in which you can select one of the 31 focal points as the point of focus for your photograph. The last option is the Quick focus mode (AFQuick). It is the fastest focusing option because it uses only nine AF points to focus.

▶ **Continuous AF.** When the Quick focus mode (AFQuick) is enabled, Continuous AF is automatically turned off.

▶ **Touch Shutter.** If you enable Touch Shutter, all you have to do is touch the LCD screen to take a photograph. If it is disabled, there is an icon on the bottom left of your screen to enable the option at any time.

▶ **Grid display.** You have two grid display options to help level your camera in comparison to your scene. One is shaped like a tic-tac-toe board, with two horizontal and two vertical lines resulting in nine squares in the grid. The second option contains 24 squares and 15 line intersections to help you compose your image.

▶ **Aspect ratio.** You have the following four aspect ratios (the shape in which the camera frames your scene) available: 3:2 (35mm film), 4:3 (old television), 16:9 (HD video standard), and 1:1 (square). The aspect ratio option is only available in the creative zone modes.

▶ **Metering timer.** Choose this option to select how long exposure settings are displayed on the LCD screen. This option is available only in the creative zone modes (in the basic zone modes, the default is 16 seconds).

The Movie Shooting Menus

You have two Movie shooting menu options. Some of the selections relate to autofocus, movie size, and sound options.

Movie shooting menu 1

In the first movie shooting menu, you find autofocus options, a grid display, and metering timer options.

The following options are available in Movie shooting menu 1 (▦):

▶ **AF method.** These are the same as the AF methods in the Live View Shooting menu (▣), except that you don't have an option for the Quick focus mode (AFQuick). Face Tracking (AF▦) detects a human face and places a focus point over it. FlexiZone-Multi (AF❑) uses multiple points to focus on the subject. FlexiZone-Single (AF❑) uses one of the 31 available points of focus. You can use the Set button (⊛) to reset your focus to the center of your screen.

▶ **Movie Servo AF.** This selection turns the Movie Servo AF feature (▦) on or off—it is on by default. If either you or your subject is moving, the Movie Servo AF (▦) will follow-focus on your subject. If you are concerned about focusing noise from your lens, consider using one of the Canon STM lenses designed to limit noise.

▶ **AF w/shutter button during ('🎥).** Your camera allows you to take still photos while shooting in Movie mode ('🎥). The One shot selection (the default) is activated by pressing the shutter button halfway. It then refocuses for your still

photograph while you are shooting your video. When this option is turned off, you can still take photographs, but the camera will not refocus.

▶ **Grid display.** Your camera has two grid display options useful for leveling your scenes. The grids are displayed on the LCD screen. This option is turned off by default.

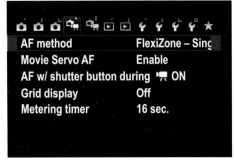

2.6 The five choices available in Movie Shooting menu 1.

▶ **Metering timer.** This sets how long the exposure settings are displayed on the LCD screen. This option is only available in the creative zone modes. In the basic zone modes, the default is automatically set to 16 seconds.

Movie shooting menu 2

The second movie shooting menu offers pixel size and frame per second (fps) options, as well as sound recording and video snapshot features.

The following options are available in Movie Shooting menu 2:

▶ **Movie rec. size.** You have four movie recording options for each of the two video systems: NTSC and PAL. *NTSC (National Television System Committee)* is the standard video system used in North America and Japan (among other countries). *PAL*

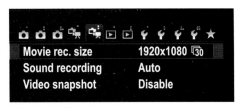

2.7 Movie Shooting menu 2.

(Phase Alternating Line) is the standard recording format for Europe, much of Africa, and China (among other countries). Each of these settings gives you a combination of movie image sizes in pixels and frame rate (frames per second). The frame rate options for NTSC are based on recording at 30 frames per second (29.97). PAL is based on 25 frames per second. The third statistic displayed is how much recording time you have before you run out of storage space on your memory card. The maximum recording time is 29 minutes, 59 seconds.

▶ **Sound recording.** This selection turns the microphone (located on top of the camera) on or off.

▶ **Video snapshot.** Your camera can create quick snapshots and save them to albums. When this setting is turned on, you can adjust the length of your clips to 2, 4, or 8 seconds. Disable this option if you want to create movies longer than your selected short clip length.

The Playback Menus

The Playback menus contain options for photographs that you have already selected. Some of these are actions or adjustments you might want to perform in editing software on your computer. Playback menu 2 (⊡) focuses on reviewing your photographs.

Playback menu 1

The first Playback menu focuses on postproduction. You can protect your image(s) from being erased, rotate photos, or erase unwanted files. This is also where you find options for book creation and creative filters.

The following options are found in Playback menu 1 (⊡):

▶ **Protect images.** This option pro-
tects images from being erased
from the memory card.

▶ **Rotate image.** If you are not
using Auto rotate (found in Setup
menu 1 (⊠)), then you can manu-
ally rotate your images using this
option.

▶ **Erase images.** This option lets
you erase selected (checked)
images. You have three options:
Erase selected images, Erase images from a specific folder, or Erase all images
on your disk. Protected images are not erased.

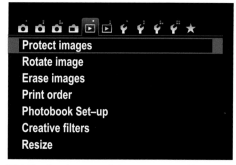

2.8 **Playback menu 1 has seven options.**

CAUTION If you use the RAW (RAW) and Large Fine (◢L) image settings, the Erase
option removes both images.

▶ **Print order.** If you use the digital print order format (DPOF) available with your
camera, this option helps you select the print type, and date or file number
imprint for your orders. The settings are applied to all print-ordered images.

▶ **Photobook Set-up.** If you want to create a photobook, this option helps you select and organize the images for it.

▶ **Creative filters.** You can apply creative filters to existing images using this selection. Options include: Grainy B&W, Soft focus, Fish-eye effect, Art bold effect, Water painting effect, Toy camera effect, and Miniature effect. When you apply a filter, the camera creates a new file.

CROSS REF See Chapter 9 for examples of the Creative filters.

▶ **Resize.** If you want to create smaller-sized images, select this option. You cannot, however, make images larger. Resize creates a new file so that your original is not erased.

Playback menu 2

Playback menu 2 (▣) focuses on image review rather than working with your photographs as in Playback menu 1 (▣).

The following options are available in Playback menu 2 (▣):

▶ **Histogram disp.** This selection gives you the option of displaying either the brightness or RGB histogram when reviewing your photographs. Press the Info button (**INFO.**) to see the histogram of your photographs.

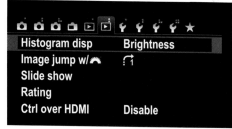

2.9 The options in Playback menu 2.

▶ **Image jump w/** ⚟. Increase the image jump number when you want to move through your photos faster. The default setting is to browse one image at a time, but here you can adjust it to move between 10 or 100 images. This is useful when you have a lot of photographs and videos on your memory card. You can also set up your browsing based on different jump methods, such as by date, folder, movies only, stills only, or image rating.

▶ **Slide show.** You can share your images as a slide show on the LCD screen, or use the HDMI output to show them on an external TV or monitor. You can select specific images, or select them by date, folder, rating, or whether they are stills or movies. You also have a choice of five transitions and music options.

▶ **Rating.** Choose this option to rate your images. This makes it easier to sort your photographs when using the Image jump or Slide show options.

▶ **Ctrl over HDMI.** When you connect your camera to a high-definition TV using an HDMI cable, you can use a remote control to activate your Canon T4i/650D's playback functions. You do this by selecting Enable and following the directions. Not all televisions allow this function. If yours does not, return to the default Disable setting.

The Setup Menus

The Setup menus are full of options to customize your camera the way you like it. There are four menus to choose from when using the creative zone modes, which are Manual (**M**), Aperture-priority AE (**Av**), and Shutter-priority AE (**Tv**). There are three options available in the basic zone modes, which are Scene Intelligent Auto (⬛), Flash off (⬛), Creative Auto (⬛), Portrait (⬛), Landscape (⬛), Close-up (⬛), Sports (⬛), Night Portrait (⬛), Handheld Night Scene (⬛), and HDR backlight (⬛).

Setup menu 1

Setup menu 1 (⬛) contains options for file location, numbering rotation, and formatting the memory card.

The following options are in Setup menu 1 (⬛):

▶ **Select folder.** This option allows you to assign photographs to folders. You can also create new folders here.

▶ **File numbering.** You have three options when it comes to file numbering. Continuous numbers your files from 0001-9999. Auto reset reverts the file number to

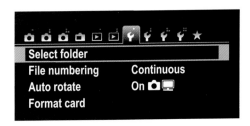

2.10 Setup menu 1.

0001 with each new memory card you insert or new folder you create. Manual reset gives you the opportunity to reset your file numbers to 0001 at any time.

NOTE A new folder is automatically created when your file numbers reset using the Continuous file numbering setting.

▶ **Auto rotate.** When this is on, the camera rotates vertical images to display them in the horizontal frame of the LCD screen or computer. You also have the option to not have your images rotate during playback; they still rotate when viewed on the computer, however. You may also turn the Auto rotate option off.

▶ **Format card.** When you purchase a new memory card or use one that was initialized by another camera, you should format the card for the Canon T4i/650D. After formatting the card, you may not be able to recover any images that were on the card. To ensure complete formatting of all sectors of the memory card, select Low-level formatting. This takes longer to execute than the Normal formatting, but it completely clears the card of recoverable data. There are many reasons a photographer might want to permanently remove all data from a memory card, such as to erase photos of a sensitive or security-related nature.

Setup menu 2

Setup menu 2 (■) addresses power, the LCD screen, date/time, language, and video systems.

The following seven options are in Setup menu 2 (■):

▶ **Auto power off.** You can set the camera to turn off if left untouched for 30 seconds or 15 minutes. You can also disable this option—however, if you do (or set it for a longer period of time), you risk wearing down the battery before its next use.

▶ **LCD brightness.** This option controls the brightness of the LCD screen.

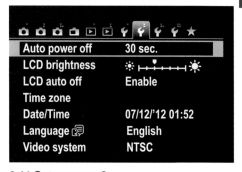

2.11 Setup menu 2.

▶ **LCD auto off.** This setting disables the eye sensor from turning off the LCD screen, which it does when you bring your eye to the viewfinder. It turns back on when you remove your eye from the eyepiece.

▶ **Time zone.** This option lets you set the time zone based on a major city in your zone. The sun icon allows you to turn daylight saving time on or off.

▶ **Date/Time.** Use this option to set the date and time on your camera.

▶ **Language.** This option lets you select the language you want your camera to display.

▶ **Video system.** Use this option to select the video recording standard you want to use for your movies, NTSC (the default) or PAL.

Setup menu 3

The Setup menu 3 (⚙) gives you options for screen color, the feature guide, touch control, sensor cleaning, and GPS device settings.

The following menu options are available in Setup menu 3 (⚙):

▶ **Screen color.** Your camera has five screen color options: Black, light gray, dark gray, blue, and red. Red is often used for night photography to help prevent the loss of night vision.

▶ **Feature guide.** This is like an in-camera tutorial that explains different features as you review

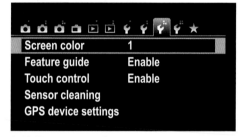

Screen color	1
Feature guide	Enable
Touch control	Enable
Sensor cleaning	
GPS device settings	

2.12 Setup menu 3.

them. This is helpful when you are new to the camera. You can choose to enable or disable this option here.

▶ **Touch control.** This option turns Touch control on or off. You can select features using the Cross keys, the Set button (⊛), or by touching the LCD screen.

▶ **Sensor cleaning.** When you turn the power switch On or Off, you activate the camera's sensor cleaner. The cleaner shakes dust off of the camera's front sensor. This setting gives you three options: Enable or Disable the auto sensor cleaning, Clean your sensor now, or Clean manually. If you choose manual cleaning, the camera locks the mirror up for easier sensor access. I recommend that you leave the auto sensor cleaning on.

CAUTION You should always use the proper tools or have an experienced professional clean the camera sensor; otherwise you risk creating unwanted scratches.

▶ **GPS device settings.** If you purchase GPS accessories for your camera, this is where you control the settings for them. This menu option is only available if you are connected to a GPS device, such as the Canon GP-E2.

Setup menu 4

In Setup menu 4 (🔧), there are options for Custom Functions, copyright, clearing settings, and firmware updates.

The following options are available in Setup menu 4:

2.13 Setup menu 4.

▶ **Certification Logo Display.** Highlight this menu option and press set. The camera displays some of the manufacturer certifications.

▶ **Custom Functions (C.Fn).** This selection allows you to control all eight of the camera's Custom Functions individually. The following four Custom Functions are available on the Canon T4i/650D:

- **C.Fn I: Exposure.** Here, you can adjust the exposure level in 1/3 or 1/2 stop increments. If you prefer more refined increments for your exposure settings, such as shutter speed, aperture, and exposure compensation, use the 1/3 stop option. The other option under this function is turning ISO expansion on or off. ISO expansion allows you to shoot at the equivalent of ISO 12800 for stills or ISO 6400 for videos.

- **C.Fn II: Image.** In this menu, you can turn the Highlight tone priority function on or off. This option expands the camera's dynamic range into brighter areas, improving the highlight detail in your images.

- **C.Fn III: Autofocus/Drive.** There are two options here: AF-assist beam firing and Mirror lockup. The AF-assist beam supports the pop-up and external E–TTL flashes to properly expose your subject. I recommend that you leave this option on. The Mirror lockup function locks the camera mirror to help prevent vibration during long exposures when using telephoto and macro lenses.

- **C.Fn IV: Operation/Others.** You can adjust three settings in this menu. The Shutter A/E lock button can be assigned different functions, such as autofocus lock, exposure lock (without autofocus lock), and autofocus lock (without exposure lock). Assign Set button allows you to assign a specific function to the Set button (SET), such as image quality, flash exposure compensation, or ISO speed. You can enable the LCD display when power on function if you want the LCD screen automatically turned on when the camera's power

switch is turned on (this is the default). To save power, use the Previous display status option. To activate it, with the LCD screen turned off, press the info button (**INFO.**) before turning off the camera. When you turn the camera back on, the LCD screen will not turn on automatically. To return to the default setting, press the info button (**INFO.**).

▶ **Copyright information.** This option inserts copyright information into your files. You can view this information under File Info in standard photo-editing programs.

▶ **Clear settings.** Use this option if you want to clear all of the camera's settings and return them to their default status. You can clear all settings or Custom Settings only.

▶ **Firmware ver.** This setting displays the camera's current *firmware* version (that is, the software running your camera). Make sure that you register your camera because Canon will send you notifications about firmware updates. You then activate those updates here. To do so, you use your computer to download the latest firmware to a clean, formatted memory card. The Format memory card option is in Setup menu 1 (▣).

NOTE The LCD touch screen is disabled during firmware updates.

My Menu Settings

We all have settings that we use often or like to adjust. My Menu (★) gives you six locations in which to keep your favorite options at your fingertips. To get started, you need to select and register each option that you want to display in your menu.

Follow these steps to customize your My Menu settings:

1. **Select My Menu settings under My Menu (★).**

2. **Select Register to My Menu.** All of the available options are displayed. If an option is grayed out, this means that it is already on the My Menu list.

3. **Press the Set button (⊛) to register your option.** Repeat this process until all six locations are filled.

These settings are not permanent—you can Sort or Delete them at any time in My Menu (★).

Choosing the Right Settings for Your Camera

You've probably noticed all of the buttons on the back of your camera and are wondering what they do. This chapter covers the functions of many of these buttons, including how they adjust the exposure, focus, white balance, and drive modes. Your camera has a full line of modes to help you take great photos. Certain modes are better for particular situations, so it's important to understand what they do and how they benefit your photography. Some types of photography require fast shutter speeds, while others look better with a shallow depth of field—all of which are handled effectively by your camera's 14 exposure modes. Focus modes help keep your subject in or out of focus (depending on the desired result), while white balance can give you the best colors in a scene. Flash modes help you control light—the most important element in photography.

This image uses the foreground and a shallow depth of field to lead your eye to the tomatoes.

The Basic Zone Modes

Your camera has some excellent options to help you take the best image for different types of photography. Portraits, landscapes, and sports require preferred settings to capture the best image. The automatic modes are easy to recognize because they use icons representing the type of photography for which they are best used.

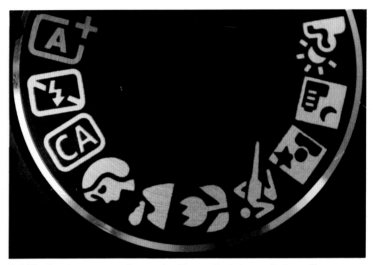

3.1 The basic zone modes make it easy to take a photo—all you have to do is press the shutter button.

The basic zone modes are easy to use—just press the shutter button for a proper exposure. The following are the basic zone modes on the Canon T4i/650D:

▶ **Scene Intelligent Auto mode (⊞).** This is the ultimate program mode. It analyzes the scene and sets the shutter, aperture, ISO, white balance, and focus modes to take the best photograph. It uses all nine zones of focus to focus on the closest subject in the frame. If the camera detects a moving subject, it switches to the AI Servo mode (**AI SERVO**) to follow-focus. The camera uses the flash when necessary, such as in backlighting situations.

> TIP When using the pop-up flash, you should stand at least 3.3 feet away from the subject to properly expose it. If you are too close, the bottom of the photo may be dark.

▶ **Flash off mode (⚡).** If you don't want your flash to turn on at any time, use the Flash off mode (⚡). This mode is the same as the Scene Intelligent Auto mode (🅰) without the flash. It is helpful when shooting in places where flash is distracting or not allowed, such as at a museum.

▶ **Creative Auto mode (CA).** This setting uses the Scene Intelligent Auto mode (🅰) as a default setting, but gives you a host of creative options. Press the Quick Control/Print button (🔲) to view a screen with the Creative Auto (CA) options. From there, make adjustments using the touch screen or traditional controls. This mode allows you to change the ambience options and control the depth of field with a convenient slider to adjust the amount of blur you want in the background. The Drive mode (DRIVE), Self-timer drive mode (♦), and flash controls are also available.

> **NOTE** Ambience effects are available in all basic modes, except Scene Intelligent Auto (🅰), Flash off (⚡), and HDR backlight (▣).

▶ **Portrait mode (♠).** This mode (♠) sets your aperture to the lowest possible number to create a shallow depth of field. A shallow depth of field blurs the background to separate the subject from it, which keeps the focus on your subject. This mode is for more than portraits, though. Any time you need a shallow depth of field for food, product, or pet photography, use the Portrait mode (♠). Use the Quick Control/Print button (🔲) to adjust ambience settings, color scene filters for white balance, and shooting modes.

> **NOTE** If you want to see what your depth of field looks like in advance, press the Depth-of-Field Preview button (▣) on the front of your camera.

▶ **Landscape mode (▲).** The goal of this mode is to give you the largest depth of field possible. In this mode, you have control over the ambience setting, color scene filters for white balance, and shooting modes.

> **CAUTION** When shooting landscapes, be aware that the shutter speed greatly slows down as the sun sets. Make sure that you use a tripod if the shutter speed goes below 1/30 second.

▶ **Close-up mode (✿).** This mode is designed for close-up photography, like the image shown in Figure 3.2. It is similar to Portrait mode (♗) because it is designed to help pop your subject from the background using a shallow depth of field while leaving enough depth to see small subjects. In this mode, you have control over the ambience setting, color scene filters for white balance, and shooting modes.

3.2 This image was shot in the Close-up mode. (100mm macro lens, ISO 400, f/5.6, 1/160 second)

▶ **Sports mode (➴).** The goal of sports photography is to keep the shutter at the highest level possible. Sports mode (➴) is a good option any time you are shooting moving objects. The default shooting mode is Continuous, which photographs at a rate of approximately 5 frames per second. You can also use Sports mode (➴) to photograph active children. In this mode, you have control over the ambience setting, color scene filters for white balance, and shooting modes.

▶ **Night Portrait mode (◪).** Use this mode when it is dark outside and you want to capture background lights. This mode combines flash to freeze your subject and a slow shutter speed to expose for the light in the background. If you move the camera, though, it creates *ghosting* (motion blur that often occurs when using a slow shutter speed with flash). In this mode, you have control of the ambience settings and shooting modes.

▶ **Handheld Night Scene mode (▤).** Exposing for bright city lights and street detail is difficult. Usually this type of photography requires a tripod. The Handheld Night Scene mode (▤), which was used to shoot Figure 3.4, allows you to hold

3.3 This photo was shot with the Night Portrait mode. The camera slowed the shutter speed down enough to capture the lights on the house and in my daughter's shoes. (12-24mm lens at 12mm, ISO 800, f/4.0, 1/6 second)

3.4 Using the Handheld Night Scene mode, the camera took four quick photos to expose for the bright lights and dark sky. (Multiple exposures, 24mm lens, ISO 4000)

3

the camera while it takes four consecutive shots at different exposures. The camera then combines the four images to create one. This mode is very useful when shooting street scenes at night, especially cities. These scenes typically have a lot of bright lights that blow out and dark areas that turn black—this mode handles those issues well. The default setting in this mode is Flash off (⚡). If you want to take portraits in this mode, press the Quick Control/Print button (▣) and turn on the flash. The first exposure triggers the flash, so make sure to tell your subject not to move during the additional three exposures. You also have control of color scene filters and shooting modes.

NOTE Although the flash goes off only once when it is turned on in the Handheld Night Scene mode (▣), ask your subject to remain still until the camera takes all four shots.

▶ **HDR Backlight mode (**▨**).** High Dynamic Range (HDR) exposes for both highlights and shadow detail by combining multiple photographs at different exposures. The HDR Backlight mode (▨) takes three quick exposures and combines them into one image to compensate for any intense light behind your subject. For example, if you're shooting a statue with the sun behind it and you don't want to create a silhouette, use the HDR Backlight mode (▨) to improve both the highlight and shadow detail for a properly exposed photo.

3.5 Three rapid shots were taken in the HDR Backlight mode and combined in the camera to create this image.

NOTE Although you can handhold your camera when using the HDR Backlight mode (▨), you must remain very still. Consider using a tripod whenever possible. If you move the camera, the three images might not align correctly.

The Creative Zone Modes

Your camera's creative zone modes are designed to give you more flexibility while taking photographs. Sometimes, you need control of the shutter, while other times the aperture is more important. When you're not sure what is most important, you have the Program AE mode (**P**). It takes over and uses the technology in your camera to help you create a well-exposed image.

When you want a little more control over the exposure, use one of the following creative zone modes:

▶ **Manual mode (M).** When you are comfortable with your camera, you may want to begin using Manual mode (M). It's not for everyone, but there may be times when you disagree with the camera's automatic settings, and want to take full control of the shutter speed and aperture. It is especially useful in difficult lighting, such as backlighting or when shooting night scenes. The camera displays how under- or overexposed the image will be based on its exposure meter readings. You can make adjustments based on the camera's internal light meter information.

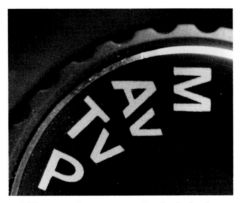

3.6 The creative zone modes include the Manual, Aperture-priority AE, Shutter-priority AE, and Program AE modes.

▶ **Aperture-priority AE mode (Av).** Some types of photography, such as landscape and portraiture, require that you control the depth of field. The Aperture–priority AE mode (Av) gives you control over the aperture, while the camera controls the shutter. The *aperture* allows light into the camera, so as you open it, the camera increases the shutter speed to compensate. When you close down the aperture, the camera does the opposite.

▶ **Shutter-priority AE mode (Tv).** When photographing sports or wildlife, you need a fast shutter speed to freeze the action. When shooting landscapes, you often need a slower shutter speed to achieve a larger depth of field. The Shutter–priority AE mode (Tv) gives you control of the shutter speed, while the camera controls the aperture. As you increase the shutter speed, the camera opens up the aperture to allow more light into the camera; when you lower the shutter speed, the camera closes the aperture.

▶ **Program AE mode (P).** When you don't know what to do or just don't want to think about the finer points of composition and light, use the Program AE mode (P). It gives you the confidence you need to take good photos with a little more control than the automatic basic zone modes. Program AE mode (P) sets the shutter speed and aperture for the proper exposure. Unlike the Scene Intelligent Auto shooting mode (🅐⁺), it doesn't automatically set Picture Styles, white balance, focusing modes, or the ISO (ISO).

Focus Modes

Autofocus is a standard feature on most cameras. Camera manufacturers are improving autofocus systems all of the time by adding new capabilities. However, how to use these capabilities is often a mystery. The type of photography you plan on doing usually determines the best autofocus solution. Autofocus is not perfect; sometimes you have to use Manual focus (**MF**). The Autofocus/Manual focus switch, as shown in Figure 3.7, is on the left side of your lens—don't be afraid to use it. To change your autofocus mode, press the Autofocus button (**AF**), which is located to the right of the Set button (⑤). Next, select one of the three focus modes. You will know if your subject is in focus if the round focus confirmation light appears in the bottom-right corner of the viewfinder.

3.7 The Autofocus/Manual focus switch on a lens.

The following list includes the focusing options available on the Canon T4i/650D:

▶ **Autofocus mode (AF).** If you are using a basic zone mode, the optimal focus for that mode is automatically set. For example, in Sports mode (🏃), the camera sets the focus to the AI Servo focusing mode (**AI SERVO**) to follow-focus on moving subjects. In the creative zone modes, you can change the focus mode or focus points at any time. If you see the round focus confirma-

3.8 Patterns in low light can make it tough for your camera to focus.

tion light blinking in the viewfinder, this means that the camera is having trouble focusing, and you may need to try one of the other focus modes.

▶ **Manual focusing mode (MF).** You will not always agree with your camera's choice of focus. It is programmed, when using the default automatic AF point selection, to focus on the largest, closest object to the lens. This default does not always match what you want to photograph. You can try using individual focus points to force your desired focus point but, in many cases, Manual focusing mode (**MF**) is your best bet. The following is a list of situations in which you might want to switch to the Manual focusing mode (**MF**) or select one of the nine focal points:

- **When shooting low-contrast subjects, such as the sky or a gray wall**

- **When a subject is in low light**

- **When shooting repetitive patterns, such as rows of windows on a building**

- **When shooting horizontal stripes**

- **When shooting water or other reflective subjects**

- **When an object is too close to the camera (you may also need to back up or change lenses)**

NOTE If focus cannot be achieved (because you are too close to the subject or the environment is too dark, for example), the round focus confirmation light blinks.

- **When shooting a subject with extreme backlighting, such as a small object with the sun behind it**

- **When shooting very small subjects (use a macro lens)**

- **When a subject is too far way for the camera to detect**

▶ **One-shot autofocus mode (ONE SHOT).** This is a good mode to use when you are photographing a still subject. Point your camera at the subject, and then press the shutter button halfway. The camera focus locks on the subject. When you see the round focus confirmation light in your viewfinder, you are free to recompose. If you need to refocus, lift your finger off of the shutter button and focus again.

NOTE In One-shot autofocus mode (**ONE SHOT**), the camera takes its exposure settings at the same time that you lock focus.

▶ **AI Servo focusing mode (AI SERVO).** Photographing moving objects is not easy. The AI Servo focusing mode (**AI SERVO**) continuously refocuses on your subject until you fully press the shutter button to take a photograph. Pressing the shutter button halfway is a good idea so you can snap your picture quickly, but it doesn't stop the camera from refocusing as you move your lens or as the subject moves.

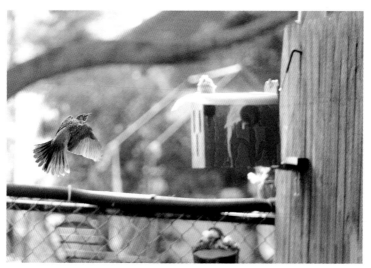

3.9 I followed this robin in the AI Servo mode to keep it in focus as it flew to the fence. (100mm lens, ISO 1600, f/2.8, 1/000 second)

NOTE The round focus confirmation light does not blink in the AI Servo focusing mode (**AI SERVO**), even if the subject is in focus.

▶ **AI focus (AI FOCUS).** If your subject starts to move while you are photographing in the One-shot autofocus mode (**ONE SHOT**), it may be out of focus by the time you press the shutter button. The AI focus mode (**AI FOCUS**) defaults to the One-shot autofocus mode (**ONE SHOT**), but switches to AI Servo mode (**AI SERVO**) if the subject moves. For example, if you are photographing an animal in the wild, the camera defaults to One-shot autofocus mode (**ONE SHOT**) if the subject remains still. If something spooks the creature and it moves, your camera switches to AI Servo mode (**AI SERVO**) as you follow the animal. When using the AI focus mode (**AI FOCUS**), the default One-shot autofocus mode (**ONE SHOT**) lights up the round focus confirmation light. When it switches to the AI Servo mode (**AI SERVO**), the light shuts off.

▶ **Focus points.** Your Canon Rebel T4i/650D uses nine focus points (in Live View shooting mode (■) it has up to 31 focus points). It automatically focuses on the subject closest to the lens using one of these points. If the camera doesn't focus on the main subject, switch to Manual focusing mode (**MF**) if you are using one of the basic zone modes. In the Program AE (**P**), Manual (**M**), Aperture-priority AE (**Av**), and Shutter-priority AE (**Tv**) modes, you can press the AF point selection button (⊞) to manually set the focus point that you want. It is common to set the middle focus point as the default so that you can point the camera at the subject, lock the focus by pressing the shutter button halfway, and then recompose the scene. When all points of focus are lighted, the camera is in autofocus mode and chooses the point of focus for you.

▶ **AF–assist beam (⊞ AF).** When light is low, this beam fires to help your camera focus on the subject. It works automatically in basic zone modes and only if the flash is popped up in creative modes. The beam is actually emitted from your flash quickly triggering in a rapid cycle. The AF-assist beam does not function in the Flash off (🕸), Sports (🏃), or Landscape (⛰) modes.

CAUTION Make sure that you warn your subjects not to move if the AF-assist beam fires. It is common for subjects to leave thinking that you already took the photo.

▶ **Tracking modes.** Your camera has three tracking modes in the Live View shooting mode (■). The first option, Face Tracking (AF☺), looks for faces. If no face it detected, it switches to Flexizone-Multi (AF●) and tracks whatever you point to on the LCD touch screen. When the camera detects a face, it switches back to Face Tracking mode (AF☺) and follows it. In the Flexizone-Multi mode

3.10 The AF tracking options in the Live View Shooting menu.

(AF●), you have 31 focusing touch zones. If you press the Set button (⊛), the center zone lights up and tracks any object it detects. Use the Cross keys for fine adjustments or the touch screen to select a specific object in your frame. The Flexizone-Single mode (AF□) uses only one AF point, and does not adjust with the movement of the camera or subject. You may adjust the focus point using the Cross keys or LCD touch screen.

CAUTION If you press the shutter button halfway, even in a Tracking mode, the camera refocuses.

▶ **Live View shooting mode (⬛).** When your camera is in this mode, you have four focusing options. To get to them, press the Menu button (**MENU**) when the camera is in the Live View shooting mode (⬛), and then select the AF method you want to use. You may adjust the focus method by pressing the Quick Control/Print button (⬛) for options. The Quick focus mode (AFQuick) is a good default because it focuses quickly. If you are in a basic zone mode, such as Portrait mode (❡), the camera selects the focus zones. If you are using a creative zone mode, such as Aperture-priority AE (**Av**), you may select the focus zone via the LCD touch screen or Cross keys. Your other options are the slower (but useful) tracking methods of focus.

CROSS REF For more about the Live View Shooting mode (⬛), see Chapter 8.

Picture Styles

Different types of photography look better with certain adjustments. Picture Styles (≋) help when you want to add a little more to your images. Your camera has seven options, plus three customized, user-defined Picture Styles. Each Picture Style adjusts sharpness, contrast, saturation, and color tone.

NOTE Picture Style options only work in the Progam AE (**P**), Manual (**M**), Aperture-priority AE (**Av**), and Shutter-priority AE (**Tv**) modes.

The following Picture Styles are available on the Canon T4i/650D:

▶ **Auto (≋A).** This mode starts out as a neutral setting, but adjusts based on the detected scene. It is a good default if you don't want any specific adjustments applied to photographs.

▶ **Standard (≋S).** This is another good default Picture Style setting. It adds sharpness and produces vivid colors in your scene. Unlike the Auto Picture Style (≋A), it does adjust to different types of scenes.

▶ **Portrait (❡).** This Picture Style softens the image. The default leaves all of the other tones in neutral settings, but you may want to adjust the skin tone to suit your style or subject. To do so, in the Picture Style menu (≋), select Info and

four options (Sharpness, Contrast, Saturation, and Color tone) appear. If you select Color tone, your subject will look more red the closer you get to the minus sign. The closer you get to the plus sign, the more yellow it will appear.

▶ **Landscape (🏔).** Use this Picture Style to create impressive landscapes. It is sharp and produces vivid blues and greens.

▶ **Neutral (⚙N).** If you prefer to enhance your photos using software outside the camera, then the Neutral Picture Style (⚙N) is a good choice. It is designed to produce natural-looking colors.

▶ **Faithful (⚙F).** This is another Picture Style that is ideal for people who like to process their images on the computer. Of all of the Picture Styles, it offers the best color representation based on a white light exposure of 5200K.

> **NOTE** *Kelvin* is the temperature measurement of light. Temperatures between 5500K and 6000K are considered neutral (or white) light. Lower Kelvin temperatures produce light that appears warmer, and higher temperatures produce light that looks cooler.

▶ **Monochrome (⚙M).** Choose the Monochrome Picture Style (⚙M) if you want to take black-and-white photos, as shown in Figure 3.11. Because the Monochrome Picture Style (⚙M) doesn't need saturation or color tone, those options are replaced in the menu with filter and toning effects. The filter effect works like a color filter over black-and-white film, with the following options: None, Yellow, Orange, Red, and Green. Each of these filters absorbs the color it represents. Toning effects change the monochromatic color of the image. The options are None, Sepia, Blue, Purple, and Green.

3.11 The Monochrome Picture Style. (ISO 400, f/5.6, 1/20 second)

3.12 The Monochrome Picture Style with a yellow filter. (ISO 400, f/5.6, 1/20 second)

3.13 The Monochrome Picture Style with an orange filter. (ISO 400, f/5.6, 1/20 second)

3.14 The Monochrome Picture Style with a red filter. (ISO 400, f/5.6, 1/20 second)

3.15 The Monochrome Picture Style with a green filter. (ISO 400, f/5.6, 1/20 second)

CAUTION If you think that you might want to convert your photograph to a color image later, make sure that you use the RAW setting (**RAW**). Other image formats, such as JPEG, cannot be converted back to color.

▶ **User-defined Picture Styles 1 (⬚1), 2 (⬚2), and 3 (⬚3).** Here, you can create your own Picture Styles. Unused Picture Styles default to the Auto Picture Style. You may use any of the camera's preset Picture Styles as a starting point to create your own custom styles. The following settings can be adjusted to create a custom style:

- **Sharpness.** This adjusts the clarity of the image. The closer to 0 the sharpness is, the softer the image. The closer to 7 this setting is, the sharper the image.

- **Contrast.** Use this setting to increase or decrease the contrast or vividness of the colors in your image. The closer to 0 the contrast is, the duller the image. The closer to the plus sign (+) the setting is, the more contrast and vividness the image has.

- **Saturation.** This enhances the colors in your image. The closer to 0 it is, the more muted the colors. The closer to the plus sign (+) it is, the bolder the colors.

- **Color tone.** Use this setting to adjust skin tones. The closer to 0 it is, the more red your subject's skin tones look. The closer to the plus sign (+) it is, the more yellow they appear.

Drive Modes

Your camera has five Drive modes (**DRIVE**) and each has its benefits, depending on the type of photography you are doing. However, a lot is governed by personal preference. To quickly adjust this, press the Drive mode button (**DRIVE**) located to the right of the Set button (⊛) on the back of your camera.

3

The following drive modes are available on the Canon T4i/650D:

► **Single-shooting mode ().** In this mode, the camera takes only one photograph with each press of the shutter button. It is most useful for portraits and landscapes.

► **Continuous drive mode ().** This mode is helpful when shooting action, such as sports, children, or wildlife. Use it when you need to take multiple photographs in quick succession—it shoots approximately 5 frames per second (fps). It is also helpful to have your camera on AI Servo (**AI SERVO**) or AI focus (**AI FOCUS**) mode if your subject is moving.

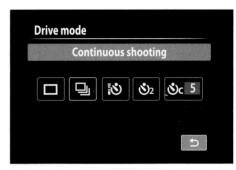

3.16 You have five Drive modes to choose from, including three Self-timer options.

NOTE If you use flash, the frames per second (fps) rate is slower because the flash must recycle.

► **Self-timer drive modes ().** When you press the Drive mode button (**DRIVE**), you see the following three self-timer options: 10 seconds (), 2 seconds (2), and a multi-shot continuous timer (c). The continuous timer starts as a 10-second timer, but takes up to 10 continuous photos.

White Balance Settings

Above the Set button () on your camera, you'll find the White Balance selection button (**WB**). These settings are used to correct the light in your scene so that it is as close to neutral (or white light) as possible. In other words, the goal is to make a white piece of paper look white under any lighting conditions. White light has a temperature of between 5500K and 6000K (Kelvin). *Kelvin* is the unit of measurement used for the temperature of light. The higher the Kelvin temperature is, the cooler the appearance. The lower the Kelvin temperature is, the warmer the appearance. For example, an incandescent light bulb is around 3000K, which looks yellow, and a white fluorescent

lamp is around 5000K, which is closer to white light. Each setting tells you what the Kelvin temperature is for each adjustment.

You can choose from the following white balance settings:

▶ **Auto (AWB).** This is a good default white balance mode for almost any scene because the camera adjusts the light automatically. If you are shooting in the RAW format, you can make additional adjustments to the light temperature in editing software, including the software that came with your camera, Photoshop Camera Raw, and Lightroom.

▶ **Daylight (☀).** You can use this setting on bright days when the sun is high in the sky. It is a more neutral setting than others. Some photographers prefer it to the flash setting when using an on-camera or external flash.

3.17 The result of the Auto white balance setting. (100mm lens, ISO 400, f/5.6, 1/80 second)

3.18 An example of the Daylight white balance setting. (100mm lens, ISO 400, f/5.6, 1/80 second)

► **Shade (⌂).** This white balance setting has a higher (bluer) Kelvin temperature, so the camera adjusts the color to make the image warmer. Use this adjustment when you find yourself in dark shade or shadows.

► **Cloudy (☁).** Like the Shade white balance setting (⌂), the Cloudy setting (☁) has a higher Kelvin temperature. Your camera is set to adjust a cool scene to make it look warmer. This is useful on cloudy days and in domed buildings where light penetrates the roof, such as a sports arena.

3.19 The Shade white balance setting was used on this image. (100mm lens, ISO 400, f/5.6, 1/80 second)

3.20 An example of the Cloudy white balance setting. (100mm lens, ISO 400, f/5.6, 1/80 second)

▶ **Tungsten (☀).** Tungsten (the traditional round light bulb) is an artificial light that emits a yellow cast. This white balance setting adjusts light that is around 3200K. Incandescent lights turn more yellow over time, so results vary.

▶ **Fluorescent (☰).** This is a good starting point to adjust fluorescent lights that are around 4000K (results depend on the type of fluorescent light used in your scene). Like incandescent bulbs, these change color over time, and there are many types on the market. If the Fluorescent white balance setting (☰) doesn't work to your satisfaction, consider using a Custom white balance setting (◪).

3.21 An example of Tungsten white balance setting. (100mm lens, ISO 400, f/5.6, 1/80 second)

3.22 An example of the Fluorescent white balance. (100mm lens, ISO 400, f/5.6, 1/80 second)

▶ **Flash (⚡).** This setting is designed for use with on-camera or external flashes. It is set to adjust light at 6000K to warm the cooler flash. If the image is too warm, you may want to consider using the Daylight white balance setting (☀).

▶ **Custom (◻⊿).** This setting allows you to set your white balance to any temperature for a more precise light-color balance. You should adjust your custom setting under the lighting conditions in which you plan to work.

▶ **White Balance Auto Bracketing (WB).** If you are not sure about the white balance results the camera will deliver, you can use what is called *White Balance Auto Bracketing* (WB). To do so, press the Menu button (**MENU**) and, in the Shooting menu 2 (⚙), you see WB shift/bkt. Once you make this selection, the camera displays the bracketing options, as shown in Figure 3.24.

3.23 This photo is an example of the Flash white balance. (100mm lens, ISO 400, f/5.6, 1/80 second)

Flash Modes

This section focuses on the flash modes you can use with the pop-up flash. However, I highly recommend that you purchase a more powerful flash with additional features for regular use. The pop-up flash is for casual use when a larger one is unavailable.

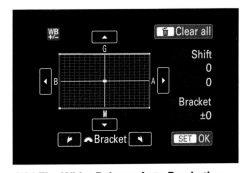

3.24 The White Balance Auto Bracketing menu. You can choose blue (B) to auburn (A), or green (G) to magenta (M) bracketing depending on your needs.

The following flash modes are available on your camera:

▶ **Auto.** Most of the basic zone modes use the pop-up flash in low light. It is not used in the Landscape (▲) or HDR backlight (▣) modes.

▶ **Red-eye reduction.** The Red-eye reduction feature (see Figure 3.25) is designed to prevent or minimize red eye in your subjects when you photograph them in a dark or dimly lit environment. The same as the camera's aperture, pupils dilate in dark environments to let in more light. When this happens, more light reflects back to your camera. If your flash is close to your lens, your subjects will look like they have

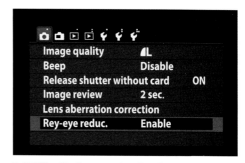

3.25 The Red-eye reduction feature is found in Shooting menu 1 when you are using a basic zone mode.

red eyes. When you press the shutter button half way, the Red-eye reduction lamp emits a light to shut the subject's pupils down and reduce red-eye when using a flash mode. The light turns off when the shutter button is pressed completely. The Red-eye reduction setting does not work in the Flash off (🌫), Landscape (▲), Sports (🏃), or HDR backlight (▣) modes.

▶ **Slow sync.** When using flash, your camera sets the shutter speed between 1/60 second and 1/200 second. If you are in a dark environment, in most cases the background will appear black. If you want to see more of the environment or lights in the background, slow down the shutter speed while using flash. To do so, you can use the Shutter-priority AE (**Tv**) or Manual (**M**) modes, which slow the shutter speed below 1/30 second. The best shutter speed depends on your ISO setting and how much light is in the background. The other option is to use the Night Portrait mode (🌆).

▶ **Curtain sync.** *Ghosting* leaves movement trails (or lights) behind your subject, as shown in Figures 3.26 and 3.27. This occurs when you combine flash with a low shutter speed. The flash freezes your subject and the camera records movement with the slow shutter. The default setting on all cameras is that the camera's flash fires first, and then the slow shutter comes after leaving a front-moving trail. This is called using the front curtain. Your camera offers the option of either Front-curtain (first curtain) or Rear-curtain (second curtain) sync. In the Shooting menu 1 (📷), select Flash control. In that menu, select Built-in flash settings, and then select Shutter sync. Rear-curtain sync means that the

slow shutter fires first, and then the flash. To get to this option, press the Menu button (**MENU**) and look in the first menu. Select flash control at the bottom, and then select Built-in flash settings. Go to Shutter Sync and choose your setting (First or Second curtain).

3.26 I used Front-curtain sync for this image. The flash fired immediately and the slow shutter speed left a trail moving in front of the subject. (12-24mm lens at 18mm, ISO 400, f/6.3, 1/4 second)

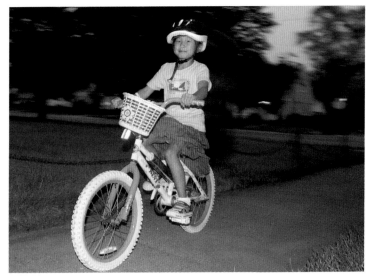

3.27 I used Rear-curtain sync for this image. The flash fired at the end of the slow shutter speed exposure, leaving a trail behind the subject. (12-24mm lens at 21mm, ISO 400, f/7.1, 1/3 second)

▶ **Fill flash.** The sun can cast harsh shadows on your subject's face. You can use fill flash from the camera's pop-up or external flash to help minimize the shadows. If you place your subject in the shade with a bright background or in a direct backlight situation, use fill flash to prevent your subject from becoming a silhouette. If you are using a basic zone mode, your camera activates the built-in flash if it senses the need. When you are using the creative zone modes, if fill flash is necessary, press the Flash button (⚡) located below the pop-up flash on the left side of your camera, as shown in Figure 3.28.

3.28 The button to activate the pop-up flash is on the front left of the Canon Rebel T4i/650D.

▶ **Wireless.** You can use the pop-up flash as a trigger for any external speedlites. To use your speedlite as an off-camera flash, switch it to Slave mode, and then press the Flash button (⚡) on the left side of your camera. For the camera and speedlite to sync, both have to be set to the same channel (speedlites default to channel 1). You have up to four channels from which to choose, but I recommend sticking with channel 1 unless you have a specific reason to switch, such as when using a more complex lighting setup or there is a conflict with another photographer using the same channel.

3.29 The Canon T4i/650D pop-up flash.

TIP For easy wireless flash photographs, press the Quick Control/Print button (⌷) (in the creative zone modes only), and then press the Flash button (⚡) on the right side of the LCD screen. Select the Easy Wireless Flash option (⚡).

▶ **Flash Exposure Compensation.** Sometimes you might disagree with the results that your camera and flash produce, and want your subject to appear a little lighter or darker. The Flash Exposure Compensation button (■ ⁺⁄₋ ■) lets you make adjustments in plus or minus 1/3-stop increments up to 2 stops. This option is useful in backlit situations. To quickly adjust the Flash Exposure Compensation when using a creative zone mode, press the Quick Control/Print button (▣₆), and then press the Flash Exposure Compensation button (■ ⁺⁄₋ ■) below the ISO setting. This option is not available in basic zone modes.

NOTE If the Auto Light Optimizer is on any setting, photos with a negative stop adjustment may still appear bright.

CAUTION Don't forget to set the Flash Exposure Compensation setting (■ ⁺⁄₋ ■) back to 0 when you finish using it.

ISO Settings

The ISO setting represents the camera's sensitivity to light. Your camera has eight settings ranging from ISO 100 to ISO 12800. ISO 25600 is available when Custom function 2 is engaged. Each step doubles or halves the amount of light sensitivity. This is the equivalent of changing the shutter or aperture 1 full stop. The higher the ISO setting, the less light you need for an exposure. The lower the ISO setting, the higher the quality or less digital noise will appear in your image.

3.30 High ISO settings are helpful when shooting at night. (ISO 8000, f/5.6, 1/4 second)

To set the ISO, press the ISO button (ISO) on top of your camera. There are eight options ranging from 100 to 12800. If you see the option H, this means that Custom function 2 (found in Setup menu 4 (⚙)) is on and will set the ISO to 25600.

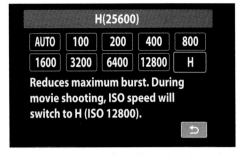

The lower ISO settings—ISO 100, ISO 200, and ISO 400—are good, all-purpose settings for use outside and in bright building interiors. Use ISO 800 and ISO 1600 when shooting in

3.31 When Custom function 2 is selected, the ISO range extends to ISO 25600 (Custom Functions are found in Setup menu 4).

the evening, on overcast days, or indoors without a flash. When shooting at night or in a dark room, use ISO 3200, ISO 6400, ISO 12800, or ISO 25600. You can set the ISO at any point when using a creative zone mode. When your camera is set to a basic zone mode, the ISO is set automatically.

> **NOTE** In Portrait mode (👤), your camera sets the ISO to 100. In the Bulb shoot-ing mode (**B**), it sets the ISO to 400. The higher the ISO is, the farther the light of your flash extends.

When Auto ISO is set on your camera, it selects the proper setting based on the shoot-ing mode. In this mode, the ISO ranges from ISO 100 to ISO 6400 in most modes. You can limit this range by setting a maximum ISO. To do this, press the Menu button (**MENU**), choose menu 3 (third from the left), and then select Auto mode.

The higher the ISO setting, the more noise you see in your images. *Noise* is the digital equivalent of grain in film. Camera companies, including Canon, have done a good job of limiting noise as they increase the ISO limits in cameras. The Canon T4i/650D is equipped with noise-reduction technology. For example, in Shooting menu 3 (📷), select Highspeed noise NR to help reduce noise when you are photographing at a high ISO setting, such as ISO 12800. Another option in Shooting menu 3 (📷) is Long exp. noise reduction, which is used for exposures over 1 second.

Choosing File Quality and Format

The Canon Rebel T4i/650D has multiple file formats, and the quality option selection is not always easy. The best rule is to use the highest quality possible because you can always downsize, but you can't upsize. Don't be tempted by the large number of

available photographs when you use a smaller file size and greater file compression. The number of photographs you can take may be impressive, but they will not be the best. If you need to take more images at one time, invest in larger memory cards. For the best quality results, set your camera to RAW (RAW).

The maximum camera resolution is approximately 17.9 megapixels, or 5182 × 3456 pixels (based on an aspect ratio of 3:2). This is the equivalent of a 17 × 11 photograph at 300 dpi (dots per inch). Your camera offers additional file size options that create file sizes as small as 720 x 480 pixels. Although larger files take up more room on a memory card, I recommend that you use the largest file size possible. It is always better to have the option of downsizing your images later instead of wishing you had a larger photo after creating photo files that are too small.

CAUTION The RAW (RAW) and Small 3 (S3) file formats cannot be resized. Also, remember that resized images cannot be made larger later.

Image size and file numbering

Your camera's multiple image sizes range from 0.35 to 17.9 megapixels. It is best to use the largest size possible. Sometimes, you may want to downsize an image. This can be done in the Canon Digital Photo Professional software (which came with your camera on the EOS Digital Solutions Disk), Photoshop, or with software on the web. You also have the option of adjusting the image size in your camera. To do so, press the Playback button (▶), find the photograph you want to resize, and then press the Quick Control/Print button (Q). A menu appears on the left side of your screen and the bottom option is Image resize.

CROSS REF For more information about the Canon Digital Photo Professional software, see Appendix A.

The files in your camera are numbered from 0001 to 9999 and continue in this same order, even if you replace the memory card. If you want the number system to restart, you can set your camera to do so at any point. To select the numbering system, go to Shooting menu 1 (📷) and select File numbering.

NOTE You can create folders for more than one series of photos in Setup menu 1 (🔧).

The RAW file format

When you want the highest quality possible, RAW (**RAW**) is the best choice. However, you need special computer software to work with RAW files. Your camera comes with the EOS Digital Solutions Disk that includes the Canon Digital Photo Professional software. This program can handle RAW images and so can Photoshop.

The good thing about the RAW file setting is that it stores the original data collected by your camera before a photograph is compressed into a Large fine JPEG image. When you make adjustments to compressed files, such as JPEGs, the images lose quality with each adjustment. When you use the RAW format with the proper software to make adjustments, it is like re-exposing your image without losing quality.

The JPEG file format

JPEG (Joint Photographic Experts Group) files are much smaller and easier to work with than RAW image files due to their size. This is the most common image file format used by photographers. One benefit of using JPEGs is the option to adjust the amount of compression applied to your photograph. The more a file is compressed, the smaller it is. However, the smaller a file is, the more information is lost. Your camera is capable of shooting in both

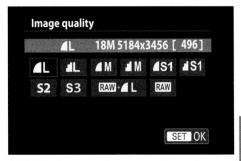

3.32 You have ten image quality options; RAW is the highest and S3 is the lowest.

the RAW and Large fine JPEG formats at the same time, giving you more options later in postproduction. However, this option also takes up more room on a memory card. If you are going to be shooting an event and taking a lot of photographs, the JPEG option is a good choice. It makes it easier to work with a large number of files later.

Your Canon Rebel T4i/650D offers the following eight JPEG size and compression options:

▶ **Large fine (◢L).** Images at this setting are 17.9 megapixels. This is the highest-quality JPEG file setting your camera offers.

▶ **Large normal (◢L).** These images are also 17.9 megapixels but, as it uses additional compression, you can store about double the number of images versus the Large fine setting.

▶ **Medium fine (◢ M).** Images at this setting are 8 megapixels. This is a good average setting that still produces large prints.

▶ **Medium normal (◢ M).** These images are also 8 megapixels. However, this setting produces about double the amount of images compared to the Medium fine setting by using additional compression.

▶ **Small fine (◢S1).** Images at this setting are 4.5 megapixels—a very small file size. This setting is useful for photographs created for websites, social media, or small 4 × 6 prints.

▶ **Small normal (◢S1).** Images at this setting are also 4.5 megapixels; however, additional compression means that it produces about double the amount of images compared to the Small fine setting.

▶ **Small 2 (S2).** At 2.5 megapixels, images shot at this very small file size are best used for e-mail or the web.

▶ **Small 3 (S3).** Images shot at this setting are only 0.35 megapixels and, thus, are not ideal for most photography needs. However, this size is useful for special applications, such as web thumbnails or high-volume documentation.

Movie Modes

To shoot a video, press the Movie mode button ('🎥) on the camera's power switch. When shooting video, it is a good idea to use fast (class 6 or higher), large-capacity memory cards. Slower cards may not write as fast as the video is produced and playback quality could be affected. Your camera is considered full HD, meaning it has 1080 vertical pixels (or scanning lines) required for HD. When playing videos, connect your camera to a TV or monitor for better viewing.

CROSS REF See Chapter 9 for more about how to connect your camera to a television.

Exposing for video

If your camera is set to any of the basic zone modes, it defaults to the automatic Scene Intelligent Auto mode (🄰). This means that the camera sets the shutter speed, aperture, and ISO. In Scene Intelligent Auto mode (🄰), the camera also applies scene detection filters to enhance the video. The scene filter the camera detects appears on the LCD screen in the upper-left side of the frame. Auto exposure is fine for casual

shooting, but when you want higher-quality video, experienced videographers recommend using the Manual shooting mode (**M**). This is because the camera tries to make adjustments as the scene changes in the automatic modes. This may seem convenient but, unfortunately, the results don't look very professional.

It is highly recommended that you use the creative zone modes when shooting video. The camera treats Aperture-priority AE (**Av**), and Shutter-priority AE (**Tv**) modes the same as the Program (**P**) mode. The Program AE mode (**P**) sets the camera shutter speed, aperture, and ISO. The biggest difference between the Scene Intelligent Auto (⊞) and Program AE (**P**) modes is that Program AE mode (**P**) does not use scene detection. This means that you have more control over things like exposure compensation.

Manual (**M**) is the best mode for shooting high-quality video. It gives you control over the shutter speed, frame rate, aperture, and ISO (the range is ISO 100 to ISO 6400). Using Custom Function 2, you can set the ISO on High, which is the equivalent of ISO 12800. However, if you do this, you will encounter a lot of noise in your video and exposure compensation will no longer be available.

CROSS REF For more about the relationship between shutter speed and frame rate, see Chapter 8.

Setting the file size and focus

The Canon Rebel T4i/650D has the following three video size options:

► 1920 × 1080 (30 or 24 fps)

► 1280 × 720 (60 fps)

► 640 × 480 (30 fps)

CROSS REF For more information about the effect the frame rate has on your videos, see Chapter 8.

Your camera has a shooting time limit of 29 minutes and 59 seconds. If you use the highest file size (1920 × 1080), you need at least a 16GB memory card to record uninterrupted for the full time available. When you reach 29 minutes and 59 seconds, the camera automatically stops recording. Press the Live View shooting mode button (◘) and the camera starts a new video file.

NOTE Your camera turns on Live View Shooting mode (⬛) for video capture and you have the same tracking options that you do when shooting still photography.

The default setting for video focus is Movie-servo AF (▦). This means that the camera focuses on the subject closest to it. You can turn this off by touching the Movie-servo AF (▦) icon in the lower-left corner of the LCD screen. When Movie-servo AF mode (▦) is off, your camera focuses once when you press the shutter button halfway. If you are not using a Canon STM lens, the audio of your video will likely include lens focus noise. Consider using Manual focus for higher-level video productions—to do so, select the Manual focusing mode (**MF**) on your lens.

NOTE If you press the shutter button all of the way, your camera takes a photo whether it is recording a movie or not.

Aaron Hockley's Things to Check After a Shoot

After you return from a photo shoot, don't immediately put your camera away—take a minute to reset your preferred settings. Any experienced photographer has grabbed his camera and started to shoot, only to realize that he left a setting in a strange position after an earlier outing.

Before you put your camera away, here are some things to check:

▶ **The white balance.** Reset it to Auto (⊞).

▶ **The shooting mode.** Reset it to the mode you prefer.

▶ **The ISO.** Reset it to Auto or a low ISO setting

▶ **The Mode dial.** Do you like Program AE (**P**), Aperture-priority AE (**Av**), or Manual (**M**) mode?

▶ **Make sure that a blank memory card is in the camera.** There's nothing worse than being ready to take a shot and discovering there's no card in your camera.

▶ **The image size/quality.** If you prefer shooting in the RAW format, make sure that the camera is set to RAW (⊞). If you're a JPEG shooter, make sure that the camera is at your preferred quality setting.

▶ **Exposure compensation.** Reset it to 0.

▶ **Autofocus.** Is it on? If so, to which mode is it set?

▶ **The Metering mode.** Set it to Evaluative (⊡) or Spot (⊡) metering, depending on your preference.

Many of these settings are personal preferences, and there is no correct configuration. However, it's important that you're consistent so that each time you grab your camera, you get the results that you expect.

Aaron Hockley is an event, commercial, and portrait photographer from Vancouver, Washington. He shares commentary and information at his website: http://aaron hockley.com/

3

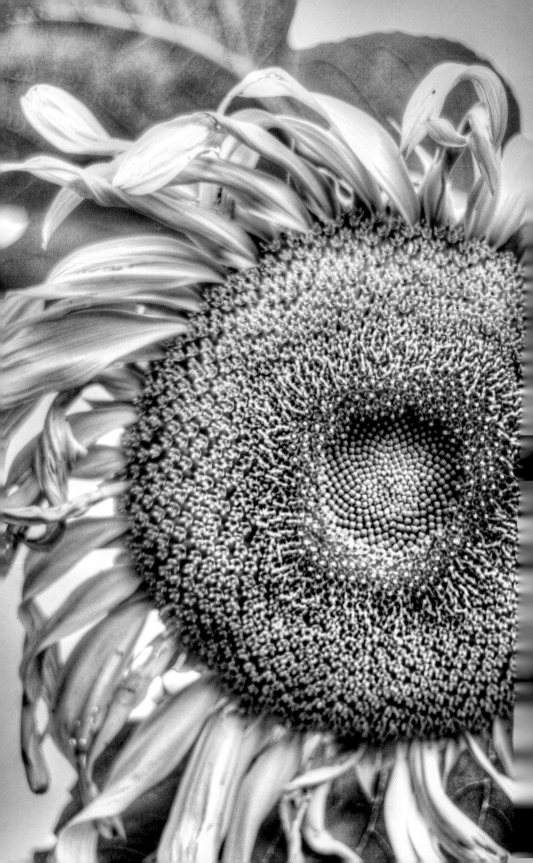

Using Lenses with the Canon EOS Rebel T4i/650D

How do the pros get such sharp, vibrant photographs? A photographer's skill and experience play an important role, but when it comes to equipment, lens quality is extremely important. The image that you shoot travels through the lens before it reaches the camera's digital sensor. If the lens is of poor quality or defective, it affects the outcome of your photograph. The Canon EOS Rebel T4i/650D is a *dSLR (digital Single Lens Reflex)*, which means that you can change the lens. This is helpful because it means you are not limited by the quality or type of lens attached to your camera. This chapter covers the camera's lens, and how you can make better decisions about the lenses you purchase and use.

This photograph was taken using a fisheye lens.

Choosing a Good Lens

Before talking about lenses, let's make sure that you know the basics, such as the proper way to hold your camera and attach a lens. The idea is to use your arm as a tripod to support your camera and lens from the bottom. The larger the lens, the more important it is to properly support it, as shown in Figure 4.1. The *EF* (electro-focus) lens is Canon's standard model. EF-S lenses are designed for Canon cameras, such as your Rebel T4i/650D, because they have a smaller mirror and sensor than full-frame sensor cameras (resulting in a 1.6 crop factor). The *S* in *EF-S* stands for *short back focus,* meaning that the back of the lens element is closer to the camera sensor. EF–S lenses are all wide-angle, allowing the photographer to use the full lens range and eliminate the vignetting created by some lenses. The L (luxury) lens series is Canon's premium lens (with the price tag to match).

To put a Canon EF or L lens on your camera, match the red dot on your lens to the one on your camera. With the lens facing away from you, turn the lens to the left. For EF-S lenses, follow the same steps using the white squares. Remember, you can only use lenses with Canon-designated mounts on your camera.

4.1 Always use your hand to support your lens and keep your arms against your body for additional support.

Now for the big question: Why are lenses so expensive? It's because of the high cost of their design and manufacture. They have many parts that need to work with precision. It's safe to assume that the higher a lens is priced, the greater the quality of the glass and construction.

When choosing a lens, think about what type of pictures you want to take. Do you plan on photographing family activities or taking formal portraits for clients? Do you like to experiment with landscape shots or document your travels? Making an informed choice about a lens saves you image quality and money. Buying lenses is an investment because, chances are, you will have your lenses longer than you will have your current camera.

> **NOTE** Old EF lenses can be used with your Rebel T4i/650D, but older, manual FD-style lenses cannot.

So, how do you know if you have a good lens? As the lens is the window to your camera, it needs to be sharp. Low-quality lenses are not sharp around the edges, especially at lower apertures. Good lenses are made with high-quality glass. High-quality lenses also have lower aperture numbers. The best zoom lenses have the same aperture (usually f/2.8) at all focal lengths and are solidly constructed—the best are even weatherproof.

4.2 A good lens is sharp, and has high-quality glass so you can easily see details, as shown here. (ISO 1600, f/5.0, 1/1000 second)

4

Your camera's lens is a combination of multiple glass elements. When a manufacturer describes a lens, it lists the number of elements in the lens. The idea is that the more elements there are, the better the image quality will be. On the other hand, a lens that has more elements also has more that can go wrong if it is not well made.

Many wide-angle lenses include an aspherical lens. An *aspheric lens* is designed to correct spherical and optical aberrations. In other words, they are used to correct lens distortion and blur that can occur around the edges. Most of what you pay for when you purchase a high-quality lens is the elements, which help decrease distortion in your images, such as a bubbled or bowing look. Quality lenses will increase the fine detail of your images, limit *vignetting* (dark edges), and improve contrast, which will improve the quality of whites and blacks in your image.

Focal lengths

When beginners ask me which lenses they should buy first, I usually recommend that they buy two zoom lenses to cover the full spectrum. For example, a 17-35mm lens and a 35-200mm lens cover most situations. This is a simplistic answer and is not right for everyone. However, this chapter should help you figure out what combination will work best for the type of photography you want to pursue.

With the development of digital photography came the creation of the *crop factor,* or what the digital camera captures when compared to using the same lens on a 35mm film or full-frame digital camera. This is the result of a camera sensor being smaller than 35mm film. If a sensor is smaller than the traditional 35mm, it captures a portion of the image coming through the lens. It might seem cool that a 200mm lens is now working like a 300mm lens. Unfortunately, when it comes down to the wide-angle lens, such as the 24mm and 28mm, there is not as much to be enthusiastic about because the crop factor turns them into higher millimeter equivalents, too.

For the Canon T4i/650D, bear in mind what the effective focal lengths are for the lens you are considering. The crop factor for your camera is 1.6x. To figure out the effective focal length for your lens, multiply the lens value by 1.6. In other words, a 100mm lens is the equivalent of a 160mm lens.

The following list covers the different types of lenses and how they can be used:

▶ **Ultrawide angle.** Manufacturers have come to the recue for cameras with crop factors, like the Canon Rebel T4i/650D, by creating ultrawide lenses. These can be a blessing or a curse due to the distortion found along the edges. How much of an issue the distortion is depends on how you approach your subject. Take advantage of all of the real estate these lenses cover. Photojournalists regularly use ultrawide lenses to layer as much information into the frame as possible. When you use these lenses, make sure that your subject is not too far way and that you fill the frame. Canon produces four ultrawide zoom lenses. Three of them are L lenses, meaning they are high quality and expensive. The 10-22mm f/3.5-4.5 USM is a good, all-purpose ultrawide lens worth considering for your Rebel T4i/650D.

4.3 The difference between a 50mm lens on a full-frame camera and the 1.6X crop factor with the Canon Rebel T4i/650D. (ISO 100, f/5.6, 1/500 second)

▶ **Wide-angle.** Standard wide-angle lenses are the 24mm and 28mm. For a Rebel T4i/650D, they are closer to a standard lens. Canon has nine standard lenses in the range of 20-35mm. The EF 24mm f/2.8 is a reasonably priced wide-angle lens to have in your bag. If you want to step up to a higher-quality lens, the EF 24mm f/1.4L is a good choice.

▶ **Standard.** Traditionally, the 50mm lens was considered the standard lens for a 35mm film or full-frame dSLR camera because it was the closest lens equivalent to the human eye. Anything below 50mm is considered wide-angle and anything above is considered a telephoto. It is a good all-purpose prime lens. For photography purists, a 50mm is standard equipment because it doesn't distort the image. For your T4i/650D, a 30mm or 35mm is a closer equivalent to the eye. Canon makes three 50mm lenses, but the EF 50mm f/1.4 is priced in the middle. The Canon 40mm is a good choice for video use. It is not very expensive and is designed to be quiet.

▶ **Zoom.** These have multiple focal lengths and are good all-purpose lenses for everyday photography. Economy zooms have *variable apertures*, which means that the aperture increases as you increase the focal length. Higher-end zooms have the same aperture (such as f/2.8) at all focal lengths. Because your camera has the ability to follow-focus while shooting video, I would recommend the EF-S 18-135mm f/3.5-5.6 IS STM lens as a good all-purpose zoom lens. If you want to upgrade, the EF 24-70mm 2.8L USM and 24-105mm f/4L IS USM are both excellent choices.

4

► **Telephoto.** This type of lens brings the world closer to you. Wildlife and sports photographers use telephoto lenses from 200mm to 600mm. When using a telephoto lens, it is important to keep track of your shutter speed (over 1/500 second). A faster shutter speed keeps your subject sharp. If using a fast shutter speed is not possible, a tripod or monopod may be required.

One of my favorite Canon telephoto lenses is the EF 135mm f/2.8 with soft-focus portrait lens (I rarely use the soft-focus option, however). Portrait lenses are generally 70mm to 135mm. Unlike wide lenses, they do not distort or exaggerate your subject. I use this lens for many types of photography, including events, because it is light and easy to move around in stealth mode. The EF 70-200mm f/2.8L is considered a standard telephoto zoom and is an excellent high-quality lens to consider. Canon makes three variations of this lens, with and without Image Stabilization (IS), but it also has a wide variety of telephoto zooms available at every price point. Canon makes telephoto lenses ranging as high as 800mm (these are considered *super-telephoto lenses*). However, the larger ones cost thousands of dollars.

> **NOTE** *Lens extenders* increase the reach of a lens. Canon sells two models for its L series lenses: The EF 1.4X III increases the focal length of a lens by 40 percent; the EF 2X III doubles the focal length. However, keep in mind that extenders also decrease the amount of light reaching the sensor by 1 to 2 stops.

Autofocus

Most modern cameras are autofocus cameras. That doesn't mean that you have to keep your camera on autofocus all of the time, though. There is a switch on the side of your lens that allows you to turn autofocus on and off. I do this a lot, depending on the subject. Sometimes, if it's dark or I just want to prefocus for an expected event, such as an athlete crossing the finish line, I turn off autofocus. Today's autofocus systems are very good and highly dependable.

> **TIP** Some Canon lenses have focus preset buttons. These are handy when shooting sports, or events with a goal or finish line.

Aperture and depth of field

When photographers talk lenses, they first mention the focal length and then the aperture. The *aperture* is the diaphragm opening in the lens that controls the amount of light allowed into the camera. Photographers also sometimes refer to lenses as *slow*

or *fast*. A lens with a large aperture, such as f/2.8, is considered fast because it allows more light into the camera. More light means that you can increase your shutter speed, photograph in lower light, and see your image better with a brighter view. Slow lenses are generally darker, and don't have the low-light and speed advantages.

Higher-quality zoom lenses have the same aperture at every focal length. The more affordable lenses have *variable apertures*, meaning that the longer the focal length, the smaller the aperture will be. It may be represented by f/3.5-5.6, which means that the lens starts out with a larger f/3.5 aperture at a shorter focal length, and then decreases to f/5.6 as the focal length increases. This is a disadvantage because you often need the larger apertures when photographing at a longer focal length to keep the shutter speed higher.

Depth of field is the area of focus around the subject. The larger the depth of field is, the larger the area around the subject that is in focus. The focal length of each lens has a different affect on depth of field. As a rule, the lower the aperture number, the higher the quality of the lens is when compared to equivalents.

4.4 This image has a shallow depth of field, which blurs the background. (100mm macro lens, ISO 1600, f/2.8, 1/250 second)

4

CROSS REF For more information on depth of field, see Chapter 5.

Image Stabilization

When you see IS in the name of a Canon lens, it means it has *Image Stabilization*. The lens detects camera shake using microchips and gyro sensors to help the camera provide sharper images at lower shutter speeds. In many situations, the photographer gains 1 to 4 stops of equivalent shutter speed.

However, this doesn't mean it fully eliminates blurring. Fast-moving subjects and very low shutter speeds still show movement and IS does not correct the sharpness of subjects that are not in proper focus. Image Stabilization is designed for stationary subjects, but it's helpful when you have low light and don't want to use a higher ISO. You find Image Stabilization most often on longer lenses because camera shake is more of a problem at a lens tip far way from the focal plane.

> **NOTE** You can pan with Image Stabilization lenses because they automatically turn off if they detect a panning motion.

Vignetting

Vignetting happens when light falls away and doesn't reach the edges—notably the corners—of your frame. It is most noticeable with wide-angle lenses, but a good lens does not have this issue. With that in mind, vignetting is not always bad. It can be corrected to a point in Photoshop or your favorite photo-editing program by using dodging or anti-vignetting tools.

4.5 A dark area around the edges of a photograph is called vignetting. (50mm lens, ISO 100, f/5.6, 1/500 second)

Some photographers like the effect it has on their images, and it is not uncommon to add it during postproduction. You can test your camera lens for vignetting by photographing a white piece of paper with the aperture wide open. Look for darkening corners to determine how much vignetting occurs with each lens.

Types of Lenses

Beginning photographers usually start with the kit lens because it is inexpensive and easily available. Not all lenses are the same. On the contrary, each one is different and worth testing to make sure you get the sharpest picture. Even the same type of lens from the same manufacturer can produce different results. Some photographers test multiple lenses before they purchase one.

> **TIP** Test any lenses you are considering buying at your local photography store. You can also use websites like www.borrowlenses.com to rent one and see if you like it before you purchase it.

The following list covers different types of lenses and their uses:

► **Kit lenses.** A kit lens is one that is bundled for sale with a camera, like the one shown in Figure 4.6, which came with your T4i/650D. Some kit lenses are better than others, but as a rule they tend to be lower quality. They are intended to get you started without adding too much money to the price of the camera body. If you already have lenses that you are happy with, the kit lens will not be an upgrade to your gear and you should consider purchasing the camera body only.

► **Electro-focus (EF) lenses.** All modern (after 2003) Canon lenses are referred to

Image courtesy of Canon

4.6 The EF-S 18-135mm f/3.5-5.6 IS STM is the lens that comes with the T4i/650D.

as EF lenses (see Figure 4.7). They are good autofocus lenses and are priced much lower than the professional L lenses that Canon also manufactures.

▶ **Electro-focus short back focus (EF-S) lenses**. The S in EF-S stands for *short back focus,* meaning that the back of the lens element is closer to the camera sensor. This lens, shown in Figure 4.8, is designed for digital crop cameras, like the Rebel T4i/650D, which has 1.6 crop factor. The white square on the camera's lens mount means that it accepts EF-S lenses. However, this type of lens does not work on full-frame or film cameras.

Image courtesy of Canon

4.7 The 28mm f/2.8 IS USM lens is one of Canon's many EF lenses.

Image courtesy of Canon

4.8 The Canon EFS 15-85mm f/3.5-5.6 IS USM lens is design for Canon cameras with a 1.6 crop factor.

Image courtesy of Canon

4.9 You can tell that this is a premium Canon L lens by the red line around the lens barrel.

▶ **Luxury (L) lenses.** These are Canon's premium lenses. They are easily identifiable by the red line around them. They are constructed of excellent glass, which gives you sharp photos from edge to edge and good contrast. They are built for heavy use in all types of environments and weather. L lenses are expensive and, as such, a true investment in your photography.

▶ **Stepper Motor (STM) lenses.** Autofocus lenses make noise, and this is a problem if you are shooting in Movie mode ('🎥) and using the Rebel T4i/650D continuous-focus technology. Most lenses for dSLR cameras are not designed with video in mind. However, the new Canon STM lens system uses *step motor technology* for quiet focusing while in Movie mode ('🎥). This is helpful for keeping the noise level down while the camera continues to focus in the AI Servo mode (**AI SERVO**).

Image courtesy of Canon

4.10 The Canon 40mm f/2.8 lens was designed as a quiet lens for video.

▶ **Ultra Sonic Motor (USM) lenses.** These are ultra-quiet, fast-focusing lenses for Canon cameras. Many of the high-quality lenses from Canon are USM lenses, such as the EF 24mm f/1.4L II USM.

Image courtesy of Canon

4.11 The Canon 70-200 2.8 USM lens.

4

▶ **Third-party lenses.** Camera manufacturers like Canon and Nikon make lenses for their cameras only. Third-party manufacturers make lenses for multiple brands of cameras at a lower price point. The quality of third-party lenses has greatly improved over the years, and some even make lens types that are not available through Canon. The following companies make lenses for Canon bodies:

- **Bower.** This company is known for specialty lenses, including a wide range of fisheye lenses.

- **Rokinon.** This manufacturer is best known for its selection of wide-angle lenses at affordable prices.

- **Sigma.** This company has been one of the top third-party lens manufacturers for over 50 years.

- **Tokina.** One of my favorite third-party brands, Tokina offers sharp lenses at affordable prices. I use the Tokina 12-24 f/4.0 regularly.

- **Tamron.** This company offers a full line of zoom lenses in a competitive price range.

- **Vivitar.** Best known for its flash accessories, Vivitar also has a full line of inexpensive, mid-range lenses.

- **Zeiss.** This company has a long tradition of manufacturing high-quality lenses.

Image courtesy of Tokina
4.12 The Tokina 12-24mm f/4.0 is an excellent third-party lens.

CAUTION If a lens costs a lot less than a comparable Canon model, there is most likely something missing, such as Image Stabilization (IS).

All lens manufacturers seem to go through phases in which they excel in one lens type over another. It is always important to read reviews, test, and evaluate lenses before you buy one.

Prime versus Zoom Lenses

A *zoom lens* gives you multiple focal lengths. They are convenient, especially as your scenery or subjects change. *Prime lenses* are fixed to one focal length. They are light, easy to use, and tend to deliver a sharper image.

Understanding prime lenses

A prime lens has a fixed focal length. They are lighter, faster, and traditionally sharper than zoom lenses at lower price points. Primes tend to be a good value for the money. Photographers appreciate the shallow depth of field they gain with the larger aperture prime lenses offer.

Not every photographer takes advantage of prime lenses. Some only use a 50mm prime lens to capture their environments because it is nearly equal to what the eye captures. Commercial photographers often use prime lenses, especially in a studio, to achieve the best possible focus and clarity. The disadvantage is that you have to change your lens if you want a different focal length. If you plan on using many different focal lengths in a short period of time, you should consider a zoom lens.

Understanding zoom lenses

Zoom lenses are an excellent choice for vacation photography—you only need to pack one or two to cover almost any situation. One moment you could be photographing a landscape and the next you could capture a candid portrait of an interesting local. You always want to be prepared and a good zoom helps.

There are different types of zooms. Some, such as the Canon EF 16-35mm f/2.8L II USM, cover a short focal-length range. Others, such as the EF-S 18-200mm f/3.5-5.6 IS, cover a wide focal-length range. Telephoto zooms, such as the EF 70-300mm f/4-5.6 IS UM, cover higher focal lengths. Event photographers often use zoom lenses because they need to be ready for anything at any moment. Sports photographers use telephoto zooms so they can make adjustments as a game develops.

4

Specialty Lenses

Specialty lenses perform specific functions. You may not use them every day, but it is nice to know they are in your bag if needed. The following list includes some types of specialty lenses:

▶ **Fisheye.** The difference between the ultrawide-angle and fisheye lenses is the presentation of the wide view. A fisheye produces a highly distorted image, as shown in Figure 4.13.

4.13 The fisheye is not a wide-angle lens you use every day. However, if you think one would be useful, I recommend the Canon EF 15mm f/2.8 fisheye. (ISO 200, f/2.8, 1/1000 second)

▶ **Macro.** Macro lenses are built for photographing the world of the small. Most lenses are not able to focus close enough to create decent images of small objects. Macro lenses are designed to solve this problem. As always, you should test different lenses to see what type of macro you prefer. Some are dedicated to close-up photography, while others can also be used as regular lenses. Nature photographers often use a macro lens to photograph insects, flowers, and plants. This type of photography is a lot of fun because you get to see things that are often overlooked, or see something familiar in a new way. There are lots of subjects to photograph in your own backyard if you have a macro lens. Canon makes six macro lenses, but I recommend the 100mm f/2.8 Macro USM. It is versatile and, in my experience, can also be used as a portrait lens in a pinch.

▶ **Tilt-shift.** When you photograph a building with a wide-angle lens, you will notice that the lines of the building lean in the image. A tilt-shift lens corrects this by allowing the photographer to shift the lens to create proper perspective and tilt it to alter the focus plain. These lenses have many advantages when correcting for perspective, as well as depth of field. While it's often suggested that a tilt-shift lens changes the depth of field, it doesn't. Rather, it moves the center point of the focal plane to match the subject instead of the plane of focus cutting through the subject, rendering part of it out of focus (due to a shallow depth of field). The photographer can adjust the focus plane to match the subject, keeping the subject in focus and the rest of the scene out of focus. Using a tilt-shift lens for panoramic photographs is an excellent way to keep lines straight while still having the advantage of a wide-angle

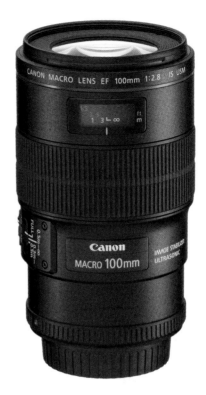

Image courtesy of Canon

4.14 The Canon 100mm f/2.8L Macro lens is for close-up photography.

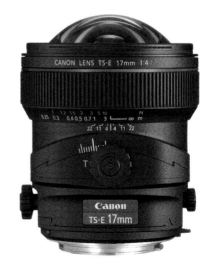

Image courtesy of Canon

4.15 The Canon TS-E 17mm f/4.0L tilt-shift lens is commonly used for correcting perspective.

4

lens. Canon has four tilt-shift lenses in its lineup ranging from 17mm to 90mm. All are high quality and expensive. If you need this type of lens, your biggest consideration is how wide you need it to be. For the T4i/650D, my recommendation is the wider the better.

The following list recommends the best lens for specific types of photography:

▶ **Architecture.** Wide-angle lenses are most popular for architectural photography because the ability to get the entire structure in the shot is important. If you want to spend the extra money, a tilt-shift lens is the way to go.

▶ **Family.** I recommend a good all-purpose lens for family photography because you never know what you are going to need. One moment you may be photographing a child and the next a group photo with all of your relatives.

▶ **Landscape.** This type of photography is similar to architecture and wide-angle lenses are preferred. Of course, whenever you are in the field, you never know what you might find, so having a good telephoto lens is also highly recommended.

▶ **Portrait.** A good portrait lens is between 70mm to 135mm because it does not distort the subject. Plus, you don't have to be in the person's face to take the photo. Unless you are creating an environmental portrait, people prefer to be photographed by a longer lens because wider lenses distort and widen the subject. None of my portrait clients have ever asked to be widened. Larger lenses, such as a 70-200mm f/2.8, do work, but they can overwhelm your subject.

▶ **Environmental portraits.** This is a photograph of a person in her environment. Usually, the person is looking at or posing for the camera, which is different than a candid shot, in which the subject is either ignoring or unaware of the camera. These types of images can be taken with any lens, but a wide-angle is the traditional choice.

▶ **Travel.** One or two good, all-purpose zoom lenses are very helpful when traveling. The less gear you need to think about during your trip, the happier you will be.

▶ **Sports.** Sports photography requires a fast lens, especially indoors. Dark gymnasiums and arenas are not a photographer's best friend. It is common to see sports photographers with longer telephoto lenses because they need to catch action across a long field. They also use wide-angle lenses to capture action happening directly in front of them.

▶ **Wildlife and nature.** Wild animals don't like you to get too close and there are some you probably don't want to get too close to you. This is why telephoto lenses are popular with wildlife photographers. Birds are a specialty and usually require at least a 300mm lens or longer. Also, consider bringing a macro lens with you to photograph the little things you find along the way.

CROSS REF For more information on different types of photography, see Chapter 7.

4

Exploring Exposure and Composition

When photographers talk shop, the most common subjects discussed are equipment and exposure settings, such as the f-stop or shutter speed used for a particular shot. Budding photographers especially want to understand the thinking behind their choices. If you want to be a professional photographer, you need to understand the mechanics of exposure. There is no such thing as a perfect exposure. If you correctly exposed every point in your photograph, it would produce a gray sheet of paper. The exposure process is a series of under- and overexposures. It is your job as the photographer, with the help of your camera's metering system, to find the right combination. Although there are many automatic exposure options, I encourage you to explore and learn more about how exposure works. Don't settle for what the camera gives you; take charge and create the results you want.

The shallow depth of field in this image was achieved by using a large aperture.

Choosing the Right Exposure

You can turn almost anything into a camera, which is just a lightproof box. Even the room you are in could be a camera if you cover the windows and keep out all of the light. If you place a large white piece of paper on one wall and drill a hole in the other, you see an image of the outside world reflected upside down on the paper. Light travels in a straight line, reflecting from its source. The piece of paper is the light-sensitive material that captures the image. In your camera, the light-sensitive material is electronic, and it is known as a sensor.

The hole in the wall is the aperture that allows light to pass through. If you let the light continuously hit the light-sensitive material, it overexposes the image. You need something—a shutter—to stop the light from traveling into your camera. The intensity of light and the sensitivity of the light-sensitive material (the sensor) also determine how large or small the opening (the aperture) in the wall is, and how long the shutter must remain open.

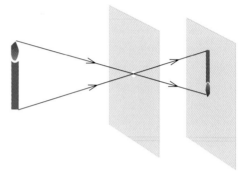

5.1 This illustration demonstrates how light travels in a straight line.

Fortunately, you don't have to worry about all of that complicated stuff because your camera has advanced technology that automatically reads the proper exposure. This gives you the flexibility to use the creative zone modes for full or partial control of your camera, or the automatic zone modes for multiple exposure options.

Here are some quick tips to get you started (they are explained in more detail later in this chapter):

▶ **Use the Programmed AE mode (P).** Consider this P for panic mode. When you are not sure what to do and need to get the shot, let the camera do the thinking.

▶ **Select a high-enough shutter speed.** When you hand hold your camera, use 1/60 second or higher to prevent blur. If you want to stop the action, use a shutter speed of more than 1/500 second.

▶ **Select the right aperture.** The higher the aperture number is, the greater the depth of field.

▶ **Select the right ISO setting.** The higher the ISO setting is, the less light is needed for an exposure.

▶ **Use the Bulb setting (B) for long exposures.** This setting holds the shutter open for as long as you press the shutter button. Use a cable release to make this easier and avoid camera shake when pressing the shutter button.

▶ **Understand the dark side of filters.** When you put dark or color filters on your lens, the photograph needs more exposure. This also affects the shutter speed or aperture, depending on what exposure setting you use. The amount of light blocked by the filter is called the *filter factor*. Knowing how a filter affects your exposure helps you determine what support equipment you might need, such as a tripod.

▶ **Know how the shutter speed and aperture work.** Increasing the shutter speed by 1 stop cuts the amount of light entering the camera by half; decreasing it by 1 stop doubles the amount of light entering the camera. Opening the aperture by 1 stop doubles the amount of light entering the camera; closing it by 1 stop cuts the amount of light in half.

▶ **Meter the exposure.** If you photograph a subject at a distance, use a gray card to meter the same lighting conditions to get the best exposure.

A photograph is *underexposed* when there is not enough light during the exposure process. This makes the photograph look too dark, as shown in Figure 5.2.

5.2 In this underexposed photo, the details are lacking in the shadows. (50mm lens, ISO 100, f/5.0, 1/3000 second)

5

A photograph that is *overexposed* has received too much light in the exposure process. This makes the picture look too bright, as shown in Figure 5.3.

The basic zones are automatic; you do not have to make any adjustments when using them. The following is a list of the basic zone modes and when to use them:

▶ **Scene Intelligent Auto (⊞).** You can use this all-purpose mode for everyday photography. It analyzes the scene and adjusts the shutter speed, aperture, and focus as needed.

▶ **No flash (⚡).** When it is not appropriate or allowed, such as in a museum, this prevents the flash from firing.

5.3 In this overexposed image, the details are lacking. (50mm lens, ISO 100, f/1.4, 1/60 second)

▶ **Creative Auto (CA).** Unlike the Scene Intelligent Auto mode (⊞), in which the camera sets everything for you, Creative Auto mode (CA) gives you some flexibility to adjust the depth of field, the drive mode, and flash firing. You can also add ambience settings to your photographs.

▶ **Portrait (🙎).** This mode creates a shallow depth of field, which is helpful for portraits.

▶ **Landscape (🏔).** This mode creates a large depth of field, which is helpful for panoramic shots.

▶ **Close-up (🌷).** Use the macro setting to shoot close-ups or for small-object photography.

▶ **Sports (✖).** This mode uses a fast shutter speed to stop action. It is commonly used for wildlife, sports, and fast-moving children.

▶ **Night Portrait (▣).** This slow shutter speed mode helps capture background lights at night. Remember that the flash pops up if the camera detects the need.

Setting the shutter speed

Photographs of fast-moving objects frozen in motion, such as a cheetah bounding through the grass toward its prey, are a result of a fast shutter speed. Likewise, a trail of stars advancing across the night sky is the result of a slow shutter speed.

Shutter speed is measured in seconds. Your camera has shutter speed settings that range anywhere from a 30-second exposure to 1/4000 second. In most cases, any speed more than 1/500 second stops action. You start to see more motion blur at 1/30 second or lower; the faster you or your subject is moving, the more blur you see.

When considering shutter speed, ask yourself whether you want to show motion or stop it. If stopping or showing motion is an important element of your photograph, consider using the Shutter-priority AE mode (**Tv**). This mode allows you to control the shutter speed, while the camera controls the aperture. Pay attention to the aperture number displayed next to the shutter speed in the viewfinder. If it is blinking, the shutter speed is too high or low for a proper exposure.

> TIP The longer the camera lens is, the higher the minimum shutter speed should be to avoid blur from lens movement.

When to use fast shutter speeds

Use a fast shutter speed whenever you want to stop action. When you photograph wildlife, active children, or sports, you generally require faster shutter speeds. This is because the subjects are often moving and motion causes an image to blur at lower shutter speeds. A fast shutter speed is considered over 1/125 second. If you want to stop action with little or no movement, consider 1/500 second. The top shutter speed on your camera is 1/4000 second. You rarely need or reach a shutter speed that fast, unless you are photographing at a high ISO setting in bright sunlight.

5

Use the Shutter-priority AE mode (**Tv**) when photographing sports, wildlife, or any moving subject to help prevent blurring. If you prefer to use the basic zone modes, the Sports mode (🏃) is a good option because it keeps the shutter at the highest possible setting for every shot. If you are not getting a fast enough shutter speed to achieve the results you want, consider increasing the ISO setting.

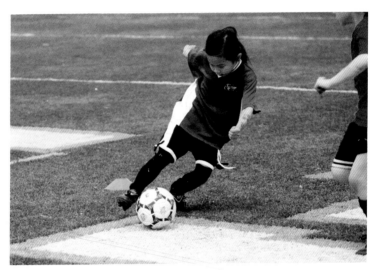

5.4 When shooting action, such as sports, a high shutter speed freezes the subject. (70-200mm 2.8L lens,130mm, ISO 400, f/4.5, 1/2000 second)

When to use slow shutter speeds

A slow shutter speed is required when you want to show movement. It is also used to show a more ambient background light when using flash. Using motion well in your photos can turn everyday pictures into action-filled images, as shown in Figure 5.5.

If you need a greater depth of field (which is explained later in this chapter), try slowing down the shutter speed until you reach the desired aperture. As the shutter speed decreases, the aperture number needs to increase to keep proper exposure. Landscape and architectural photographers often use very slow shutter speeds, especially in the early morning or late evening, to help keep the aperture numbers high for a greater depth of field. For this type of photography, use a tripod to steady the camera.

Generally, you should use a tripod when the shutter speed is set below 1/60 second. One guideline to remember is if the shutter speed is lower than the focal length of the camera lens, you should use a tripod. This doesn't always work, however, because there are other factors to consider, such as the movement of your subject. If your

subject is still or moving toward you, though, the previous guideline should work. If your subject is moving from side-to-side, a faster shutter speed is usually required.

5.5 This photo shows movement because a slow shutter speed was used. (ISO 200, f/16, at 1/25 second)

Moving water, such as waterfalls or crashing waves, is a great opportunity to influence the outcome of the image with the shutter speed. Use a fast shutter speed, such as 1/500 second, to capture individual water droplets cascading down a falls or to stop the action of breakers crashing onto rocks. Use a slow shutter speed, such as 1/8 second, to bring out the silken flow of the falling water or to create a peaceful seascape. You can use fast and slow shutter speeds to set different visual tones. For example, you can demonstrate speed using the motion blur of a fast-moving train, or convey the power of a hammer hitting a rock by using stop action at the point of impact.

If you need a slower shutter speed, but don't want to blur your photo, use the Handheld Night Scene mode (⬛). Canon's Image Stabilization (IS) lenses are also helpful when lens shake might ruin a good photo opportunity. The stabilization technology cancels out much (if not all) of the blur by adding the equivalent of up to 4 full shutter speed stops.

CROSS REF For more details about lenses, see Chapter 4.

If you shoot at a slow shutter speed (under 1/60 second), both the background and the subject show motion in the image. How much motion depends on how slow the shutter is, how steady you hold the camera, and the speed and movement of your subject.

Try playing with the blur by moving the camera in different directions while you shoot to see what forms and shapes you can create.

5.6 When shooting this image, I quickly turned the camera during the exposure to add movement. (ISO 200, f/16, 1/20 second)

When you use a tripod and set your camera to a slow shutter speed to shoot a moving object, the object shows blur but the background remains in focus. How much blur is created depends on how fast the object is moving and how slow you set the shutter.

5.7 This shot was taken using a tripod while cars sped past at about 40 mph. (ISO 400, f/5.6, 1/6 second)

Panning is a fun technique to use with a slow shutter speed. To do so, track a moving subject with your camera and use a slow shutter speed. This technique delivers an image with the subject in focus against a blurred background, as shown in Figure 5.8.

The Bulb setting (**B**) is commonly used for extra-long exposures to capture streaks of light, as shown in Figure 5.9. Use this setting when you are trying to capture car headlights on the highway, stars moving across the night sky, or the silky movement of water.

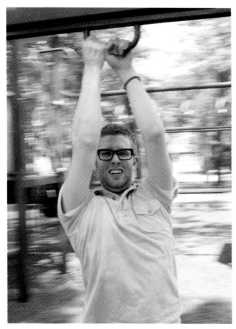

5.8 Panning creates an image in which the subject is in focus and the background is blurred. (ISO 400, f/18, 1/30 second)

5.9 I photographed my daughter dancing around in her LED light-covered shoes. You can see the lights, but you can't see her due to her movement and the slow shutter speed. (ISO 800, f/9.0, 12 seconds, tripod)

Your camera syncs with the flash up to 1/200 second. If you use a faster shutter speed, part of your image will be dark or black because the flash didn't keep up with the shutter. Fortunately, you can prevent this from happening. Even if you set a higher shutter speed, as soon as you turn on the flash, it reverts to 1/200 second.

Although you can't set the built-in flash over the 1/200 second sync level, you can slow down the shutter as much as you want. External flashes, such as the Canon Speedlite series, have high-speed sync, which can sync with your top shutter speed of 1/4000 second. When you use a slow shutter speed with flash, you create a *ghosting* effect. This happens when the flash freezes the subject, but the slow shutter speed causes a blur. If you move the camera in different directions or turn it during the exposure, the result is a motion-filled image.

CROSS REF See Chapter 6 for more details about ghosting.

Night photography and painting with light

Have you ever wanted to create one of those beautiful shots of a skyline at night, or capture a large moon rising over a landscape? Night photography offers many dramatic photographic opportunities—all you need is a little knowledge and the right tools. Two necessary accessories for night photography are a cable release (remote switch) and a tripod. A tripod is necessary to keep the camera steady for long exposures. You can use a cable release to trip the shutter at any shutter speed without touching the camera. This is especially helpful for extra-long exposures of more than 30 seconds.

5.10 The Milky Way. (12-24mm f/4.0 lens at 12mm (19mm equivalent), ISO 1600, f/5.6, 30 seconds)

NOTE The Canon RS-60E3 Remote Switch (cable release) fits the Canon T4i/650D remote control terminal.

Jeff White's Night Photography Tips

Jeff White is a well-known, urban night photographer in Michigan. Home, office, and restaurant designers have purchased his work to display on their walls. The following are Jeff's tips for night photography beginners:

► **Experiment with apertures and shutter speeds that you are unable to use during the day.**

► **Shoot in the RAW format so you have more creative control over the mixed lighting of night skies and artificial light sources.**

► **Experiment with moving objects while taking long exposures.**

► **Bring a flash or flashlight to illuminate smaller, closer objects, and add more depth to your shots.**

► **If you are shooting in a city or unfamiliar territory, take a friend along for safety.**

Jeff captured this image with the Canon T4i/650D on the streets just outside Detroit. (ISO 100, f/5.6, 8 seconds)

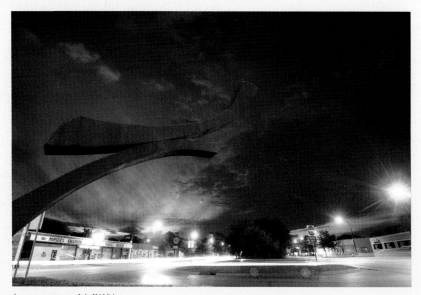

Image courtesy of Jeff White

5

When shooting nighttime photographs, it is tempting to use the camera's higher ISO settings, but if you are using a tripod, time is on your side. Consider using a slower or midrange setting, such as ISO 800 or ISO 1600, for better image clarity, color, and less noise. Night photographs tend to have more digital noise, so consider using your long exposure noise reduction Custom Function (C.Fn-4) to minimize it.

Photographing stars is always a treat. In just a few minutes of exposure, you can create an image of stars moving across the sky. To see a lot of stars and movement, you need to get away from the city and leave the shutter open. It can take minutes to hours to get the desired image. Make sure that your camera is securely mounted to a tripod, and that the tripod is anchored. Any movement can cause blurring in the photo. When considering night scenes, look for colors, shapes, and patterns. Expect to take more than one photograph at multiple exposure settings.

Painting with light is a fun technique that requires a slow shutter speed and a tripod. It is best to do it in a dark room or outside at night. Try leaving the shutter open using the Bulb setting (**B**) or a long shutter speed, such as 30 seconds. Use a flashlight, match, or glow stick to write or draw a design in the air, as shown in Figure 5.11. If you are the subject, set the drive mode to Self-timer mode continuous (☉c) so you can take up to ten shots in a row without running back and forth to the camera.

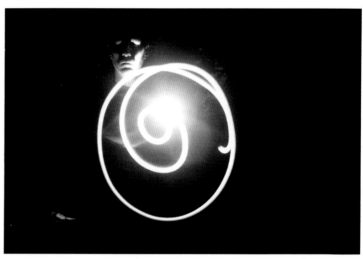

5.11 You can use a flashlight to experiment with light painting. (ISO 400, f/5.6, 8 seconds, tripod)

Setting the aperture

When you see an amazing landscape with everything in focus, aperture played a role. A portrait in which only the eyes are in focus with everything else softly faded is also a function of camera aperture. *Aperture* is the diaphragm opening inside the camera lens that lets in light. Aperture numbering isn't intuitive and can be confusing. The larger the number is, the smaller the opening; the smaller the aperture number is, the larger the opening. Most standard lenses range from f/2.8 to f/22. Some standard apertures are f/2.8, f/4.0, f/5.6, f/8.0, f/11, f/16, f/22, and f/32.

> **NOTE** If no lens is attached to the camera, 00 is displayed as the aperture setting.

Think of *depth of field* as the area of focus around the subject. If there is a large area in focus surrounding the subject, then the photograph has a large depth of field, such as in landscape photography. If there is little focus around the main object of the photograph, then you have a shallow depth of field. For example, a portrait with a blurry background has a shallow depth of field. Unfortunately, you can't make the statement that f/8.0 has a depth of field of 8 feet in front of, and 16 feet behind, the subject. The combination of focal length and distance between the subject and the camera determines the total available depth of field. In other words, each focal-length has a different effect on the depth field around the subject at the same distance.

A 28mm lens at f/8.0 that is 10 feet from the camera doesn't have the same depth of field at the same distance as a 200mm lens. The 28mm lens spreads out the image and creates a larger depth of field, displaying everything in focus between 6 and 24 feet from the camera. The 200mm lens compresses the field of view, leaving little room for error with only 9.89 to 10.1 feet from the camera in focus. The Aperture-priority AE mode (**Av**) is good to use when depth of field is an important consideration. This mode lets you control the aperture, while the camera controls the shutter speed to create the proper exposure.

If the camera is in the Program AE mode (**P**), you can adjust the aperture by turning the Main dial (⌒). Please note that if you increase the aperture, your shutter speed will be slower, and if you decrease the aperture, your shutter speed will be faster. Although the shutter and aperture numbers are moving up and down, the exposure stays the same because they are moving in proportion. If the shutter speed increases 1 stop, such as 1/60 to 1/125 second (which cuts the amount of light in half), and your aperture opens from f/8.0 to f/5.6 (doubling the amount of light), your exposure stays the same.

The following are some common situations in which you would use a large or shallow depth of field:

▶ A large depth of field is excellent when shooting landscapes, wildlife photography, or *environment portraits* (that is, pictures of people posing in their environment).

▶ A shallow depth of field is commonly used in studio portraits, sports, and fashion photography because it separates the subject from the background. A shallow depth of field adds a stylized look to your pictures. When you want a shallow depth of field, move in close to the subject. Fill the frame with different objects and see what happens. Use a lower aperture to add a new dimension to your photographs. Everything in a shallow depth-of-field image is not in focus. When using this setting, decide on a *focal point*—the part of the subject on which you want the viewer to focus.

5.12 This image has a shallow depth of field in both the fore- and background. (ISO 200, f/2.8, 1/400 second)

Setting the ISO

The ISO (International Organization for Standardization) setting is the light sensitivity of the camera's digital sensor. The higher the number is, the less light you need to take a photograph. The lower the number is, the more light you need. For example, ISO 100 is perfect for a sunny day. ISO 1600 is good for indoor use. Each time you increase your ISO to the next step—from ISO 400 to ISO 800, for example—you double the light sensitivity. This allows you to increase the shutter speed or reduce the aperture by 1 full stop.

So why not use a high ISO setting, like ISO 6400, all of the time? Because high ISO settings create more digital noise than lower ones. *Digital noise* is the equivalent of grainy texture on film. Prints or enlargements of photos shot at ISO 6400 are not as

crisp and clean as those at ISO 100. Not needing as much light is a nice advantage in dark rooms, but sometimes you do need more. Your Canon Rebel T4i/650D is expandable to 12800 ISO using Custom Function 2. This is helpful when you need a bit faster shutter speed, aperture, or can't use a flash. However, ISO 12800 also has a lot more noise than the lower settings.

A fast shutter speed is important for stop-action photography, such as sports, animals, or children on the move. If you don't have enough light to reach the desired shutter speed, then you need to adjust the ISO to a higher setting. Another advantage of a higher ISO setting is that the flash has a farther reach. If you are at an event, push the ISO higher to extend the reach of the flash across the room. How much noise can you handle? Your camera has the following eight

5.13 A low ISO setting was used to allow for a slow shutter speed and create a silky look on the water. (ISO 100, f/20, 1/15 second)

ISO settings: 100, 200, 400, 800, 1600, 3200, 6400, 12800, and is expandable to 25600 for still photography with the camera's Custom Function. When using ISO 3200 and above, the additional noise may be more than optimal.

The following guide might be helpful when setting the ISO:

▶ **ISO 100-400.** This range is ideal for sunny days.

▶ **ISO 400-1600.** Use these settings when shooting with overcast skies or in the evening.

▶ **ISO 1600-6400.** This range is ideal for night photography or when shooting indoors in low light.

▶ **Custom Function 2.** Here, you can set the ISO to 12800 for use in low-light situations.

Fortunately, there are a few options on your Canon T4i/650D that can help reduce the grain in your photos. Custom Function 5 is designed to reduce grain when you use high ISO settings, although it reduces digital noise at all ISO settings. You have the following four options with the high-speed noise reduction feature in Shooting menu 3 (◙) (in most cases, the Standard option should do the trick):

▶ **0: Standard**

▶ **1: Low**

▶ **2: Strong**

▶ **3: Disable**

Custom Function 4 is for exposures of more than 1 minute. If you are not concerned about noise reduction related to long exposures, leave this setting turned off. The function has an auto mode that detects if an image took more than 1 second to expose; it then automatically applies the function. You may also leave it in the *on* position, which applies noise reduction each time an exposure of more than 1 minute is created.

> **NOTE** If you activate a noise reduction function, you cannot take another photograph until the process is complete.

The Multi-shot Noise Reduction option combines four consecutive images at high ISO settings to create low-noise images. This mode also optimizes to reduce subject blur, making night photography much easier. You can find this option with *High ISO speed NR* listed in Shooting menu 3 (◙). You may also want to consider shooting in the RAW mode (RAW). Both your Canon software and Adobe Raw have noise-reduction filters. There are also plug-ins available for Photoshop that help reduce noise.

The ISO settings in the basic zone modes are between ISO 100 and ISO 3200 (except Portrait mode (❀), which is fixed at ISO 100). The creative zone modes set the ISO between ISO 100 and ISO 6400. The auto setting for the Bulb shooting mode (**B**) is ISO 400.

Using Exposure Compensation

Your camera is packed with a lot of advanced technology designed to help you capture the best exposure, but this doesn't mean you will always agree with its choices. If your photographs are regularly under- or overexposed, consider using exposure compensation to correct the problem.

If you photograph a white cat in the snow, the exposure may not turn out as you expect. You might need some help with all of the white light bouncing back to your camera, depending on the exposure mode you use. In this case, try overexposing the image to create a more accurate one.

Photographing a black horse in front of a dark background is another example of an extreme that might require exposure compensation. In this case, underexpose the photograph to better bring out the detail of the horse. When the main source of light is behind the subject, this is called *backlighting*. You can use exposure compensation to prevent unwanted silhouettes or the main subject from becoming too dark to see. This can happen if your subject is in front of a window or in bright sunlight.

CROSS REF See Chapter 6 for more information about lighting.

If you are not sure of the exposure you want to use, you can play it safe and bracket. *Bracketing* is taking multiple shots at different exposures. You can do this manually using the exposure compensation and taking one photograph at -1 (underexposed), another at normal exposure (or 0), and a third image at +1 (overexposed). This gives you three images with different exposure options.

Your camera is also equipped with Auto Exposure Bracketing (🖼). AEB automatically takes three images—an underexposed image, a normal exposure, and an overexposed frame. You control the difference in the exposure range among the three images, up to 2 stops in 1/3-stop increments.

High Dynamic Range Photography

High Dynamic Range (HDR) is how photographers create colorful, high-contrast fantasy-like images of landscapes, cityscapes, buildings, or even people. *HDR* photos are made by combining bracketed images to create a new hybrid image. Each image brings different exposure merits to the final one. Some images capture highlights while others capture the shadow detail. Combined, they do what a traditional single image cannot: expose for detail in both highlights and shadow at a high level of accuracy.

Sometimes photographers manipulate images to create a fantasy effect. This is a popular technique among landscape photographers. Not everyone likes the surreal quality of this photography style. Remember that HDR images also can be adjusted for a more natural look. Traditionally, HDR photographs require a steady camera on a tripod to get multiple images of the same scene at a variety of exposures. This is one

reason why you rarely see true HDR photographs of people or moving objects. The Canon T4i/650D has modes that can help you use the HDR technique. The nice thing about these modes is that you can hand hold the camera while shooting, if you are really steady.

5.14 This HDR image is a combination of three exposures. (ISO 200; f/10; 1/80, 1/200, and 1/500 second)

The Handheld Night Scene mode (▨) found in the basic zone (second to last position) takes four photographs while you are handholding the T4i/650D. It then creates one image that exposes for detail in the subject of your scene, while still allowing for ambient light.

The HDR Backlight control (▨) is one of ten modes found in the basic zone (last position). It takes three consecutive shots at multiple exposures in a backlit setting, and then creates a well-exposed image. This function displays the detail from the bright light source, such as the sky, as well as the subject in the foreground. I recommend using a tripod with this mode. The camera will not always line up the images correctly if there is camera shake.

If you take individual brackets without using your camera's HDR features, the HDR Backlight control (⬛), or the Handheld Night Scene mode (⬛), you need software to combine the images. Although you can do this in Photoshop, one of the more popular programs is Photomatix. It gives you a good range of options to create both natural-looking and high-contrast, fantasy-style HDR images.

Exposing for Video

Auto exposure is a good standard for most of your video needs. When your camera is in the Auto Exposure movie mode (⬛), it sets the ISO, shutter speed, and aperture.

The Manual exposure mode (**M**) is standard for advanced users, and it's a good option once you are comfortable with your camera. It prevents your camera from changing the exposure during the middle of a scene. When shooting a moving subject, shutter speeds from 1/30 second to 1/125 second are recommended. It is also worth noting that it is not a good idea to change your exposure while shooting. The change will distract the viewer and signal that an amateur shot the video.

> **NOTE** Remember that you can't use exposure compensation when in the Manual exposure mode (**M**).

You don't have as many options for exposure in Movie mode ('🎥) as you do for still pictures, but there are a few. Exposure compensation is available in the Auto Exposure movie mode (⬛), and this is helpful when photographing light, dark, or backlit sub-jects. You are limited to three stop adjustments in Movie mode ('🎥) (for still photos, you can make up to five). You also have Picture Styles available in the Movie mode ('🎥). These are the same as those found in the still shooting modes. Picture Styles adjust color and tone based on the characteristic style or subject matter you are shooting.

> **TIP** The ISO can be set anywhere between ISO 100 and ISO 6400, and expanded to 12800 in Movie mode ('🎥).

Composition

Have you noticed that most of the photographs you appreciate don't have the main subject directly in the middle of the frame? This is because point-and-shoot photogra-phy (with the subject positioned in the middle of the frame) usually doesn't capture

the scene as well as a planned out and thoughtful composition. When it comes to composition, challenge yourself. Create variety in your photographs. Every scene or subject doesn't have to be shot in the same way.

While your camera does so much for you, the one thing it can't do is create your vision. The way that you see things is different from anyone else. The way that you frame an image is up to you, and that is what composition is all about. The Rule of Thirds and filling the frame are guidelines that can help you make good decisions when photographing the subjects in front of your lens. Another way to improve composition is to look for different points of view—every photo doesn't have to be shot at eye level. Get down on your knees or climb up high (be careful!) to capture new angles. If you are photographing children, make sure that you get down on their level.

5.15 This image fills the frame with the foreground and also satisfies the Rule of Thirds. (18mm, ISO 200, f/4.0, 1/200 second)

Your choice of lens also plays a role in how you frame your shot. A wide lens spreads out a scene, which gives you a lot more real estate to work with in your frame. A long lens brings the scene or subject closer to you for a tighter shot.

CROSS REF For more about lenses, see Chapter 4.

Sometimes, even though you may be following the rules, some compositions don't sit well with the viewer. Sometimes, it may be because part of the subject is cut off in an awkward position. There is nothing wrong with cropping your image later, but I don't

recommend that you shoot with the mind-set that you can crop during editing. Work on getting your composition right the first time. Later, if you notice that the image could still use some adjustments, you can crop.

> **TIP** When cropping images, make sure that you don't crop people at the knees or elbows—it looks awkward and uncomfortable to the viewer.

You have two ways to view a scene when developing a composition. You can use the viewfinder or Live View Shooting mode (■). The Live View shooting mode (■) is real-time viewing of the scene in front of the lens on the LCD screen. Some photographers find the screen on the back of the camera easier to use. However, this is not always the case—in bright sunlight, looking through the viewfinder is often the better choice. The flexible, 180-degree LCD screen is also helpful when holding the camera high over crowds, when shooting down low from a ground view, or even for shooting around corners.

Rule of Thirds

I'm a firm believer that you need to learn the rules before you can break them. After you learn them, you can use the rules as guides. When it comes to rules about composition, the Rule of Thirds is the most important. The idea behind it is to mentally divide your camera frame into thirds, both horizontally and vertically. Combining the two creates what looks like a tic-tac-toe board, as shown in Figure 5.16.

5.16 This grid demonstrates the Rule of Thirds. Notice how the subject has been placed off to the side. (ISO 200, f/2.8, 1/500 second)

There are many ways to use this tic-tac-toe board on your camera. Consider the four cross sections in the frame as points at which you can place your subject. Another way to satisfy the Rule of Thirds is to mentally draw a diagonal line through the frame and photograph the main subject above or below that line. I also recommend that you fill the frame. It's important to note, however, that sometimes you *do* want your subject in the middle of the frame. The Rule of Thirds encourages asymmetrical images, but that is not always the best result. In some circumstances, the best photograph is a symmetrical one, in which everything is balanced.

Horizon lines should follow the Rule of Thirds. The horizon line between the earth and the sky should not be in the center of your frame. It also should not cut through the back of the subject's head. When photographing from a distance, the Rule of Thirds still applies. For example, a boat on the horizon should be placed anywhere but in the middle of the frame. Consider the direction in which the subject is moving, and then leave room in front of it to create a sense of motion. In the case of a runner, place him on the right side of the frame if he is moving to the left across the LCD screen.

Fill the frame

One way in which you can always satisfy the Rule of Thirds is to fill the frame, as shown in Figure 5.17. Don't be afraid of the frame's edge—you can get in closer. In fact, get as close as your lens allows and don't worry if some parts are left out of the shot.

> **NOTE** It is important to understand the limitations of your lenses. Some only allow you to get so close before proper focus is unavailable.

Lines and shapes

One of the most important rules of composition is that you have a *focal point*, which is something to which the eye is automatically drawn, or a starting point at which to view the image. The eye then follows a pattern, shape, or lines through your image. Understanding this concept is helpful, whether you are developing high-level conceptual ideas or just photographing your kids at the playground.

One of the first things a viewer's eyes are drawn to is the lightest object in the frame. Leading lines take the viewer's eye to the final destination of your image. S shapes are another nice compositional tool and geometric shapes can be very powerful. The triangle is the most powerful shape in art. Start looking at your environment. You will be amazed at the patterns you find around you. Parking lines, columns of streetlights, rows of corn, and architectural details, such as windows, are all good examples of everyday patterns.

5.17 Filling the frame with your subject gives the image a more personal feel. (ISO 100, f/5.6, 1/80 second)

5.18 I used lines here to lead the viewer's eye to the subject. (50mm lens, ISO 400, f/9.0, 1/160 second)

5

Challenge yourself to look for patterns, and see if you can incorporate them with your subjects. Use leading lines to guide the viewer's eyes where you want them to look. An S-shape takes the viewer on a journey across the page. You can also lead your viewer's eyes into the distance with strong leading lines, or use them to create a vanishing point deep in the image.

Foreground and background

Most things do not happen on a single plane. You should consider the fore- and backgrounds as part of your composition. When you look at a scene, consider whether you should take a two- or three-dimensional photograph (see Figure 5.19). If you keep everything on the same focal plane, such as a straight-on shot of a building, it creates a flat look. You can add dimension to your photographs by placing objects in the fore- and background.

You can also play objects off of the foreground. If you are shooting a mountain off in the distance, look around to see if there is something of interest to use in the foreground, such as a flower or an interesting rock. Consider how you can use the background, such as clouds moving behind a mountain, as part of your composition.

5.19 I used leaves in the foreground here to add dimension. (ISO 800, f/3.5, 1/4000 second)

Keeping it simple

Many of the best compositions are great because they are simple. The saying *less is more* holds true in photography. Every part of your photo should be there for a reason. *When in doubt, leave it out* is another good rule to live by. Make it easy for the viewer

to understand what you are trying to show. When you keep things simple, it is much easier to create an obvious focal point for the viewer, as shown in Figure 5.20.

5.20 This image was shot tight to keep the scene simple and avoid distracting from the subject. (100mm macro lens, ISO 1600, f/2.8, 1/2000 second)

A shallow depth of field is helpful because it sets the subject apart from the background. It also creates form and shape, rather than identifiable options in your photo background. Sometimes colors, lights, shadows, or shapes can also be used as compositional balancing tools in an image.

In the beginning, composition is something you think about if you are trying to improve your photos. Fortunately, over time, composition becomes a habit, and you will automatically place subjects a little to the right or left, and fill the frame. It just takes time and practice.

5

Working with Lighting and Flash

A photographer has a lot to consider before pressing the shutter button. One of those considerations is whether there is enough light (or the right light) to create the desired image. Each subject requires its own considerations regarding light. If you are taking action photos, ask yourself whether you have enough light for a fast shutter speed at your desired ISO. If you are photographing a landscape, is there enough light to use a large aperture for maximum depth of field? Will you need to pull out your tripod and slow down your shutter speed to capture the ambient light of a cityscape? If poorly lit, even the most compelling subject won't make an interesting photograph. This chapter will help you find the best light for your images.

Understanding light can greatly improve your photographs.

The Importance of Light and Shadow

Light is the foundation of photography, and how you approach it separates the beginner from the more experienced photographer. The direction, quality, and color of light all play a role in the image results. Lighting doesn't have to be difficult, though. The basic rule is to start with one light source. After all, there is only one sun and because of this, we are accustomed to seeing one shadow. This means that you should start with one dominant light source and build from there. If you keep this basic rule in mind, using lighting to your advantage should come more naturally over time.

The best way to improve your lighting skills is to practice. Look for images and photography that inspire you. Chances are that the lighting is playing a key role in these images. Try to figure out what decisions the photographer made to create the image. The rest of this chapter covers concepts, tips, and the Canon T4i/650D features that can help you create beautiful images. A good way to approach light is by managing shadows. This doesn't mean that you should try to avoid or remove shadows from your photographs, but rather, you should have an awareness of how they affect your subject or scene. Look for shadows that help balance your photograph. Some shadows can make the subject look mysterious or edgy. Observe patterns in shadows or think about how different shadow shapes may enhance your subject. Not all shadows need to be harsh or solid black—soft shadows can add dimension to a photo. In fact, a photograph without shadows is often flat or boring.

6.1 Experiment with shadows. You never know what will work until you try. (50mm lens, ISO 400, f/8.0, 1/200 second)

The Direction of Light

Light direction plays a role in the mood and depth of your photographs. Straight-on lighting tends to flatten the subject, while sidelight adds shadow and dimension. Always be aware of the location of the sun. Midday sun is not as dramatic, colorful, or interesting as sunrise and sunset. If you are using an on-camera flash, your lighting options are limited. However, depending on the type of flash, it can be aimed and bounced in different directions to create a variety of lighting effects. If you use off-camera or multiple flashes, the world of lighting opens up even more. Rather than being dependent on straight-on flash or the current position of the sun, you can aim the light in any direction you desire.

6

Frontlighting

Frontlight is generated from the sun behind you or an on-camera flash. When photographing nature or architecture, it is nice to have the sun at your back. If you are looking for a clean image with no shadows, frontlight does the trick. The downside to frontlighting is that you don't see the shadows that often add character to a photograph. Images with frontlighting from the sun or your flash appear flatter than images using sidelighting.

6.2 This image was shot with frontlighting (direct sunlight). Although you can see some shadows, you don't see the character in the wood that sidelighting would reveal. (135mm lens, ISO 400, f/4.5, 1/500 second)

Overhead lighting

This type of light comes from the midday sun or artificial, overhead lighting. *Overhead light* can be dramatic, but it's generally not flattering for shots of people because the eyes are cast into dark shadow. In some cases, overhead light enhances texture in subjects, but in most cases photographers avoid it without the support of other lights and reflectors. Photographers encounter overhead lighting on a regular basis in office buildings and at stage productions, such as concerts.

Sidelighting

Sidelight is more dramatic and adds depth to the subject, as shown in Figure 6.3. It is created when the light source is coming from the left or right of the subject. This casts the opposite side of the subject in shadow. The more intense the light source, the greater the contrast, and the darker the opposite side appears. Additional light sources or reflectors can be used to soften the harshness of sidelighting.

Sidelight is helpful for creating dramatic landscapes. For example, early-morning sunlight slanting through a stand of trees creates a dramatic shadow effect. In architectural photography, a sidelight against a row of columns adds interest and dimension. Sidelight is used to bring out texture in subjects. For example, a brick wall may look flat with frontlighting, but sidelighting brings out the details.

6.3 This image was shot with sidelighting to add some drama and character. (100mm lens, ISO 200, f/5.6, 1/200 second)

There is more than one type of sidelighting. Any position between front- and backlighting could be considered a variation of sidelighting. Two of the most common types of sidelighting are short and broad lighting. Short lighting is created when the light is focused on the opposite side of the subject away from the camera,

as shown in Figure 6.4. Broad lighting comes from the same side on which the camera is positioned, as shown in Figure 6.5, and is a flattering form of lighting.

6

6.4 This photo was taken with the light on the far side of the face, opposite the camera. (100mm lens, ISO 100, f/5.6, 1/125 second)

6.5 Lighting the subject on the same side as the camera creates a broad light. (ISO 100, f/6.3, 1/100 second)

Another popular form of sidelighting for photographing people is called *Rembrandt lighting*, after the master painter. This is achieved by positioning the light at a 45-degree angle at, or above, the top of the subject's head. You know you have achieved this type of lighting when you see an inverted triangle below the subject's eye on the opposite side from the light source. Sidelight adds dimension to your subjects and is good for portraits.

Backlighting

Backlight is sometimes difficult for photographers to get right. It takes practice to achieve the proper exposures to get the look that you want. Once you master this technique, backlight offers two main options for the photographer. Metering off of the light behind the main subject creates *silhouettes*, which turns the subject into a solid black outline against the light source, as shown in Figure 6.6. If you meter off of the subject or shadows with a strong light behind the subject, you generally get a form of *rim lighting.* This type of lighting outlines the subject with a soft light, and sometimes even blurs the edges of your subject.

Backlighting is a good choice when photographing translucent objects, such as leaves, flowers, or snow. Backlight is a popular advanced lighting technique when photographing people or subjects with interesting shapes. A hard, undiffused light (explained later in this chapter), such as direct sunlight, is recommended for displaying detail in a subject, as shown in Figure 6.7.

6.6 This silhouette was created by metering off of the sky behind the subject. (100mm lens, ISO 100, f/2.8, 1/2500 second)

6.7 Lighting the leaf from behind helped display the cells and details. (100mm macro lens, ISO 200, f/5.6, 1/200 second)

Remember to protect your eyes when pointing your lens toward the sun. Consider using the Live View shooting mode (⬛) on the LCD screen to develop your desired composition. Also, if you have a lens hood, use it to help prevent undesired *lens flare* (unwanted light directed into your lens).

The Canon T4i/650D's new HDR Backlight mode (🖼) is designed to ensure that back-lit subjects are not underexposed or made into an undesired silhouette. The camera combines three consecutive shots taken at different exposures (underexposed, correctly exposed, and overexposed). This creates a properly exposed final image with both good shadow and highlight detail.

The Quality of Light

The mood of your images is greatly affected by the quality of the light. The *quality of light* refers to the light source and how it affects the overall relationship of the subject or scene. Contrast, color, and textures revealed within your image all depend on the light quality.

Hard lighting

Direct light without diffusion is called *hard light* (see Figure 6.8). The rule is that the narrower the light source, the harder the light will be. This type of light generates high-contrast images with deep, dark shadows. Many photographers avoid this type of light in favor of softer light. However, hard light offers many opportunities to create exciting and intense images. It helps define the edges, curves, and angles of a subject. Photographers using hard light depend on good shadow management to create powerful images.

6.8 Hard light is unfiltered and produces strong shadows. (ISO 400, f/2.8, 1/125 second)

The direct summer sun or your unfiltered flash are good examples of direct light sources. You may wonder why the sun is considered hard light as it is so huge. This is because it's 93 million miles (150 million kilometers) from the Earth and only represents a small fraction of the daytime sky.

> **TIP** Hard light is an effective tool for creating contrast in black-and-white photographs.

You can create dramatic portraits using hard light because texture and details pop out, and shadows are strongly defined. Hard lighting can also bring out the detail in bricks on a building or highlight a fabric's texture. When used well, hard light can add drama and depth to your images.

6

Soft lighting

Diffused or reflected light produces what is called *soft light*. The rule is that the broader the light source is, the softer the light will be. Soft light is popular for portraits because it reduces the hardness of shadows. It doesn't show textures as well as hard light, but for many subjects this is positive because soft shadows make the skin look smoother. Placing translucent material, such as plastic, fabric, or a softbox, in front of the light source creates soft light, as shown in Figure 6.9. Soft light can also be achieved by bouncing light off of walls or reflective material, such as a photo umbrella. Nature offers its own soft light filters in the form of cloud cover, which diffuses harsh sunlight.

6.9 This image has softer shadows due to the light being filtered through white fabric. (100mm lens, ISO 100, f/5.0, 1/200 second)

TIP Remember, when you bounce light off of a wall or ceiling, the color of the surface bounces with it.

Soft light is ideal for subjects with multiple elements, such as a group shot. It limits the harshness of the shadows between the complex elements that can detract from the image. Soft light is also popular when shooting video because it is easier to manage when following moving subjects. Harsh shadows move around as a subject moves, but soft light minimizes the need for heavy shadow management.

Lighting Tips from a Pro

The following are professional photographer Joseph Cristina's tips for working with lighting:

▶ **Think of lighting as a building process.** A photograph requires a strong lighting foundation to elevate it from good to great.

▶ **Don't fear the shadows.** Shadows not only allow you to tell a story, but they also give you the ability to create the illusion of three dimensionality on a two-dimensional medium.

▶ **When in doubt, turn them off.** If for any reason you become overwhelmed by your lighting setup or can't figure out how to correct a problem, stop, turn off every light source but the main one, and start again. Remember, your goal is to build a strong foundation first, and then light the shadows with vision and purpose.

Joseph Cristina is a professional photographer based in Palm Beach, California. He has over 20 years of experience in Photography and Graphic/Multimedia Production. He specializes in branding portraiture, as well as commercial, actor, model, and fashion photography. You can view his work at: http://alluremm.com.

Types of Lighting

There are three main sources of light: Natural light from the sun, artificial light from man-made sources (light bulbs), and your flash. Many photographers have a favorite light source that they use often, but it is always good to stretch your skills and try new options. Photographers don't always have a choice of lighting options. Sometimes flash is not allowed at events, or the sun might not be pointing in the optimal direction for a professional assignment. The ability to work with the light available to you is a valuable skill.

Natural light

Sunlight is a favorite source of light for all skill levels because it is free and available to everyone. It is always changing, offering a variety of opportunities throughout the day. The only downside is that the photographer is limited by the direction, color, and quality of the light nature is providing at the moment. When it comes to natural light direction, you have three basic lighting types: Front-, side-, and backlighting. You also have midday, overhead light in the summer. The nice thing about sunlight, which may seem obvious, is that it always looks natural.

Keeping that in mind, it is important to understand what type of light you find during different times of the day and during various weather conditions. The harsh or soft light on sunny or cloudy days affects contrast. The warmth or coolness of the light (depending on the time of day) sets the mood. Early-morning or evening shadows add dimension. All of these factors play a role in your photos.

Windows are an excellent source of natural light and can be used for indoor photography. You don't have to be satisfied with one light source—you can use reflectors to tone down harsh, direct light coming through a window. You can also use mirrors to redirect light. Beyond sunlight, there are other natural light sources. Using higher ISO settings, long exposures, and your tripod, you can capture images using light from the moon, the stars, or even an aurora borealis.

CROSS REF See Chapter 5 for more details about long exposures.

Taking Better Landscape Photos

In the following list, professional photographer, Gary Crabbe, shares a few lighting and composition tips to improve your landscape images:

▶ **Shoot when the sun is low in the sky.** Landscapes often look best bathed in the warm light of the sun when it is closer to the horizon. A good rule of thumb is to start shooting a couple of hours before sunset or an hour or so after sunrise. The lower the sun gets on the horizon, the warmer the light will be. This is why the hours just before or after sunrise and sunset are called the *golden hours.*

▶ **Give landforms, plants, people, and animals room to grow and move.** Try to keep the top of your frame away from the top of a mountain, plant, tree, or someone's head. Similarly, if the subject is facing right or left, give it a little extra room on the side of the frame that it's facing.

▶ **Check the edges of your frame for speed bumps.** Before you press the shutter button, run your eyes over the outside edges of the frame and look for what I call visual *speed bumps*. These are often bright spots or things sticking into your frame, like tree branches, people's arms, or a rusty old sewer pipe.

Gary Crabbe is a professional landscape, nature, and travel photographer based in San Francisco. You can view his work at: www.enlightphoto.com.

Continuous light

Artificial light (also known as a *hot light*) directs *continuous light* onto your subject, as shown in Figure 6.10. This type of light helps the photographer visualize what the photograph will look like in the final image. Some photographers mix continuous light with flash. Remember, flash light only extends so far and casts your background in darkness. Slowing your camera's shutter speed helps pick up the continuous ambient light in the background, adding dimension to the photograph.

There are many new types of continuous light sources available on the market. Light-emitting diodes (LEDs) are a popular lighting choice because they produce a flattering light that doesn't emit a lot of heat. This is valuable when photographing people. HMI (Hydrargyrum medium-arc iodide) lights produce a powerful, consistent light,

6.10 This model was lit using a hot light with a soft filter. (ISO 800, f/2.8, 1/200 second)

and are used to provide additional light inside, outside, or when competing with the sun. Continuous lights are also commonly used when shooting video. The light source may be attached to the camera or on a stand facing the subject. In most cases, a filter or softbox is used to diffuse light for video.

Flash

The flash produces a burst of white light. Many photographers are unsure about using flash. Fortunately, the Canon Evaluative Through-the-Lens (E-TTL) technology allows the camera and lens to communicate easily to create the proper exposure.

The Canon Rebel T4i/650D has a maximum ISO rating of 12800, which is expandable to 25600. This allows you to photograph using white balance filters in many indoor situations. You can use this technique in situations in which flash is not allowed or is inappropriate. When you photograph inside using *ambient* (available) light, you are dependent on the fixed placement and direction of the established lights.

Mastering the use of flash opens a new world to photographers. The ability to control the light on your subject gives you a flexibility that is not available when depending on sunlight or ambient light in a given environment. Whether you are using a Canon speedlite (covered later in this chapter) or the camera's pop-up flash, you may control the flash and its accessory setting via your camera's LCD screen.

6

Shutter speed and flash

You may set your shutter speed anywhere between 1/200 and 30 seconds in the Shutter-priority AE mode (**Tv**). This means that you may select slower shutter speeds for different lighting and movement effects. This is helpful when you want to show more ambient light in the background. If you set your shutter speed too slow, and either you or the subject is moving, the camera creates a ghosting effect, as shown in Figure 6.11.

6.11 Ghosting is created by the combination of flash, slow shutter speed, and subject movement. (100mm lens, ISO 100, f/11, 1/15 second)

Your camera syncs up to 1/200 second with the built-in flash. This means that you may not set your shutter speed above 1/200 second. If you do, only part of your picture will be exposed. This is why the camera automatically adjusts the shutter speed back to 1/200 second if you set it higher than the maximum sync. If you use a dedicated speedlite, you can engage its High-speed Sync mode and sync to the maximum shutter speed.

Aperture and flash

The Aperture-priority AE mode (**Av**) controls the amount of light that enters your camera. It also controls the *depth of field*, which is the area of focus around the subject. When using a larger aperture, it takes more power for the flash to achieve the proper exposure. This wears down batteries faster and slows the recycle time, especially if you use a high aperture setting, such as f/16 or f/22.

Manual mode and flash

Many advanced amateurs and professionals set their cameras to Manual mode (**M**) when photographing with flash because it gives them exposure control. As a general rule, the shutter is used to control the amount of background or ambient light visible in the scene, while the aperture is used to control the intensity of the flash.

CROSS REF For more about shutter speed and depth of field, see Chapter 5.

In Scene Intelligent Auto mode (⬛), your camera selects the aperture, shutter speed, and ISO. In Program AE mode (**P**) the camera selects the shutter speed and aperture. In Aperture-priority AE mode (**Av**), you select the aperture and the camera selects the shutter speed. In Shutter-priority AE, you select the shutter speed (up to 1/200 second) and the camera selects the aperture. In Bulb shooting mode (**B**), the shutter stays open until you release it and the camera sets the aperture. In Full auto mode, the camera sets both the shutter speed and aperture to match the goals of the setting.

Direct flash produced by the pop-up flash or an external model attached to your camera's hot shoe is convenient for everyday casual photography. Unfortunately, it doesn't always produce the most flattering light when compared with other options. If you are trying to achieve more advanced results in your photography, it is important to learn about all of the opportunities flash photography offers.

Be aware, too, that ambient light from a ceiling fixture is not often flattering to your subject. It can be dull, flat, and does not enhance color as well as a direct light. Despite the criticisms of direct flash, the white light from it gives you more accurate color and pops your subject out of the background when used indoors or outside. If you have a Canon Speedlite 430EX II or equivalent that you can turn and adjust to bounce light off of ceilings and walls, you have more options than straight-on flash. If you bounce your flash off of the ceiling or wall, you achieve a softer light, and often produce a more natural-looking result.

> **TIP** Bouncing light off of a high or dark ceiling is not very effective.

A diffuser is helpful when trying to soften the light produced from your flash. You may flip down the built-in diffuser available on many Canon flashes. Another option is to cover your flash with a translucent fabric or other material. There is a large selection of flash diffusion and bounce accessories available at your local camera store or online. One such accessory is an *umbrella*. You can use umbrellas to bounce light from inside back to the subject. Some umbrellas are so thin that they are translucent, or they convert to a translucent material, allowing the photographer to use them as a flash diffuser.

Different materials create different results. A gold umbrella bounces warm light toward the subject. Metallic silver creates more contrast and *specularity* (the brightness or metallic feel in reflective highlights) when compared to the softness of a white, pearl-colored reflector. A light fabric disperses the light differently than a plastic cover. Both may be good options, but it is good to test multiple options and styles of bounce flash and diffusion accessories to find the right one for you. Flash is also helpful outdoors. It can be used as *fill light* (support or secondary light) to help minimize shadows from harsh, direct sunlight, as shown in Figure 6.12. Outdoor flash is also helpful for separating the subject from the background.

6.12 This portrait was taken using an off-camera flash under the shade of a large tree. (100mm lens, ISO 200, f/9.0, 1/125 second)

For more advanced results, remove the flash from your camera. Canon makes an E-TTL, off-camera shoe cord that attaches between the camera hot shoe and flash. This gives you the flexibility to move the flash around and create customized lighting. You can also use one or multiple flashes off-camera with Canon's wireless system, which allows you to fire multiple flashes at once. However, before you start using multiple flashes, make sure that you know how to use one flash well.

The Color of Light

Whether you use warm, cool, or unnatural-looking colors in your photography depends on the mood and style you are trying to create. The color of the light is measured by its *Kelvin temperature*. For example, white light is measured as 5500K. Light with a temperature below 5,500 degrees displaying reds, oranges, and yellows is considered warmer, even though its temperature in degrees Kelvin is lower. Light with a temperature above 5,500 degrees that displays more blue tones is considered cooler, but it is actually hotter based on degrees Kelvin.

> **NOTE** The color of the light alters the appearance of the objects in the scene.

Photographers use the adjustments in their cameras, as well as external gels, to change the color of the light source. Some changes are modest and others are more dramatic. Many of the new artificial lights, such as LEDs and modern white fluorescents, offer daytime light or neutral colors, while others, such as older-style fluorescents, display unpleasant green casts. Older tungsten light bulbs give a distinctive yellow cast.

> **TIP** You can mix different types of artificial light, such as LED, tungsten, fluorescent, or neon to create colorful images.

Images don't have to be neutral or balanced to white light. Photographers have the following choices:

▶ **Warm light.** The early-morning and late-day sun produce reds, oranges, and yellows, providing the opportunity to create beautiful and inviting images. This light is excellent for landscapes and outdoor portraits. Near cities and high-pollution areas, sunsets tend to be warmer than sunrises. This is because the particles from daytime pollution increase the amount of scattered light.

▶ **Cool light.** Cool colors have a blue tint to them, representing cold or winter weather. Dark or sad moods are also connected with cool lighting. Winter is a good time to capture cool light landscapes. Snow reflects the blue sky, increasing the visual feeling of cold weather.

Combining warm with cool lighting can create a dramatic effect. A warm foreground with a cool background is a creative option. Lighting one side of a subject with warm light and the opposite side with cool can create an interesting contrast.

White balance options

The term *white balance* means correcting available light so that it creates natural or white light. White or natural light is not always available, so the existing light needs to be corrected to give the scene a more natural look. Even the sun changes color temperature throughout the day. To adjust for the changes in light or different color light sources, your Canon T4i/650D has seven white balancing options beyond the Auto white balance (⬛). If one of the seven settings doesn't satisfy your needs, you can set your own white balance, which is helpful in mixed-light situations. White balance saves time when color-correcting your images on the computer.

CROSS REF Use the white square on the color chart in Appendix C to adjust white balance under the actual light source.

Like exposure bracketing, which is explained in Chapter 5, your camera has a White Balance Auto Bracketing mode (⬛) that takes three consecutive shots, adjusting between blue and amber, or magenta and green. This gives you white balance options while you are editing your photographs. As with exposure, white balance adjustments can be made later without degrading image quality if you photograph in the RAW setting (⬛).

CROSS REF For a full list of the available white balance settings on your Canon T4i/650D, see Chapter 3.

Using Picture Styles

Picture Styles are a convenient way to photograph scenes or subjects based on preset or custom settings. These settings are like the past practice of selecting different types of film. Each style adjusts the color, saturation, contrast, and sharpness commonly preferred in such images. For example, you may want softer images with higher color saturations for portraits instead of what you get in standard shooting modes. The Portrait Picture Style setting (⬛) is a preset that provides just that.

CROSS REF The Canon Rebel T4i/650D has eight preset Picture Styles (⬛) from which you can choose. The full list is available in Chapter 3.

Canon also offers a Picture Style Editor on the DVD that comes with your camera. Designed for advanced users, this method is more precise than using the LCD screen to create custom Picture Style adjustments. To do this, open a RAW image in the Picture Style Editor. Apply a Picture Style to the image, and then make adjustments with the multiple color adjustment options. Once you have made your custom changes using the editor, save your changes as a Picture Style file (.PF2). Use the EOS utility program (also found on the Canon DVD) to register the file in the camera so you can apply it to future photographs.

NOTE To upload a PF2 file to your camera, it must be connected to your computer via a USB cable.

Ambience Effects

When photographing in the automatic modes, you can set Ambience Effects to enhance your images. These are similar to Picture Styles for automatic settings. If you want to enhance your images, select from the following effects:

▶ **Standard.** The camera makes no adjustments to your photograph.

▶ **Vivid.** Adds color saturation, and increases contrast and sharpness.

▶ **Soft.** Decreases the sharpness for a soft-focus look.

▶ **Warm.** Adds warm tones, such as reds and oranges, and softens the image.

▶ **Intense.** Increases color saturation and contrast beyond the Vivid setting.

▶ **Cool.** Adds cool blue tones to your image.

▶ **Brighter.** Lightens the photograph.

▶ **Darker.** Darkens the photograph.

▶ **Monochrome.** Creates black-and-white photos with color tint options similar to Picture Styles.

Choosing a color space

A common dilemma among photographers is deciding which color space to use. The available options—Adobe RGB or sRGB—are found under Shooting menu 2 (◘). Adobe RGB is the standard choice for photographers who regularly print their images. This is because Adobe RGB has a larger color gamut (that is, more colors to work with). As more images are shared on the Internet, many photographers have switched to sRGB because it displays colors better for e-mail and web use.

Color Calibration

When you view your photograph on the LCD screen on your camera, it looks different from your computer's display. This is because different manufacturers and styles of screens use different technologies. Plus, all screens shift color over time. When you e-mail your photos, or post them to a website or social media platform, each viewer sees it (at least slightly) differently. Even the lighting in the room in which they are sitting affects the way people view images.

This is why it is important to calibrate your computer monitor with a color management system or CMS. A CMS helps your monitor display the best possible colors. The goal is the keep the color as consistent and true as possible between all of your devices (camera, monitor, printer, and so on). There are various brands and price ranges. If you are looking for the most accurate color, a good CMS is worth the investment.

Measuring Light

What is a correct exposure? The answer depends on your goal for the photograph. Consider which part of your subject or scene you want to see or highlight. The direction of the light and how much of it is illuminating your main subject help determine what metering mode you use.

When you press your shutter button halfway, the camera measures four distinct elements to calculate the proper exposure of a scene: The intensity of the light (source), the size of the opening allowing light in to the camera (aperture), how long the camera lets light in (shutter), and the light sensitivity of the material capturing the image (ISO). With dSLRs, photographers have a large latitude of digital sensitivity settings.

Choosing the proper exposure

The first step is to look at the highlight and shadow detail of your image. Everything has detail, and it is important to show as much as possible in a properly exposed photograph. *Highlight detail* is found in the light or white areas of your photograph. If your subject is wearing a white shirt, you should be able to see the fabric details. If there is no texture in the whites, the detail is considered *blown out.*

Shadow detail is the fine points found in the shadows or blacks. If your subject is wearing a black shirt, the detail in the shirt should be visible. You also want your photographs to have a nice balance of contrast. Too much contrast leaves your photos with little or no highlight and shadow detail. Low contrast leaves your images flat and lifeless. Often in high-contrast scenes, it is difficult to successfully capture the entire highlight and shadow detail. In this case, the photographer must decide which of the details is more important.

CROSS REF The Canon T4i/650D offers multiple exposure mode options. A full list and explanations are found in Chapter 3.

When evaluating your exposure, consider the histogram—an often feared and misunderstood, yet valuable tool for the digital photographer. The *histogram* is a graph that charts the brightness levels in an image from darks to lights, in a range from 0 to 255. In the center is medium gray. The darker areas are on the left and the lighter on the right, as shown in Figure 6.13.

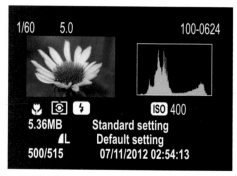

6.13 The histogram in this image shows some overexposed highlights from the sky.

A brightness histogram gives you a sense of the distribution of the lights and darks in your image. Generally, a good histogram spreads across the entire screen, but this is not always the case. If you photograph a white cat in the snow, chances are the histogram will not break anywhere near the left side. It is worth noting that if your histogram bumps up to the edge of the graph with a lot of pixels, you may be losing some important shadow or highlight detail. If your histogram is bunched up in the middle of the graph, you may find you have a rather flat image.

TIP To view your image's histogram, press the Playback button (▶), select the image you want to view, and then press the Info button (**INFO.**) to display it.

A color or RGB histogram displays how the brightness levels of all three colors (Red, Green, and Blue) are distributed in the image. Colors on the left side of the graph are more prominent than the brighter or least intense colors on the right. If a color is bumping up against the left side of the graph, it may be oversaturated and not

displaying much detail. If the color histogram channel is bumping against the right side, it may be completely lacking in the scene. Ultimately, a histogram is a guide, not a pattern you must obey.

6

Metering modes

Your camera has four metering modes from which you can choose. Each mode calculates the scene exposure using different parts of the camera's frame.

Evaluative metering mode

This is Canons all-purpose metering system. The camera divides the viewfinder into zones to work from when calculating the proper exposure of a scene. In the Evaluative metering mode (⊡), the camera software selects multiple points and applies different weight to any of the active nine focus points seen through the viewfinder. The Evaluative metering mode (⊡) is the default metering system for the camera's automatic modes. It is also a good default setting to leave your camera in for everyday photography.

Center-weighted metering mode

The Center-weighted metering mode (⊏⊐) averages the light in the entire frame, but assumes that the subject is in the center, giving more weight to those points of exposure. The advantage of this metering system is that it is not overly influenced by bright edges or spots of light within the scene. It is the default setting for many photographers because the exposure is more predictable than the Evaluative metering mode (⊡), which uses complex calculations to determine the best exposure. As long as the subject is in the center, this is a good standard exposure setting.

Spot metering mode

The Spot metering mode (⊡) focuses on approximately 5 percent of the frame to calculate the best exposure. A circle in the middle of the viewfinder represents it, as shown in Figure 6.14. If you need a precise meter measurement, this setting gives you more control over the exposure. You can also use this mode if you need the best exposure for only part of a scene. This setting is helpful when there is a lot of light behind your subject or if it is in the shade.

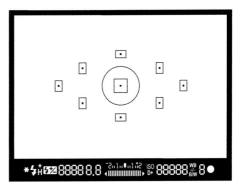

6.14 The circle in the middle of the frame represents the Spot meter's coverage.

If you set your camera to the Spot metering mode (⊡) and point it at bright light behind your subject, you create a silhouette. If you don't want to create a silhouette, use the Spot metering mode (⊡) and focus on your subject. The spot meter calculates the proper exposure based on approximately 5 percent of the frame pointed at your subject.

If you are concerned about your exposure, consider using Auto Exposure Bracketing (⧉), which is explained in Chapter 3. This feature takes three consecutive images at different exposures. This gives you a choice of exposures when you are ready to edit or print your images. Another recommendation is to photograph using the RAW setting (RAW). This allows you to readjust your exposure while editing your images.

Partial metering mode

The Partial metering mode (⊙) is similar to the Spot metering mode (⊡), except that it takes into account double the area of the center of the frame when calculating the proper exposure. This mode is good for exposing small or distant objects.

The Canon Flash System

The Canon flash system consists of multiple flash models, called speedlites, which are available for the Canon Rebel T4i/650D. The Speedlite 270EX II is a compact flash that is a step above your camera's pop-up flash. The 270EX II is fine for casual use when photographing subjects within a range of less than 12 feet. It is also a good choice for use as a trigger flash for multiple-flash photography, which is covered later in this chapter. The Speedlite 430EX II is a good all-purpose flash with a swivel head and enough power to cover most of your needs. If you need a durable, high-performance flash, the Speedlite 600EX-RT is a good choice. The 600EX-RT is a wireless, multiple-flash system that uses radio wave communication for up to five groups of flashes.

Image courtesy of Canon

6.15 The Canon 270EX II and 600EX-RT Speedlites.

The pop-up flash

The pop-up or built-in flash, shown in Figure 6.16, is on top of your camera. It is good for casual photography of subjects that are within a 15-foot range. Make sure that you are not using a lens hood because it may obstruct the flash and create unwanted shadows. If you are serious about flash photography, I recommend that you consider purchasing an external flash. You will have more flexibility, features, and power with most external flashes, especially Canon Speedlites.

Image courtesy of Canon

6.16 The Canon Rebel T4i/650D pop-up flash ready to fire.

To turn on the built-in flash, press the pop-up flash button (**⁴**) on the front of the camera to the left of the flash. You must press this button to turn on the flash in the Program AE (**P**), Shutter-priority AE (**Tv**), Aperture-priority AE (**Av**), Manual (**M**), and Bulb (**B**) exposure modes. In the automatic exposure modes, such as Sports (**⚡**) and Landscape (**▲**), the camera automatically pops up the flash when required.

While the flash is charging or recycling, a Busy (**buSY**) icon is displayed in the viewfinder. When the flash is ready, the icon (**⁴**) is displayed in the bottom left of the viewfinder. Your pop-up flash has a convenient Red-Eye Reduction mode. To enable this option, go into Shooting menu 1 (**⊡**), select Red-eye reduc., and then select Enable. Red-Eye Reduction works in every mode, except Flash off (**⚡**), Landscape (**▲**), Sports (**⚡**), and Movie (**'🎥**).

> **NOTE** The Red-Eye Reduction mode is not foolproof. It works better when there is more light in the environment.

The pop-up flash also works with the camera's self-timer, which is helpful when shooting family pictures. Your camera has two options for this: Self-timer 2 seconds (**⟳2**) and Self-timer 10 seconds (**⟳10**). You can also select up to 10 additional continuous shots so that you don't have to keep running back and forth to the camera.

Using an external flash

On top of your camera is a hot shoe for external flashes. This is where you can attach a Canon speedlite flash directly to the camera. You may also use an off-camera shoe cord and hold the flash in your hand, or attach it to a bracket. Just because external speedlites are larger and more powerful does not mean that they are more difficult to use. The Canon Speedlite's E-TTL II technology makes it easy for the flash to talk to the camera. As a result, well-exposed flash photographs are as easy as attaching the flash to the camera hot shoe, turning on the flash, and pressing the shutter button.

An external flash is generally optimal for subjects in the range of 8 to 50 feet away, depending on the flash model and ISO setting. Bouncing your flash limits the maximum range. Some flashes can reach more than 150 feet, but the intensity of the flash diminishes the farther your subject is from the camera.

All Canon Speedlites, including the T4i/650D pop-up flash, have a Flash Exposure Lock button (✦*). If you focus on your subject and press the Flash Exposure Lock (✦*) button, the flash discharges to calculate the proper exposure, and then stores it in memory. Press the AE lock button (✱) and recompose your image. Once your photograph is composed and you press the shutter button all of the way, the flash-locking system uses the flash exposure settings stored in memory.

> **NOTE** The Flash Exposure Lock doesn't work in the Live View shooting mode (▣).

When you don't agree with results of your flash photography, consider using Flash Exposure Compensation (FEC). You can quickly access it by press the Quick Control/ Print button (▣) on the back of your camera.

> **NOTE** You can set Flash Exposure Compensation directly on your speedlite, but remember, it will override any flash setting on your camera.

Flash Exposure Compensation is commonly used in fill-flash situations when the subject is in front of a bright light source, such as the sun or a window. More advanced photographers use Flash Exposure Compensation with exposure compensation. Flash Exposure Compensation is used to control the flash exposure and exposure compensation is used to adjust the ambient light. It's like adjusting two exposures in one photograph. If you are using the flash on your camera, I recommend purchasing a bounce reflector, a softbox, or a filter designed to soften its light.

Using multiple flashes

Removing the flash from your camera is a great way to quickly improve the quality of your photography. Whether you use one or multiple flashes, you can spend a lifetime learning new skills related to off-camera flash photography.

The Canon flash system includes a remote system that allows the use of multiple flashes at one time. There are many ways you can approach using multiple flashes. You can use your camera's external or pop-up flash to trigger external Canon speedlite flashes in slave mode. Another excellent option is to use Canon's speedlite radio transmitter to trigger up to 15 individual flashes at one time. Radio transmitters have an advantage over optical triggers. Optical triggers depend on light from other flashes to be triggered, whereas radio transmitters are not affected by the direction of another flash or obstructions between multiple flashes.

You should always have one main light source. When using multiple light sources, consider assigning one of your flashes as the main light at a higher power level. The rest of the flashes can then be used as support lights. How you approach multiple light sources depends on your photographic goals.

6

Shooting Photos

Your camera has wonderful features, and it is important that you understand how they work. Camera modes, such as Shutter–priority AE (**Tv**) and Aperture–priority AE (**Av**), give you flexibility and control over your photos. Automatic modes, such as Portrait (**𝕯**), give you options without the worry. This chapter examines some of the recommended equipment, best practices, and tips to improve your photography.

The principles of photography in this chapter are intended to help you take better photographs. Even better, some of the advice is given by photographers from different disciplines and backgrounds, all of whom offer great insight on improving your photography.

There are settings on your camera that are ideal for specific types of photography, like wildlife.

Portrait Photography

Have you ever wondered how photographers create such beautiful portraits of people and places? This section answers many questions about the mechanics and art of portrait photography. A good way to start is by asking yourself how your picture will be used. Are you capturing family memories or creating something for professional use? There are many reasons why people want a portrait. Images of friends and family always seem to be in demand on social media platforms. You never know which moments you capture will become a treasured family memory. Start by thinking about where the photograph will end up, and then develop a plan before you click the shutter button.

7.1 This portrait was taken outside my studio. (200mm lens, ISO 200, f/2.8, 1/320 second)

A portrait is usually taken in a controlled environment, such as a photographer's studio or portable studio on location. An *environmental portrait* is a photograph taken of a person in his environment or outside the studio. The idea behind this type of portrait is to use the subject's surroundings to tell his story. They are common in photojournalism and documentary photography. The difference between an environmental portrait and a candid photograph is that the subject is unaware of the camera in a candid photograph, whether she is looking into the lens or not.

Equipment

Most studio portrait photographers use a 70mm to 135mm lens because it doesn't distort the subject, and is not too big or intimidating. Consider purchasing backgrounds for your studio portraits—they add a more formal look to your pictures. Often, candid photographs are created using a longer lens so the photographer can stay out of the subject's personal space. In most cases, environmental photographers use a wide-angle lens, such as 24mm, to capture the environment behind the subject. However, any lens works as long as the photograph shows the environment and helps to tell the subject's story.

Lighting is an important part of creating a portrait. Most portrait photographers prefer to use a soft light to minimize the harshness of shadows. A softbox, umbrella, or using a soft filter on the flash is highly recommended. When photographing groups, a soft light is even more important because it minimizes harsh shadows created when people stand close together. Consider using window light for your portraits—the soft light or warm glow of a sunset through a window adds a nice dimension to your pictures. If one side of your subject's face is too dark, use a reflector, white board, or bounce a flash off of the opposite wall to add fill light.

The *self-portrait* is a popular form of photography. If you don't have a wide enough lens (or long enough arms), I recommend using a tripod along with your camera's self-timer to take a portrait. One nice feature of the continuous self-timer option is that you can take multiple images without having to run back and forth to your camera to reset it. If you hand-hold your camera, an ultrawide-angle lens is helpful. Use the Live View mode (⬛) and turn the LCD screen to face the same direction as your lens so that you can see what is in the frame.

7.2 I took this shot of my wife and me holding the camera at arm's length. (12-24mm lens, ISO 1600, f/4.0, 1/25 second)

It's a good idea to carry tools in your bag to make the portrait experience more pleasant for your subjects. Consider including a mirror for your subjects to check hair and makeup, clips to hold back loose clothing, and little odds and ends that might grab a child's attention. Often, these extras can make the difference between an average shot and a great portrait. Another idea is to create a booklet of sample poses from which your subject can choose; this also breaks the ice for nervous subjects.

Best practices

Most formal portraits are photographed with a long lens (over 70mm) while holding the camera vertically. However, this does not mean that all portraits *must* be shot vertically—horizontal studio portraits are interesting, too. Studio portraits are usually best when photographed using a shallow depth of field, as shown in Figure 7.3. Use the lowest aperture number possible on your lens (the optimal setting is f/2.8). The Portrait mode (❦) on your camera does this automatically.

> **TIP** When using a shallow depth of field for portraits, pay close attention to your focus, especially around the subject's eyes.

Environmental portraits tend to be horizontal, wide-angle photos. Sometimes, the best choice is to use a longer lens (70mm or more) vertically, as was done for Figure 7.4. The objective of environmental portraiture is to see the subject's environment, so creating a large depth of field by using a large aperture number (which is a smaller opening), such as f/16, is recommended.

7.3 Portraits are normally best when shot with a shallow depth of field. (100mm lens, ISO 200, f/2.8, 1/160 second)

7.4 This environmental portrait was created using a 70-200mm lens at a focal length of 120mm. (ISO 1000, f/2.8, 1/250 second)

When photographing a group, make sure that their heads are not aligned. It's better to stagger people so that they are at different heights. It is also important to make sure that all of your subjects are in focus. Make sure that you have enough depth of field by using an aperture of at least f/5.6. After you take a group shot, double check it by pressing the Playback button (▶), and then zooming in on each individual to make sure everyone is in focus. You can zoom in by pressing the Magnify button (🔍), or by spreading your index finger and thumb across the LCD touch screen.

No matter which portrait style you choose, your main goal is to keep your subject's eyes in focus. If the eyes are not in focus, it is hard for the viewer to relate to the person in the photograph. This can be tough when using a shallow depth of field, especially at apertures of f/2.8 or lower. Take the time to review a few of your portraits to make sure you are on target. Press the Playback button (▶) and you see an instant preview of your last image. Also, keep your subject away from walls. Depending on the lens and depth of field you are using, you may capture distracting details on a wall behind your subject. Pulling people away from the wall allows the shallow depth of field to do its job and blur any distracting elements in the background. Walls are not all bad, but only use them as a backdrop if you think it will enhance the photograph.

Try different compositional techniques, such as the Rule of Thirds and new perspectives. Not every portrait needs to be shot at eye level. Take advantage of your camera's Live View shooting mode (📷), hold the camera higher or lower, and use different lenses. Look for objects that compete with your subject, and if you see distracting elements, try a new angle. Make sure that the background is free of poles and other intrusive objects that might appear to be coming out of your subject's head or body.

Candid photos are taken when the subject is unaware or ignoring the camera. Many photographers do not consider these portraits, but they do capture a moment in time that often tells a story. Candids take patience and a little stealth, though. Wait for peak moments when people are laughing or smiling, and be ready to click the shutter button at any moment. When photographing children, be sure to get down on their level. Pointing the camera down at them does not effectively capture their vantage point. Interact with them by offering a toy and playing for a few minutes. If you just let kids be kids, you'll capture some memorable photographs.

You rarely get the best photo on the first shot (although, it can happen), so take a lot of photos. A slight movement, smile, or shift of the eye can change the entire mood of an image, turning a nice shot into a great portrait. The more photos you take, the greater your chance of capturing the right moment.

Tips

Use your camera in the Live View mode () to allow interaction between you and your subject while you shoot. People come in all shapes, sizes, and colors, and knowing how to approach a subject makes for a better photograph. For example, people with long noses should be photographed straight on to minimize the size, rather than allowing the nose to distract from other facial features. Ask older people to look up at you to smooth out any wrinkles in their necks and faces. Underexpose photos of people with darker skin by 1 stop so you can see the details in their face better.

It's not unusual for portrait subjects to stiffen up when the camera is pointed their way. Remember to have fun—portraits don't have to be such serious business. I'm not a very good joke teller, but I try to relate to my subjects in any way

7.5 Use the LCD screen in the Live View shooting mode to check your composition. When shooting portraits, this also allows you to interact with your subject.

that I can to make them feel comfortable and get them to smile. Sometimes, subjects may think they are smiling when they are not. Show them a few of your photographs so that they can make adjustments and understand what you are doing. A trick I learned a long time ago from an opera singer was to ask your subjects to look down and count to three. On three, ask them to look up with a big smile. Another idea is to ask your subjects to pretend that they just ran into an old friend they haven't seen in years.

Try different backdrops or locations behind your subject. Sometimes, just turning the other direction makes a big difference. It's amazing how different objects in the

background can improve your pho-
tograph. Always look for light, col-
ors, or interesting textures that
you can use as part of your com-
position. Don't be afraid to use
props in your images. Include
things the subject is known for—
such as a teddy bear if you're pho-
tographing a child. Have someone
hold a photograph of a grandpar-
ent at a younger age, or pose him
with his favorite piece of sporting
equipment. Let the props help tell
the story.

You can also use the Monochrome
Picture Style () on your camera
to create black-and-white portraits.
In some cases, you might want to
wait until postproduction to change
your photos to black and white.
This is especially true if you are
shooting JPEG files because you
cannot later convert them back to
color. If you generally don't do a lot
of post-processing, take a few
color and black and white shots
for variety. Try using the Portrait
mode (🎭) and see if it enhances

**7.6 Use the Monochrome Picture Style to
create black-and-white portraits. This portrait
was taken using a hot light so I could observe
the shadows as the subject moved. (100mm
lens, ISO 1600, f/2.8, 1/250 second)**

your photos to your satisfaction. If you don't like the results of the preset modes in your
camera, you can create up to three of your own Picture Styles.

Regardless of whether photography is your hobby or career, it is always good to remem-
ber that interesting subjects make the most interesting photos. This may seem obvious,
but it is a fact that is often overlooked. Look for interesting (not just beautiful) people to
photograph—people with character in their faces, or interesting clothing, hairstyles, and
body art.

Try photographing parts of the body, such as the hands or legs, as part of an environmental portrait. The face does not have to be in every shot, especially if the photo is one in a series of images. Creating a series can be a lot of fun. It can be composed of the subject in different poses, making faces, or in different environments. Usually a series is grouped in odd numbers such as three, five, or seven photographs. Use your imagination; you will be surprised at the interesting combinations you come up with.

7.7 Here, part of a subject's body is used to display food. (100mm lens, ISO 200, f/3.2, 1/250 second)

If you want to create a softer, cleaner look, experiment with overexposing your portraits. It's not right for every subject, but a quick test never hurts. Try playing with movement. Sometimes, blurring your subject in the foreground adds interest. This technique doesn't work well for formal portraits, but it's a nice addition to a series. Another idea is to ask your subject to stand still, and then use a slow shutter speed to show the motion of people or traffic in the background. You should also always keep model release forms on hand. You never know how you might want to use your photographs in the future. If you have signed model releases for all of your portraits, you won't have anything to worry about.

Don Giannatti's Tips for Photographing People

▶ **Respect your subject.** Images taken with disrespect have a terrible feeling about them. The people who stand before your camera need to know that you are on their side.

▶ **Choose lenses wisely.** Long lenses isolate, while short lenses include. Selecting a lens creates the image before you even look through the view-finder. Ask yourself whether isolating or including the surroundings in your photograph will better serve the image.

▶ **Put people at ease.** I used to hate having my photograph taken. To overcome this, I spent a year letting any and all who wanted to photograph me have at it. I was silly, serious, melancholy, and spirited. I took what I learned and put it to use behind the camera. Putting the subject at ease may also require putting yourself at ease.

▶ **Prepare and shoot with the end in mind.** Can you see the finished image before you start shooting? Try to. By visualizing the final image—catching and holding it in your mind's eye—you can see what needs to be done on the creative and production end to make it a realization. It takes practice, but it's worth it.

▶ **Work with subjects who want to collaborate.** When you find those subjects, nurture them and create lots of photos together.

Don Giannatti (www.dongiannattiphotography.com) is a photographer, designer, writer, and educator. He lives in Phoenix with his wife, three kids, two dogs, and a tortoise. You can read his blog at: www.lighting-essentials.com.

Shooting Action and Sports

Sports and action photos take a lot of practice. Patience and timing are two themes you hear a lot when it comes to capturing the right moment. Your goal with this type of photography is to capture the action at the *peak moment*, also known as the *decisive moment*. This is not easy to do and takes a lot of frames to get right.

7.8 The water from the goggles is frozen in the air due to the fast shutter speed. (100mm lens, ISO 800, f/2.8, 1/1000 second)

Equipment

Most sports photographers use a long, fast (f/2.8 is ideal) lens to photograph their subjects. Setting the camera at a higher ISO, such as 800 or 1600, helps get the shutter speed as high as possible. Your Canon T4i/650D has a Sports mode (✦) designed to photograph fast action.

Photographers at professional sporting events can create stunning and clear images because the buildings and locations they work in usually have bright lights for television. In some cases, they even have flashes mounted in the ceiling. I'm not suggesting that this is the only reason they capture such great images, but it is an advantage most people don't have at the local school gymnasium. Local gyms tend to have low light, requiring high ISO settings and fast lenses. Fortunately, your camera has an ISO range to help keep your shutter speed as high as possible with an f/2.8 lens.

If you are in the middle of the action and a full tripod is not practical to prevent camera shake, use a monopod (which is like a tripod, but only has one leg) to stabilize your camera. Image Stabilization (IS) lenses are also helpful when photographing action because the lens can effectively add 1 to 4 stops of shutter speed to help freeze the players.

7.9 The Canon 70-200mm f/2.8 is a good all-around sports lens.

You are going to take a lot of photographs if you're shooting action, so I recommend that you shoot in the JPEG format rather than RAW. The RAW format is nice for making corrections later, but they quickly fill up your camera's buffer. The last thing you need is your camera to stop shooting during peak action because it is processing your images. Your camera shoots 5 frames per second, which is helpful, but it does not replace good timing on your part. Don't depend on the fast frame advance to capture the action. I recommend that you use your instincts and press the shutter button at the peak moment. Leave your finger on the shutter button to continue shooting and capture the rest of the action.

Best practices

If you want stop action, you have to get your shutter speed over 1/500 second. In some cases, if the subject is moving toward or away from you, a lower shutter speed does the trick. If the action is moving from side to side, the higher your shutter speed is, the better. Keep your camera in the AI Servo focusing mode (**AI SERVO**) to follow-focus your subject so that when you are ready to press the shutter button, the camera is already focused.

Be prepared—great action shots can happen at any moment. Don't put your camera down, even if you think the play or action is complete. Watch for emotions and accidents, which often happen before and after a play. If you are on the slopes, follow the action as the skier or snowboarder does his tricks. Follow him until you see the reaction or emotion on his face after a successful run. One thing you learn over time

when shooting action is how to compose quickly. Just because something happens fast, that's no excuse for lack of composition or backgrounds that play off your subject.

Go where the players are or be patient for the action to come to you. Photos taken from across a field (unless you have a very large, expensive lens) are useless. This is especially true when shooting football, soccer, or any game played on a large field. If you have to photograph subjects from farther away, shoot horizontally and, when they get close, switch to vertical. Try to fill the frame with the action. When shooting sports, it is important to capture the faces of the players and the ball, if possible. The backs of heads and players running away from the camera rarely make for successful sports images.

7.10 This image was caught at the peak moment using a focal length of 190mm. (ISO 400, f/4.5, 1/1000 second)

Once you know that you have some good shots, try different techniques, such as *panning* or *ghosting*. Panning is using a slower shutter speed and following the subject. Ghosting is a similar process, except it's done while using a flash. In the resulting image, the subject is in focus and the background is blurred. This is a good technique when shooting cars, bikes, or other moving objects. If you know where the action ends (such as at a finish line or home plate), I recommend that you pre-focus and prepare for the runner or player to appear in the frame.

CROSS REF See Chapter 5 for more information about panning and ghosting.

Try to tell the story of the game through your images. The action may be on the field, slope, or raceway, but coaches, teammates, and fans are all part of it, too, and make great photographic subjects. Use your imagination and try to shoot images

you've never seen before. Don't be intimidated by photographers who have larger lenses. Remember, the size of a lens doesn't automatically mean its owner is a good photographer. Learn how to use the equipment you do have to the best of your ability.

Usually, a little post-processing is required for action and sports photographs. Some images may need sharpening, lightening, darkening, or color correction. The biggest alteration that might be necessary in postproduction is cropping images to better fill the frame with the action.

Tips

If you are going to be photographing a sport, learn about it. This includes Little League, school teams, and pick-up games. Sometimes the rules are adjusted at different levels, and knowing what to expect helps ease the

7.11 For this shot, I pre-focused on the hoop to capture the ball going through it. (15mm fisheye lens, ISO 1600, f/2.8, 1/4000 second)

learning curve. By understanding what should happen next, you can anticipate photo opportunities. Always keep extra memory cards and batteries with you. When you notice that your memory card is getting full, pull it during a break in the action before it gets full. This way, you won't run out of space at a peak moment.

Keep business cards with you. Even if you are photographing family and friends at a local ball field, people often ask for copies. Have a plan in place about how you will handle that request. You should also be prepared for all types of weather. Make sure that you have a way to protect your valuable equipment in case it rains or snows. Also, be prepared for the action to come a little too close. Through my years of photographing sports, balls have hit me, hockey pucks flying at dizzying speeds have just missed my head, and I have been run over by large players. Always be aware of what is going on around you.

Sports Photography Tips From a Pro

The following are longtime professional sports photographer Dan Lippitt's tips for successfully shooting a sporting event:

▶ **Capture peak action.** This is your number one goal. Peak action can be a ball connecting with a bat, a player getting his shot blocked, or a swimmer coming out of the water. You want to capture a moment at its apex.

▶ **Reaction is often better than action.** Remember to keep your camera up after the play and be aware of the game situation.

▶ **Watch for the *off* moments.** There are many interesting photographs to be made during a sporting event that have nothing to do with the game action.

▶ **You don't need a long lens.** A wide-angle lens can shoot interesting action angles or tell a story. Shooting wide can also give the photo context.

▶ **Explore different angles.** Shooting the same type of event from all of the same spots is not only uncreative—it's boring. Change your perspective and the way you see the game.

Dan Lippitt is an award-winning corporate, sports, editorial, and fashion photographer based in Detroit. To view his work, visit his website at: www.danlippitt photo.com/.

Capturing Events

One of the most common forms of photography is event photography. Once people find out that you have a good camera and like to take photos, you'll probably find yourself shooting events. When shooting an event, it's important to plan ahead and set expectations. Let people know what you are going to do, including how many photographs you plan to take, how long you are going to photograph, and where you plan to share the photos. Make sure that you understand what the event is about, know who the key players are, and if there are any special requirements regarding photography (such as no flash allowed).

Equipment

Using a zoom lens is a good idea for events because you might be asked to photograph a group one moment and an intimate exchange the next. A zoom lens helps you adjust quickly. Keep a flash handy to illuminate subjects in a dark room and use as fill flash when you have to photograph in front of bright windows.

> **TIP** If you plan to shoot video at an event, make sure that you have a tripod and an external microphone with you. This will keep your camera steady and the sound will be high quality. For more information about shooting video, see Chapter 8.

Make sure that you have extras of everything, including batteries and memory cards. An event is generally not something that can be re-created. If any piece of your equipment breaks or runs out of power, it is important to have a backup.

Best practices

When photographing an event, I use what I call the triangle method of photographing. The idea is to create a variety of images, rather than shooting the same style or composition over and over again. The triangle method forces you to think about and take a variety of shots. Begin with a wide shot to set the scene. Next, shoot medium-distance shots that help tell the story. Try to capture images featuring one to three people, either posed or candid. Finally, take some close-up shots that highlight details. For example, photograph the food, the floral centerpiece, or details on the cake. Look for decorations on the wall, signs, or focus on someone's hands holding a glass of wine, as shown in Figure 7.12. Challenge yourself to take a variety of images using different angles, lighting methods, and compositions. Employ the same three-part method of wide, medium, and close-up shots. When you are done, you will have a great collection of images that tell a story.

7.12 Use detailed shots to capture the spirit of an event. (50mm lens, ISO 800, f/1.8, 1/80 second)

Avoid using flash whenever you can so it is not flashing in people's eyes while they are having a good time. If you must use one, consider using a flash filter to soften the light. A slower shutter speed also helps capture the ambient light in the room. Ambient light adds depth to an image and prevents the room from looking like a black curtain behind your subject. If you don't use a flash, chances are that you will get better candid shots that include emotion and laughter. The best compliment an event photographer can receive is that people didn't even know she was there.

Tips

Keep your flash off of your camera to avoid red eye. Use a cord to hold your flash off-camera or a bracket in a fixed position for convenience. Try not to interrupt people by asking them to pose for photos. If you need to get a group shot, try to capture a few good candids first beforehand. Using your camera's Live View shooting mode (📷), hold the camera up high to capture crowd shots and new angles.

7.13 This detail shot was captured using the triangle method. (50mm lens, ISO 100, f/1.8, 1/200 second)

When photographing an event at which someone is speaking, make sure that you photograph the speaker before and after he leaves the podium. Many of the best photographs in those situations are captured before someone starts speaking. Pay attention to the speaker's hand movements and try to capture any interesting gestures. Look away from the podium occasionally—there are often great subjects to capture in the audience.

Avoid photographing people during a meal. It may seem like a good idea at the time, but people don't look very good when they are eating, and if you ask them to stop, they generally are not very happy about it. This is especially true if you ask them to stand up and move around the table for a better shot. It is better to get group shots after everyone is done eating and away from the dirty plates.

7.14 Capturing moments that help tell the story is an important part of event photography. (ISO 400, f/3.5, 1/80 second)

Five Event Photography Tips

As a photojournalist and independent photographer, I've shot many events. The following five tips can help you capture any type of occasion:

▶ **Use the triangle method to capture a variety of images.** Shoot a wide overall shot to set the scene, medium-range shots to help tell the story, and close-ups to capture the details of an event.

▶ **Use a 135mm, f/2.8 lens to photograph candid shots.** It is light and long enough to get close without intruding on your subjects' space.

▶ **Tell a story.** Every event has one, and it's your job to tell it.

▶ **Occasionally look away from the podium or stage.** There is often action or interesting photo opportunities in the audience or among the guests.

▶ **Always carry back-up equipment and supplies, such as extra batteries and memory cards.**

Landscape and Nature Photography

Getting outside is what attracts many people to photography. Landscape, wildlife, and nature photography are some of the most enjoyable forms of photography. The adventure and anticipation of new discoveries and subjects you have never seen before is exciting. Having a camera in your hand gives your adventure a mission. We all want to come back with great images of our adventures, but what makes a photograph great is up to you. For some people, it is a breathtaking vista, while others search for elusive wildlife (see Figure 7.15) or rare flowers. Many photographers simply want to capture the memories of good times with friends in the great outdoors.

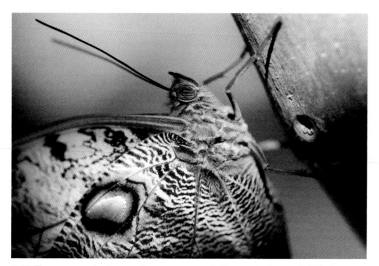

7.15 For some photographers, successfully capturing wildlife is what makes a great photograph. (100mm lens, ISO 800, f/4.0, 1/640 second)

Equipment

Landscape photographers use a wide lens to capture as much of the scene as possible. Wildlife photographers require a long lens to get close to animals that don't want to be anywhere near humans. Some forms of nature photography require all types of lenses. Macro lenses are common for photographing insects, plants, and rocks found in the field.

A strong and lightweight (carbon fiber) tripod is helpful, especially for keeping long and macro lenses steady in the field. I also prefer backpacks designed for camera equipment because it's easier to carry items in organized compartments. Make sure that

you are always prepared for changing weather—both extreme heat and cold can be dangerous. Don't forget to always carry back-up equipment, such as extra memory cards and batteries.

Best practices

Quality imagery is expected of outdoor photography. You want to use the best practices, such as lower ISO settings and photographing in the RAW format, to create the best photographs you possibly can. Lower ISO settings produce less noise in your images so you can enlarge them. Shooting in the RAW format allows you to make adjustments to your images in postproduction.

Most landscape photographs require a large depth of field so the viewer can see all of the details in the scene. Your wide-angle lens makes this easier, but a tripod is also helpful during the twilight hours because you must use a slower shutter speed as you are losing light. Remember the Rule of Thirds, and keep your horizon lines above or below the middle of the frame, depending on what you want to highlight in your scene (see Figure 7.16). The best landscape photographers understand that it's not always the land that makes the shot, but the weather. Keep an eye on the weather, especially clouds, and how they play off of the landscape and sunlight.

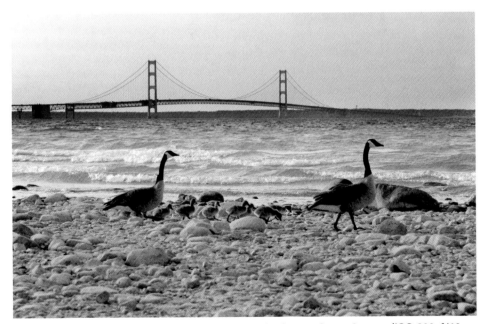

7.16 Where you situate the horizon determines the focus of your image. (ISO 800, f/10, 1/400 second)

When photographing landscapes, make sure that you have a *focal point* (where you want the viewer's eye to go) in your image. Use the fore- and background to balance each other. For example, you can balance the composition of a flower with a cloud. Look for interesting rocks to balance with the peak of a mountain off in the distance.

Look for patterns and lines. As covered previously, lines lead the eye into the distance or toward your main subject. Patterns add interest to a photograph, such as rows of corn or trees. The S-curve of a stream can lead the viewer's eye through a beautiful valley or to the base of a mountain. Look for contrasts in nature, and play the soft and beautiful off of the strong and hard.

Wildlife photography, like so many other types, takes patience. Just as it is with people, it's important to capture the eyes and faces of your subjects. Filling the frame can be hard, but it is required to be considered a successful image by many viewers. Always keep the focus on your subject—you never know when an animal might do something interesting. It is helpful to study the animals you expect to encounter ahead of time, but perseverance provides the biggest reward.

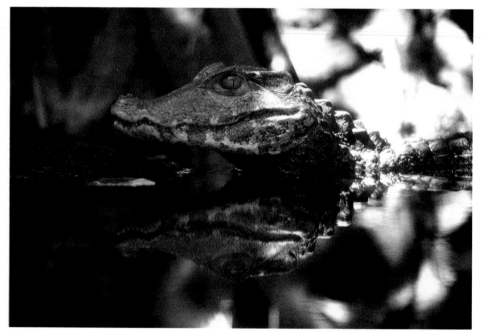

7.17 This intimidating subject was not photographed in the wild, but this is a good example of the power of eye contact in images. (100mm lens, ISO 1600, f/2.8, 1/400 second)

Try to keep your photographs simple—too much information can be overwhelming and hard for viewers to digest. Break your scene down into different photographic opportunities rather than trying to get everything in one shot. Nature photography also requires planning. For example, flowers bloom at different times of the year. If you are in a mountain region, the same flower may bloom at different times at various elevations.

For many, nature photography is a peaceful search for the small things you may never notice if you walk too fast. Others look for the grand scenes that nature has to offer. Whether you are looking for large or small subjects, good light improves the quality of them all. Plan to shoot around the golden hours of sunrise or sunset. These times of day add beautiful color and dramatic shadows to your images. In addition, just being outdoors and away from the city with your camera offers great rewards.

7

Tips

When photographing sunsets, look behind you. The clouds or landscape reflecting the fading light may be more dramatic than the sunset itself. You can practice your wildlife photography at a local zoo. You will gain patience as you realize that animals rarely do what you want them to do. When it comes to nature, you might be surprised at the number of interesting photographs you can find in your own backyard, especially with a macro lens.

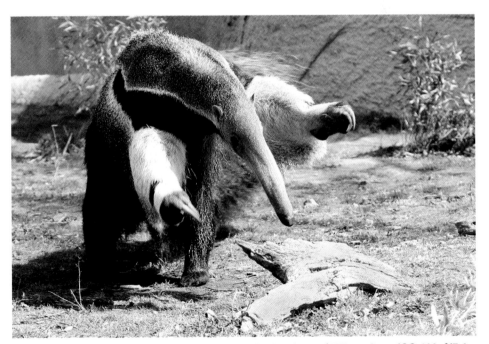

7.18 You can practice wildlife photography at the local zoo. (135mm lens, ISO 400, f/7.1, 1/320 second)

Jim Goldstein's Landscape Photography Tips

The following are landscape and wildlife photographer Jim Goldstein's tips for the outdoor photography beginner:

▶ **Capture an image with a sharp foreground and the rest will follow.** If you display something in the foreground in sharp focus, the elements in the mid- or background will lend themselves well to the scene as a whole (whether they are in sharp focus or not).

▶ **Make use of the golden hour.** The *golden hour* is the hour after sunrise and before sunset when the light is less intense and—fittingly—golden. These hours are coveted by photographers because the warm light enhances a variety of subjects, from landscapes and portraits, to cityscapes. The acute angle at which sunlight falls at this time creates dramatic, long shadows for higher-contrast imagery. Highlights are also less intensely lit compared to other times of day.

▶ **Harness the drama of changing weather.** The brief time between one weather system and the next is when most dramatic scenery reaches new heights of visual interest. Dramatic clouds, dappled light, and so on, all origi- nate from weather that you might think of as less than ideal.

▶ **Find a unique perspective.** This is a surefire way to wow your viewing audi- ence. You can achieve this in the following ways:

- **Walk around your subject (if it's safe and possible) to see if there is another angle that yields a better composition.**

- **Take advantage of different lenses to achieve varying optical effects.** For example, wide lenses often distort a scene, while long ones com- press a scene, and make near and far objects look very close together.

▶ **Use a tripod.** Tripods are a photographer's best friend. They provide a stable platform and ensure that you achieve a sharp image by minimizing movement. They're often seen as being intrusive and cumbersome, but they're a critical component of attaining great photos.

▶ **When in doubt, bracket your exposure.** If you're unsure about the best exposure for your photo, use your camera's bracketing function. This enables you to capture your subject at different settings. You can then choose the one that you like best.

Jim Goldstein is a full-time professional photographer based in San Francisco. He specializes in outdoor and nature photography. You can view Jim's work at: www.jmg-galleries.com.

Photographing the Stars

Viewing a clear, star-filled sky is a magical, mystical experience. However, photographing it takes patience, preparation, skill, and the right equipment. The following tips come from Michael Menefee, who has photographed the night sky for many years:

▶ **Prepare before you go into the field.** Download apps for your smart phone (www.google.com/mobile/skymap/) or computer (www.stellarium.org/). You can also consult cleardarksky.com to help predict the light pollution levels wherever you are within the United States. The Photographer's Ephemeris is a useful app for both smart phones and PCs. It provides the time for twilight, sunrise, and sunset, as well as moon phases, and more. The more information you have the better your experience and results will be.

▶ **Plan your outings during astronomical events.** Capturing a meteor shower or an eclipse adds interest to your images.

▶ **Make sure that you have the right equipment.** A strong flashlight (to illuminate foregrounds), a red light (to help preserve your night vision), fast lenses, a remote (for long exposures), and a tripod are just some of the items you should have with you to shoot the night sky.

▶ **Keep your camera on Manual focus.** Use the long exposure noise reduction (if you're not stacking images for star trails), keep exposures short (under 30 seconds) to capture stars as bright points of light, or long (a few minutes to hours) to show star trails caused by the rotation of the Earth.

In the image shown here, *Autumn at Pike's Peak Lunacy*, the sky was a 15-second exposure and the foreground was 30 seconds. The moon provided fill lighting. (58mm, ISO 1600, f/7.1)

Michael Menefee is a professional photographer and conservation scientist in Fort Collins, Colorado. His work has been published by National Geographic, Space.com, NASA, and the Henry Ford Museum. He also works in stock with Getty Images.

Image courtesy of Michael Menefee

It is best to travel with other people when you leave the main roads of civilization. If you go alone, always tell people where you are going and when you plan to be back. Be prepared and always dress properly for the conditions. If you are traveling in the evening to catch the golden hour of light, be prepared to stay the night if you find yourself without transportation.

Macro Photography

Macro photography is creating photographs, usually of small subjects, at 1X magnification or higher. This means that subjects are photographed at actual size or larger. This is a great way to explore previously unseen or unknown worlds, such as the details of a plant or the head of a small bug. One of the great things about macro photography is you don't have to go far to find an interesting subject. In fact, your backyard is a great place to start. Your camera has a Close-up mode (🌷) to help you out when you're shooting with a macro lens.

7.19 Plants make great subjects for macro photography. (100mm macro lens, ISO 400, f/2.8, 1/400 second)

Equipment

Macro photographers use different types of equipment for photographing small objects. A macro lens is a good start, but you can also use *extension tubes* (also known as *extension rings*) that fit between your camera and lens. These move the lens further from the image plain so the lens can focus more closely on the subject. *Magnifying filters* are another option. They fit on the front of the lens and increase magnification for macro photography.

> **NOTE** Kenko (www.kenkoglobal.com) is a popular brand of extension tubes worth considering if you want to pursue macro photography.

Macro lenses produce a very shallow depth of field. It is worth using a tripod and setting your camera at a larger aperture number to get as much depth of field as possible. Even at f/11, the depth of field will be shallow because your subject is so close to the lens.

Consider using a flash when shooting macro photography—a *ring flash* or *twin light flash holders* are beneficial. These provide additional, even light on small subjects. Try using back- and sidelighting for macro photographs, especially when photographing an object with a lot of detail, such as a bee. The backlight can come from the sun or your own external flash. Keep a reflector handy; a simple index card or piece of paper often does the trick. You can also use reflectors to either reflect light onto your subject or block unwanted light from the scene. To reflect light, place the index card opposite the source light. This reflects the light onto the darker side of the subject. To block light, place the card in front of the light source. These items can also create a clean background or block wind. Macro photography and wind do not mix well—every movement pushes your subject out of focus.

Best practices

Sometimes photographers forget about composition when shooting macro. They are so excited to get such a small subject in focus, they forget that the same rules of composition apply in the small world. When shooting macro, balance your subjects off of each other. Use your fore- and backgrounds effectively, and keep your images simple by filling the frame as much as possible.

Manual focus is highly recommended with macro photography. Your camera focuses close-up using a macro lens. Unfortunately, considering the depth of field is so shallow, you may not want to depend on where the camera decides to focus. One millimeter off in focus can make the difference between a great or unusable photo.

7.20 A rusty piece of old artwork made an interesting subject for macro photography. (100mm lens, ISO 400, f/2.8, 1/250 second)

Tips

When you photograph insects, try to get them in action. For example, photograph bees just before they land on, or after they leave, a flower. This is much easier said than done. As in wildlife photography, it takes patience. Also, just like any type of photography, viewers want to see the face of your subject, not the back end.

Don't let your tripod keep you trapped in one location. Try different angles, and look for patterns and textures. Consider the time of day. The golden hours of the morning and evening have the same quality effect on small objects that they do on larger ones. Don't forget that there are a lot of subjects to photograph—macro photography is more than just insects and flowers. Consider shooting the imperfect, old, and strange items around your yard or city. I like to look around older buildings for little details. Old cars also make interesting subjects for macro photography.

7.21 Your backyard can provide some great subjects for macro photography, like this bee I caught in my garden. (100mm macro lens, ISO 800, f/5.6, 1/160 second)

Shooting at Night or in Low Light

You may not think of nighttime as the optimal time to take photos. However, although you don't have the sun to work with, the night is full of light. In a city, you'll find neon signs, and street and car lights; in the country, you have the moon and stars. Many wonderful images can be taken at night, but because the light is not as powerful, a longer exposure is required. This means that moving lights (like headlights) create action in your photographs. If you plan it right, these movements around your scene can enhance your image. The movement of water, clouds, and lights can also add great points of interest to your photos. Like all of the other types, night and low-light photography take practice and experimentation. Experience plays a big role in your success—the more you practice, the better you will get.

7

7.22 I took this night shot on a busy corner using a tripod. (ISO 400, f/5.6, 1/6 second)

Equipment

A tripod is a must with night photography. Your camera also has a number of features to help you when you are shooting in very little light. The Long exp. noise reduction setting, found in Shooting menu 3 (■), helps reduce noise from long-exposure photographs. For really long exposures, the combination of a tripod and remote makes for much more successful photos.

Time-lapse photography has become popular in the last decade. If this is something that interests you, consider purchasing an *intervalometer* to make the process easier. An intervalometer takes photographs after set periods of time, such as every 2 minutes. It works like a remote and plugs in to your camera in the same location as the Canon remote. Like the remote, you can leave the shutter open for long periods of time on the Bulb setting (**B**) using an intervalometer. The big difference compared to a standard remote is that you can program an intervalometer to take multiple photographs over a specific period of time. When you import it into a video or slide show editing program, you can then create a time-lapse photography video. You can find intervalometers online or at your favorite camera store.

Best practices

Night photography is all about testing. The camera's light meter will be useless in most cases because there is not enough light for your average meter reading—especially if you are going to add light to the scene with a flashlight or glow stick. Photograph in the RAW format, so that you can make adjustments later. Use a wide lens set to infinite so that everything is in focus. It may be tempting to use a higher ISO setting, but you have time on your side, so keep your ISO setting as low as you can. This will give you better quality images with less noise.

Light painting is another technique that is a lot of fun. To do it, you use an artificial light to draw shapes, words, or images in the air in a completely dark environment. You can use any light source—a flashlight, a candle, a glow stick, the backlight of a cell phone— to create interesting effects. To light paint, set up a tripod in a low- or no-light environment, and then move the light source around to create different patterns. Consider using multiple types of light to capture different shapes and colors. Some lights have a dimmer switch that enables you to control the light. Like all other types of low-light photography, you should use a tripod and remote, and use Custom Function 5 (C.fn-5) to lock the mirror up when light painting.

7.23 This flower was exposed using only a flashlight. (50mm lens, ISO 400, f/5.6, 8 seconds, tripod)

NOTE To lock the camera's mirror up, go to Setup menu 4 (⌨) and select Custom Function 5 (C.fn-5).

Tips

If you want to photograph lightning, point your camera in the direction of the storm. Place your camera on a tripod and use the remote and Bulb setting (**B**) to keep the shutter open. Eventually, a flash of lightning will streak across the sky and expose your image. You'll need to take test shots to find the right exposure, depending on the time of day. Don't let a few sprinkles hold you back—reflections in the rain can be an interesting addition to a night shoot. However, weather can also quickly turn on you, so always be cautious and have a planned escape route. Keep a flashlight with you in case you need to check your equipment, light up the foreground of a photograph, or find your way back to your car.

When shooting at night, you should also consider the environment you are in. By combining the movement of the stars with trees or other fixed structures, you can add scale to your photographs. Take note of when meteor showers are happening so you can plan to catch the streaks across the sky. If you just want stars to appear as pinpoints in the sky, you have to use an exposure of less than 20 seconds for most wide-angle lenses. Record your exposure times so you have a reference point to work from in the future. Use prime lenses because they have fewer elements, thereby decreasing the chance of unwanted lens flare.

If you are going to photograph fireworks, bring a black card to use as a handheld shutter. When the fireworks start, place your camera on B and leave it open using your remote. Make sure your camera is on a steady surface or tripod, and that it is pointed toward the sky. Place the black card in front of the lens and, when you see interesting fireworks, remove it. When you think you have enough fireworks for one image, advance to the next frame and repeat the process.

Travel Photography

Travel is exciting, and photographs of your adventures keep the memories alive for years to come. To prepare for a travel shoot, professionals research their destination before they leave; you should do the same if you want to get the best shots. Think about how you want to tell the story of your location. Do you plan to do some serious photography or just use your camera to capture personal moments? Do you have specific types of photography you plan to focus on, such as architecture or food? Whatever your intentions, make sure that you bring the right equipment to do the job well.

Equipment

A zoom lens is helpful for travel photography because then you don't have to carry as much equipment. The goal is to keep it light: your camera, one or two lenses, a flash, back-up batteries, and extra memory cards should be the foundation of your travel photography kit. A large tripod is not really practical when traveling, but there are numerous mini-tripods available on the market that can keep your camera steady in low-light situations.

7.24 Travel photos, like this one taken in China, should tell the story of the location. (12mm focal length, ISO 400, f/4.0, 1/350 second)

If you have a laptop computer, make sure that you download your images on a regular basis. Bring extra CDs or flash drives to back up your images. You can even mail a CD home as a backup. If you have reasonable Internet access while traveling, consider uploading some of your best images to a cloud storage service, such as Dropbox (www.dropbox.com).

Best practices

Most travel is relatively safe, but remember that you have expensive equipment with you, so always be aware of your surroundings. Consider using small, nondescript bags and unbranded camera straps. Be respectful of the local people; not everyone wants his picture taken. Don't be intimidated, though—photos of the locals are an important part of your trip. Just be courteous and ask people if you can take their picture—you will be surprised at how friendly most are to visitors.

When you first arrive at a new location, look around before you start shooting. Look for colors, contrast, and textures. Notice the little things in your environment. What do you smell or hear? What is the weather like? Can you photograph any of these things? Using your camera to answer these types of questions helps you tell the story of your travels and create lasting memories.

After photographing the well-known sites, visit the non-touristy areas. These locations may not be instantly recognizable, but there are just as many (and in some cases, more) interesting subjects off the beaten path. Use the triangle method: shoot wide-angle establishing shots, medium shots to tell the story, and close-ups to get the details.

Food is as much a part of a culture as the clothing the local people wear. Look for interesting signs that help tell the story of the environ-

7.25 Using your camera to tell the story of a location creates lasting memories. This broom reminds me of some of the interesting things I saw in China. (135mm focal length, ISO 400, f/2.8, 1/350 second)

ment and the people who live there. Consider what a day in the life of a local person might be like, and what elements represent the native people and culture.

Learn to work with the available light. If it's not working in your favor, try creative techniques, such as creating a silhouette. A *silhouette* is the black outline of a subject with a bright light behind it. Use the Spot metering mode (⊡) to backlight your shots. If you have a tripod, use the HDR Backlight mode (⬛) for a better exposure when shooting subjects that are backlit. You can use this mode without a tripod, but you must remain very steady as the camera takes three rapid exposures. Experiment and use the different functions on your camera to see if they improve your photos.

Tips

Take notes about your trip. Keep a journal, notebook, or use a digital recorder so you will remember what you photographed on your journey. This is especially helpful when trying to remember names and places. If you're in an historic building or museum, don't shoot through glass with a flash because it will reflect into your photograph. Increase the ISO and consider buying a polarizing filter for your camera to remove the glare from glass or other reflective surfaces, including water.

Pick a different theme each day to keep things interesting. One day, it could be architecture, and the next people or food. This exercise helps you study more facets of the environment in which you are traveling. Some people put themselves in every photo, and that is fine. Unfortunately, others go through an entire vacation without one shot of themselves. Make sure that you are in at least *some* of the photos.

7.26 **Architecture, like this building in Adelaide, Australia, can make an interesting theme on your travels. (50mm lens, ISO 200, f/6.3, 1/250 second)**

Be ready at all times to take a photograph. Don't edit in the field or you might miss a great opportunity. Try to find an angle or composition that is different from what everyone else is taking, especially at tourist locations. Take the time to see the world with your eyes, as well as through the lens—after all, you want to experience the location as much as photograph it.

Travel photographer Ralph Velasco offers tours of interesting locations, while teaching his guests about photography. The following are some of his tips for getting the most out of travel photography:

▶ **Make sure that you capture the essence of the location.** Most photographers are interested in a specific type of photography, but to truly tell a complete story about a location or subject, make a concerted effort to shoot a variety of images

that create a cultural portrait. This makes for much more interesting slide shows, books, websites, and so on.

▶ **Get up early and stay out late.** Not only will you capture the best light of the day, but this is also when the locals are on their way to work and school. Those are the people you want in your shots. Plus, there's less traffic, it's cooler out, there are fewer bugs, and so on.

▶ **A few seconds can make all of the difference.** My advice is to spend an extra 2 to 3 seconds looking through the viewfinder, micro-composing the scene to get it just right. This slows you down, so you'll take fewer pictures, but you'll also get more keepers (and your hard drives will love you!).

▶ **Either it's in or it's out.** Eliminate elements of a scene that are just peeking into the frame, like a tree branch or part of a person. However, make sure that you don't have other important elements sticking out of the frame, such as the top of a building or the edge of your subject. Don't crop so tightly that there's no breathing room around the important elements of the scene.

▶ **Add a human touch.** I'd much rather see an image of a popular landmark, such as the Eiffel Tower or the Great Wall of China, with a person in the scene; otherwise, it just looks like a generic postcard shot. Including a person provides a sense of scale, a pop of color, and some human interest to which the viewer can relate.

▶ **Give yourself a theme.** At the beginning of my photo tours, I challenge my participants to think of a theme they'd like to work on throughout the trip. It can be anything from doors and animals, to people at work or sewer covers. Whatever you choose, it forces you to become hyper-aware of those subjects and you'll come home with an interesting set of images.

Ralph Velasco is a travel photography instructor, author, and international photo tour guide. He's also an award-winning travel blogger (http://ralphvelasco.com/blog) and the creator of the My Shot Lists for Travel app for the iPhone and iPad.

Shooting in the Live View and Movie Modes

Creating videos with your Canon T4i/650D is a convenient and fun way to preserve memories. Perhaps you've watched a breathtaking video created by a photographer using a dSLR camera and wondered if you could do the same thing. The video feature in your dSLR delivers many great options for doing just that. Good video, whether created with a traditional video camera or your Canon Rebel T4i/650D, should adhere to the same video production rules. The goal is consistency—it doesn't matter whether you are shooting a family video or creating the next great documentary—it is important to plan and think ahead, especially if you are going to do any editing. You don't have the same postproduction options that you do with still photography, so it isn't as easy to fix problems later. When it comes to video, you need to think differently.

A frame outtake from a video I shot with the Canon Rebel T4i/650D.

Using the Live View Shooting Mode

The Live View shooting mode (■) is helpful when taking still pictures or creating videos. The large 3-inch screen makes it easier to view and follow moving subjects in real time. The Canon Rebel T4i/650D has a 180-degree, vari-angle LCD screen that flips out. This enables you to hold or place the camera at a higher or lower angle while following your subject, for either still photography or video shoots. A helpful feature of the Live View shooting mode (■) is the magnify option. To magnify the scene in front of you, press the Magnify button (◙) on the back of the camera to view 5 or 10 times closer to your subject. You also can use the Magnify button (◙) in the lower-right corner of the LCD screen and the arrows along each side of the frame to view different parts of the scene.

8.1 You can hold your camera high or low using the vari-angle LCD screen to capture new angles.

CAUTION If you use the Live View shooting mode (■) for an extended period of time, it can heat up the camera's internal temperature, which can affect image quality. Make sure that you turn off the Live View shooting mode (■) when it's not in use.

To turn on the Live View shooting mode (■), press the Live View button (■) to the right of the eyepiece. You should note that the Live View shooting (■) and Movie shooting ('🎥) modes, while similar, have different menus and features. When you turn on Live View shooting mode (■), you see an information display on the screen. Most of this information is related to exposure settings. The exposure information display has four variations that you can access when you press the Info button (**INFO.**), including an automatically adjusting histogram and an option to clear the screen of all information.

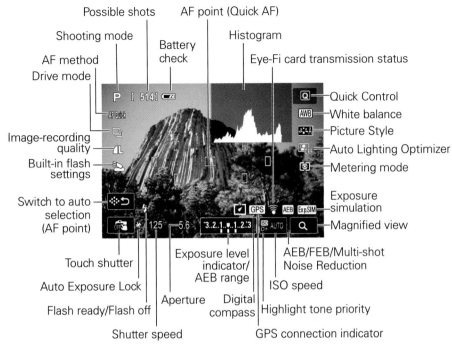

Possible shots
AF point (Quick AF)
Shooting mode
Battery check
Histogram
AF method
Eye-Fi card transmission status
Drive mode

Quick Control
White balance
Picture Style
Image-recording quality
Auto Lighting Optimizer
Built-in flash settings
Metering mode

Switch to auto selection (AF point)
Exposure simulation
Magnified view

Touch shutter
Exposure level indicator/ AEB range
AEB/FEB/Multi-shot Noise Reduction

Auto Exposure Lock
ISO speed

Flash ready/Flash off
Aperture Digital compass
Highlight tone priority

Shutter speed
GPS connection indicator

8.2 This graphic shows the information available via your camera's Info button.

NOTE If you don't see the information display on the screen after pressing the Live View button (◉), press the Info (**INFO.**) button.

The Live View information display offers four options. One is clear and the other three have different combinations of the following:

▶ **Shooting mode.** This is the exposure mode to which your camera is set, such as Program AE (**P**) or Portrait (**❧**).

▶ **Possible shots.** The total number of available shots left on the memory card.

▶ **Battery check (▰▰▰▰).** This icon shows how much battery power is left in your camera.

▶ **AF point (Quick AF).** One of the nine autofocus points available for focusing in Quick mode (▰▰▰▰).

▶ **Histogram.** A live, continuously adjusting graphical representation of the shades of white to black in your scene.

▶ **Eye-Fi card transmission status.** Indicates that the Eye-Fi card is active.

▶ **Quick Control (Q).** Press this for quick access to your shooting functions. Each individual mode displays different options.

▶ **White balance.** Internal adjustments naturalize the light found in the shooting environment. This icon indicates which white balance setting is being used.

▶ **Picture Style.** Displays the Picture Style your camera is currently using.

▶ **Auto Lighting Optimizer (⊞).** This adjusts your photograph to the optimal brightness when using the basic zone modes.

▶ **Metering mode.** Shows you which of the four meter modes your camera is using. These modes are Evaluative (⊙), Partial (⊙), Spot (⊡), and Center-weighted metering (⊡).

▶ **Exposure simulation.** Your camera displays real-time exposure (how your photo looks at the current exposure settings).

▶ **Magnified view.** This option allows you to magnify the scene.

▶ **AEB/FEB/Multi-shot Noise Reduction.** Displays the Auto Exposure Bracketing setting, Flash Exposure Bracketing setting, and Multi-shot Noise Reduction (which reduces noise at all ISO settings).

▶ **ISO speed.** Indicates the ISO setting sensitivity of your camera.

▶ **Highlight tone priority.** Indicates that this feature is active. It is designed to improve the highlight detail in your scene.

▶ **GPS connection indicator.** Shows that the Global Positioning System is active (a GPS receiver is required).

▶ **Digital compass.** Indicates the direction your camera is pointing when used in combination with a GPS receiver.

▶ **Exposure level indicator/AEB range.** Displays how under- or overexposed the camera setting is. It also indicates the set range of the Auto Exposure Bracketing feature.

▶ **Aperture.** Displays at what aperture your camera is set.

▶ **Shutter speed.** Displays at what shutter speed your camera is set.

▶ **Flash-ready (⚡)/Flash off (⚡).** Indicates whether the flash is on or off.

▶ **Auto Exposure Lock (✳).** Reminds you that the Auto Exposure Lock is engaged.

▶ **Touch shutter.** Turns the LCD screen touch shutter on and off. This option allows the photographer to trigger the shutter from the LCD touch screen.

▶ **Switch to auto selection (AF point).** Indicates that the camera is using the autofocus points you selected.

▶ **Built-in flash settings.** Lets you know that your pop-up flash is active.

▶ **Image-recording quality.** Represents the quality and size of the image file.

▶ **Drive Mode.** Indicates which of the following drive modes are engaged: Single shooting (☐), Continuous shooting (⧉), or one of the three Self-timer options.

▶ **AF method.** This shows which focusing method is being used when the Live View shooting mode (⬛) is on. The options are Face Tracking (AF⟲⠿), FlexiZone-multi (AF⟨⟩), FlexiZone-single (AF☐), and Quick mode (AFQuick).

To get to the Live View menu, press the Menu button (**MENU**), and then select the Live View shooting mode (⬛). The menu has seven options to consider, such as focusing, grid display, and aspect ratio.

CROSS REF See Chapter 2 for a full explanation of menu options.

The Quick Control/Print button

8

The Quick Control/Print button (⌨) or the Quick Control icon (Q) in the upper-right corner of the Live View screen enables you to make changes to many key functions, depending on the mode you are using. When you are photographing in a basic zone mode, Live View gives you access to the AF method, image recording quality, and drive mode. If you are shooting in one of the creative zone modes—Program (**P**), Shutter-priority (**Tv**), Aperture-priority (**Av**), or Manual (**M**)—you have access to the same options that you do in the basic zone modes, plus the built-in flash options, white balance, Picture Style, Auto Lighting Optimizer, and Metering modes.

Shooting stills

To take photographs in the Live View shooting mode (⬛), use the shutter button the same as you would when looking through the viewfinder. You also have the option of enabling the touch shutter. The touch shutter icon is in the lower-left corner of the LCD screen. When enabled, all you have to do is touch the back of your screen to trigger the shutter. Also, it's easier to use the LCD touch screen when the camera is mounted on a tripod than it is when handholding it.

8.3 This photo was shot handheld and composed using the Live View shooting mode. (100mm lens, ISO 400, f/10, 1/160 second)

185

NOTE Using the Live View shooting mode (■) to photograph stills drains the battery much faster than using the viewfinder.

You have the option of creating different aspect ratios when shooting in Live View mode (■). You have the following four options, which are found under the Live View menu (■): 3:2 (the Live View standard), 4:3, 16:9, and 1:1. When you turn on ratios of 4:3, 16:9, or 1:1, a black mask outlines the new screen proportions. These new ratios are saved permanently in JPEG format. RAW images are saved as 3:2 with the information stored and appended to the RAW file.

Focus modes

Continuous focus is the default focus mode. This means that the camera follows your subject to keep it in focus. You can turn off this option in the Live View shooting menu (■). When you do this, the camera switches to One-shot focusing mode (**ONE SHOT**), meaning that the camera focuses once and stays focused until you lift your finger from the shutter button.

You have four autofocus (AF) methods available in Live View shooting mode (■) and three when shooting videos (which is covered later in this chapter). In Face Tracking mode (AF☺), the camera detects a face and follows it until you take the photo. If you have multiple faces in your scene, the camera selects one. You can change the focus target by touching the subject's face on the LCD screen. FlexiZone-multi (AF☐) uses the available 31 autofocus points to focus on your scene. When you press the Set button (SET) or touch the LCD screen, this AF option divides your screen into nine focus zones. To revert to the larger AF focus area, press the Set (SET) button again.

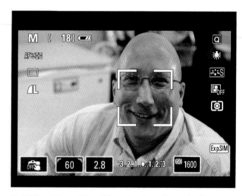

8.4 The Face Tracking technology follows your subject anywhere in the frame.

NOTE If the face of your subject is too small due to his distance from your camera or the lens you are using, Face tracking may not work.

FlexiZone-single (AF□) uses the 31 autofocus points individually. Press any point on the LCD screen and the focus point lights up where your finger is placed. You can also press the Set button (⊛) and Cross keys to make AF adjustments. The last focus option is the Quick mode (AFQuick), which is the fastest of the four focus options. It drops the mirror and uses the nine traditional focus points. This option is not available in the Movie shooting mode (🎥).

If you prefer, you can use Manual focus in Live View Shooting mode (■). While the large LCD screen is helpful for manually focusing, consider using the Magnify button (🔍) to get in close on your subject for fine focusing. To help line up horizon lines and elements in your scene, you have the Grid display option found under the Live View Shooting menu (■). You can also check the depth of field in the Live View Shooting mode (■) by pressing the Depth-of-Field Preview button (🔘) on the right side of the front of your camera.

Live View and Video

When shooting video, you use the Live View Shooting mode (■) on the back of your camera. The LCD screen makes it easy to watch the surrounding environment, and prepare for objects or subjects coming into the frame. For even better viewing, attach your camera to a larger screen, such as a TV or external monitor. The Live View Shooting mode (■) has four information display options, which you can access by pressing the Info button (**INFO.**). Some of the information included in the display options include AF method, Movie size, and Drive mode. Another option clears the scene of all information.

Here are a few tips to help you when shooting video:

▶ **Use a tripod.** Video is shot in the Live View shooting mode (■) and, in most cases, you need a tripod because camera shake is very noticeable because you do not brace the camera in the same way that you do when holding it to your eye to shoot still photographs. If you are handholding your camera or the subject is moving, take advantage of the camera's Movie servo AF (SERVO AF) to help keep your subject in focus.

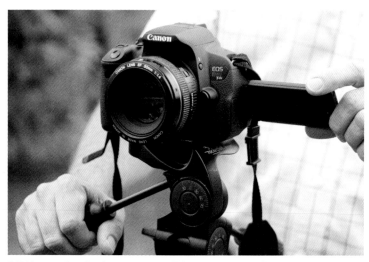

8.5 Use a tripod whenever possible to create professional-looking videos.

▶ **Use Quick Control (⊡).** There is a slightly different setup for Quick Control in the Live View Shooting mode (⊡) when you are shooting video. The creative zone modes have more options than the basic zone modes, such as white balance and Picture Style. You also have a few other options, such as Movie recording quality and frame rate. The flash control option is removed completely because you cannot use flash while shooting video.

Shooting Video

The ability to shoot video is a great advance for dSLR cameras, and your Canon T4i/650D is no exception. The camera's high-definition (HD) capabilities give you the power to create high-quality videos. One thing many people overlook when deciding to use their dSLR as a movie camera is that this type of camera is not physically designed to function for this purpose. It is important to consider the limitations of your camera and to invest in the accessories needed to work at peak performance. Helpful accessories include external microphones, a screen loupe, headphones, hot lights, and steady support brackets. Don't forget the necessary ingredients of a good video: Steady images, quality sound, well-thought-out scene development, and editing. All of these are necessary to create quality productions. The same applies to home productions of events with family and friends.

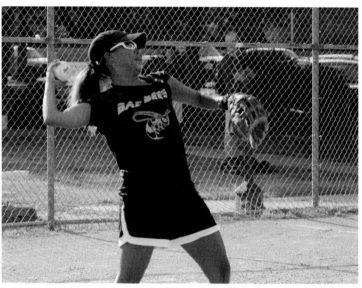

8.6 This frame was taken from a video shot with the Canon Rebel T4i/650D. (ISO 400, f/5.6, 1/1000 second)

8

There are many advantages to using a dSLR rather than a traditional video camera, and one is the cost. Many dSLR cameras offer high-quality video—in many cases, higher quality—with higher sensitivity and less noise at a much lower price. The ability to change your lens is an even bigger advantage. Traditional consumer video cameras may have a zoom lens, but you are stuck with the one that is attached. A dSLR can use any E-series lens available, which allows you to create a shallow depth of field. A lens like the 50mm f/1.4, creates a very shallow depth field to get a cinematic or stylized look, which is very popular with still photographers.

8.7 This is a frame from a video shot with a shallow depth of field at an aperture of f/1.8.

Creating video requires a different mind-set than capturing stills. When you are creating video, you capture more than the decisive moment—you capture multiple moments. All of these moments should tell a story that has a beginning, a middle, and an end. The experts recommend using manual settings when shooting video because, even with all of the great features your camera offers, automatic modes and settings will adjust in the middle of a scene. This distracts the viewer and makes your video look unprofessional.

Your camera's video shooting feature is great for everyday shooting. If your goal is to create a longer, edited video, make sure that you have lots of extra footage before and after each scene. In other words, don't shoot video clips less than 10 seconds long unless you have a good reason. Make sure that you take at least 15 to 20 seconds of video before and after a scene to give yourself room for editing.

The microphones built into your camera are very basic. They pick up camera noise because they are part of the camera body. They are not bad for a quick family-and-friends clip. If, however, you plan on shooting a lot of video, buy an external microphone. You can even use a completely external recording source to replace your camera's sound. I recommend keeping the internal microphones on if you use an external microphone and recording device because this makes it much easier to match the sound during editing. The more you can do while shooting to make your editing easier, the happier you will be in the end. Preparation and planning in advance what style of video you want to create is very important—even for family videos.

As is true for still photography, good, sharp lenses are also very important for shooting video. If you like using autofocus for everyday video, you might want to consider Canon's STM lenses. They are designed to be quiet while continuously focusing in Movie servo AF mode (🎬).

Image courtesy of Canon

8.8 The Canon 40mm STM lens is designed for shooting video.

Setting up for a video shoot

Preparing and setting up your camera for a video shoot is an important step to achieve a successful result. Take the time to plan, even if it is just a moment before you press the recording movie button (which is the Live View shooting button (⬛)). Map out what you want to accomplish. Are you documenting something or capturing family memories? Are you telling the story of a company? Remember that planning makes editing much easier later on.

What type of scene are you shooting? This is a good question to ask when making setup decisions, such as selecting the aperture. You have a wonderful advantage with a dSLR because you have a selection of multiple lenses, some of which generate a very shallow depth of field and offer a cinematic effect, as covered earlier. If your scene involves a person, shallow depth of field is the perfect choice. If you are panning over a beautiful landscape, a large depth of field is considered the better option.

You must also decide what size file you want to use. I recommend you use the largest one available. You can always downsize later, but you can't increase your movie files without losing quality. To select the video recording size, look in the Movie Shooting menu 2 (📷). Two of the three options (1920 and 1280) are high definition (HD) and shoot in a 16:9 aspect ratio. The smallest of the three is shot at 4:3. You also have the options of shutter speed and film rate, which are discussed later in this chapter. Are you

8.9 Here are the recording quality and frame rate options based on the NTSC standard. You may choose the standard under Setup menu 2.

going to use the manual modes as many professionals recommend? Do you plan to rely on the incredible technology your camera has to offer, such as the Scene Intelligent Auto (🅰️) and Movie servo (📹) modes, and the AF tracking methods?

Picture Styles work for videos, too. If you keep the Picture Style (🎨) on auto, the camera picks the best style to suit the scene. All Picture Styles apply the same sharpness, contrast, saturation, and color tone effects when shooting video that they do for still images. Standard (📝S) is a general style good for most scenes, while Portrait (📝P) is good for skin tones and softening the scene. Landscape (📝L) creates sharp images with vivid blues and greens. Neutral (📝N), as its name suggests, keeps images natural looking. Faithful (📝F) offers accurate color of images captured under light that is less than 5200K. Monochromatic (📝M) is for black-and-white photography. Your user-defined Picture Styles (those that you create) also work when shooting video.

There is more to video than shooting visuals. You must also consider how you are going to record the audio and if you plan to edit it. By the time you finish this chapter, you'll have a better understanding of how to handle the audio and editing portions of video production.

The frame rate

Don't feel bad if you confuse the frame rate (FPS) and shutter speed—you are not alone. The *frame rate* is the number of frames captured per second by the camera. The *shutter speed* is how long that frame is exposed to light. Your camera has two options under Setup menu 2 (■) for frames per second: PAL and NTSC standards. PAL is the standard for Europe, while NTSC is the standard in North America. You have three further options under each standard. Under NTSC, your options are 24, 30, and 60 fps. PAL options are 24, 25 and 50 fps. All are progressive (or noninterlaced) scanning for both standards. This means that each line of the movie is displayed in order or sequence, rather than every other line, as it is with interlaced scanning. The default setting for your camera is NTSC.

The following list includes the different frame rates and the types of video recordings for which each is best suited:

▶ **24 fps 1/50 second.** This is the combination used to achieve a classic film look.

▶ **30 fps 1/60 second.** This combination makes your video resemble 35mm film.

▶ **60 fps 1/125 second.** If you are shooting action or sports, this setting gives you a sharp video. It is especially useful if you plan on using slow motion as part of your video presentation.

The faster the shutter speed is, the less blur you will have between frames. Blur is not all bad—it can give your video more of a natural feel. No matter your fps, your shutter speed should be double your frame rate based on what is called the 180-degree rule. Your camera uses a rolling shutter, meaning that it doesn't capture the entire image at the same time. Unfortunately, the result of this type of shutter is the *Jell-O effect*, which is wobbly or skewed images created while panning or quickly moving your camera from side to side. The best way to avoid this is to use a tripod and avoid fast movement. Make sure that you have a good, smooth tripod head and pan at a slow, steady pace.

When you set the ISO to automatic, the camera chooses the right option for the best exposure. Unfortunately, maximum ISO is not available for video. If you want to expand your ISO to 12800, use Custom Function 2. However, this option is very grainy and not recommended. If Custom Function 3 highlight tone priority is set, your range is 200-6400 ISO.

The shutter speed

The shutter speed when shooting video is how long each frame is exposed to light. Slower shutter speeds show more motion, as shown in Figure 8.10, which lends a more natural feel to your video. Faster shutters speeds are much less fluid, as

shown in Figure 8.11, but are valuable for action, such as sports shooting. If you plan to use slow motion in your video, a faster shutter speed gives you a crisper image for each frame.

Sometimes you have to set a faster shutter speed or lower your ISO to set a lower aperture and achieve a shallow depth of field. Your camera does not let you go below the designated shutter set with your frame rate. It's worth experimenting to find which shutter speed is best for the type of video you are creating.

8.10 In this video frame, you can see the motion of the water in the fountain. A shutter speed of 1/50 second was used.

8.11 You can see the spray and droplets of the water in this video frame, which was captured at a faster shutter speed of approximately 1/500 second.

The combination of shutter speed, aperture, and ISO gives you the proper exposure for your video. You have a lot of latitude with higher ISO options. Although your camera allows up to ISO 6400 for stills and ISO 12800 in Movie mode ('🎥), this doesn't mean that you should use it. Avoid using the higher ISOs if possible because graininess is not as forgiving in video as it is in still photography. The lower the ISO, the better the video.

Lighting

Like still photography, video needs proper lighting to work well. However, the approach is a bit different with video. You can't use the flash to light your subject, so a continuous source of light is the solution. The most common approach is to keep the light flat and even, so that unexpected shadows don't develop while you are shooting your video. If you use more dramatic light, you need to plan for changes in the light as your subject moves or the scene changes—which is a lot of work.

There are many types of lighting that you can use for video. The sun is a good choice, but it can be harsh. Without a diffuser, it casts strong shadows on your subject. Try shooting on a cloudy day for a softer, more even light. When shooting indoors, consider bringing your own light sources rather than depending on the light available in the room.

If you leave your camera on Auto white balance (AWB), it should adjust to the light in your environment or the light that you provide. Auto white balance is not perfect; you may want to consider using a Custom white balance setting (⚖). For example, you may not be satisfied with the color tint, such as a yellowish cast, that you see in the overall environment. To fix this, make sure that you have a white piece of paper to photograph (fill the frame) in the environment in which you are shooting. Next, in Shooting menu 2 (📷), select Custom white balance. Select the photograph of the white piece of paper, and then press the Set button (⊛). This step ensures that your Custom white balance is not based on the light in the room or environment.

CROSS REF For more information on other white balance options, see Chapter 3.

When you are indoors, some of the first considerations should be where the light is coming from, and whether you have enough light to use lower- or higher-quality ISOs. Bringing your own artificial light source is a good option. You can use almost any light source, such as tungsten, if you balance it using your camera's Custom white balance. LED lights have become popular on- and off-camera—some even attach directly to your camera's hot shoe. Fluorescent lights come in a variety of Kelvin temperatures and are often used with softboxes. When you need high or powerful light output, HMI lights are a good choice.

CROSS REF For more information on lighting, see Chapter 6.

Video Lighting Tips from Lan Bui

Lan Bui, best known as one-half of the Bui Brothers team, shared the following tips for beginners using existing and artificial light when shooting video:

▶ **Sunlight.** When using sunlight, you have 360 degrees around the subject from which to shoot. I prefer keeping the sun at the subject's back and exposing in the shadow areas so that they are backlit. The shadow side provides much more even lighting. Yes, the background will blow out, but the way the light blows out on the Canon, it's flattering.

▶ **Indoors.** When shooting indoors, take the opposite approach. At an event, I look for the brightest light in the room to use as my main source. I then move so that I'm between the light and the subject, but not blocking the light. I don't want to cast a shadow on the subject.

▶ **Window light.** When shooting indoors, one of the most flattering things you can do is shut off the lights and use natural light (when available). Use a window as the main light source, and then stand between it and the subject. You can turn toward the window to create a silhouette, or, if the room has light paint on the walls (such as white or yellow), the sunlight from the window will bounce around the room, giving you enough light to backlight your subject.

▶ **Cheap lights.** I use round aluminum lights with clips and a regular bulb, as shown here. You can get these at the hardware store. They are helpful in tight places or when I don't want to bring in professional lights. They provide a nice bright, even light. I keep different types of lights (tungsten and fluorescent) with me so that I can match the lighting in the room the best that I can. I also sometimes put my light source in a Chinese paper lantern because it works like a softbox. If I'm outside, I use cool or daylight bulbs to match the daylight.

Lan Bui is a photographer and cinematographer who specializes in online media and promotional photography. You can see more of his work at: http://thebuibrothers.com.

8

CAUTION The color of paint in a room will also bounce onto your subject. Therefore, a green wall may not be flattering to use to bounce light.

Sound

It is often said that the most important part of video is the audio. Viewers will suffer through visual glitches, but bad audio will lose their attention fast. The built-in microphones are on top of the camera, as shown in Figure 8.12. The external microphone terminal is on the left side of your Canon Rebel T4i/650D. The internal microphones pick up all of the noise around you, including camera noise. This is why you should consider using an external microphone when shooting video.

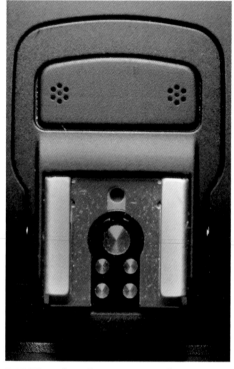

8.12 The microphones on top of your camera are good for casual use.

If you decide to use an external microphone, be aware that there are different types, such as boom, shotgun, and lavaliers. There are also many companies that make on-camera microphones that attach to the camera's hot shoe. These come in all shapes and sizes and are rather large and expensive. Price is often an indicator of quality, but it is worth testing a few microphones before you decide on one. You need a microphone with a 3.5mm diameter plug (or you can use a converter if necessary).

The following are the different types of microphones you should consider using with your camera:

▶ **Omnidirectional.** This all-purpose microphone gathers a wide range of sounds from different directions. The microphones built in to your camera are omnidirectional.

▶ **Unidirectional.** When you want to focus on a single individual or sound, this is the type of microphone you use to help minimize ambient noise.

▶ **Handheld.** Most often, you see these used by reporters interviewing someone on the street or a person singing onstage. These microphones are either omnidirectional or unidirectional. Unidirectional is best for interviews.

▶ **Shotgun.** This is also known as a boom mic because it is often held in the air by a boom. They are good for focused recording (unidirectional).

▶ **Lavalier.** You see these small microphones clipped to the clothing of people being interviewed. Also sometimes called lapel microphones, these are good for capturing clean audio from a single source.

Sound is a complex subject with many solutions. Your camera offers a few options for the internal microphones. In the Movie shooting menu 2 (📷), press the Sound recording option. Notice that the Disable level meter at the bottom of the LCD screen reacts to the sound around you.

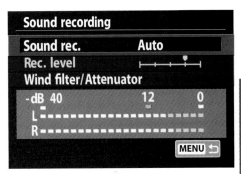

8.13 This is what the Sound recording menu looks like under Movie shooting menu 2.

On this screen, if you are in one of the basic zone modes, your option is sound On or Off. If you are in one of the creative zone modes, you have the following sound options:

▶ **Sound rec.** You have three options under this selection: Auto, Manual, and Disable. Auto adjusts the sound recording level automatically. Manual turns on the next option, Rec. level. Disable turns off the camera's audio recording ability.

▶ **Rec. level.** Advanced users select the Manual recording option to set the recording to one of 64 levels.

▶ **Wind filter/Attenuator.** The wind filter reduces wind noise; it is only available for the internal microphones. The attenuator is recommended if there are very loud sounds in your recording. It works in both Auto and Manual audio settings.

NOTE The sound level between the right and left built-in microphones cannot be adjusted.

You can add music to your videos or slide shows by registering the music using your EOS utility. The utility needs to be installed on your computer, and your camera must be connected to your computer via USB. Follow these steps:

1. **With your camera turned off, connect your computer and camera via USB.**

2. **Launch the EOS utility and turn on your camera.**

3. **Click Register Background Music.**

4. **After registration is complete, disconnect your camera from the computer.** The next time that you play a video, you can turn on the music option and your selections will be available.

CAUTION In the EOS utility, you are limited to WAV files of up to 29 minutes and 59 seconds. When you register a new list of music, it overwrites the old list.

Choosing a focus mode

Your camera automatically defaults to Movie servo AF mode (🔲) when placed in the Movie shooting ('🎥) mode. This means that it continuously focuses until it finds something to focus on, and then it continues to adjust and follows your subject to maintain focus. This is a convenient feature and the Canon Rebel T4i/650D is the first to offer it. If you are not using an external microphone, your camera picks up the sound of the lens focusing. Canon offers the STM series of lenses to minimize this problem. You can disable Movie servo AF (🔲) in the Movie shooting menu 1 (🎬). When Movie servo AF (🔲) is turned off, your camera reverts to the One-shot autofocus mode (**ONE SHOT**). Press the shutter button halfway to focus. Once the focus is locked, it stays fixed until you lift up your finger and refocus.

NOTE You can temporarily stop Movie servo AF (🔲) by pressing the Auto Exposure Lock button (✱) or tapping the AI Servo button (**AI SERVO**) on the lower-left side of the LCD screen.

You have three autofocus options available when shooting video. To access the three AF methods, press the Quick Control/Print button (🔲), and then press the top icon on the left side of the LCD touch screen. Look for the three AF methods of focus displayed at the bottom of the frame. The first option is Face tracking (🔲), which means that your camera detects faces, and then tracks them to keep your subject in focus while you shoot. If you have more then one face in the frame, the camera selects one. If you want to switch to a different subject, touch it on the LCD screen with your finger. You also can use the Set button (🔲) to reset the focus to the center of the LCD screen.

The FlexiZone-multi focusing mode ([AF○]) uses your camera's 31 autofocus points to focus on the scene. If you press the Set button (🖲) or touch the LCD screen, this AF option divides your screen into nine focus zones. To revert to the larger AF focus area, press the Set button (🖲) again. The FlexiZone-single focusing mode ([AF□]) uses the 31 autofocus points individually. In other words, you can select any one of the 31 points to focus on your subject. To do this, press any point on the LCD screen or press the Set button (🖲). You can press other points of focus or use the Cross keys to move your focus point. You are not limited to your focus choice once you start recording; you can select different AF focus points while recording.

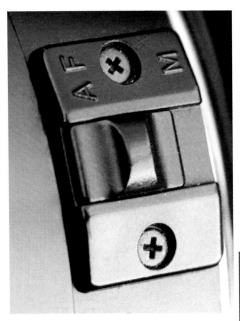

8.14 Flip the switch on your lens to change the focus mode from Autofocus to Manual.

Even with all of this wonderful technology inside your camera, professionals still recommend using Manual focusing mode (**MF**). For everyday shooting, the other options are useful, especially if you are using Canon's STM lens system. However, when you want more professional-looking videos, manual is still a good choice. To switch to Manual focusing mode (**MF**), look on the left side of your lens and flip the switch to Manual, as shown in Figure 8.14.

TIP When using the Manual focusing mode (**MF**), you can use the Magnify button (🔍) to help the camera focus. However, you cannot magnify while recording.

If you need to balance the composition of your scene, turn on the grid display in the Live View Shooting menu (▣). You have two grid display options. One looks like a tic-tac-toe board (nine sections) and the other divides the frame into 24 sections.

NOTE If your lens is in Manual focusing mode (**MF**), the LCD touch screen does not react to your touch for focus point adjustments.

Recording video

To turn on the video option, dial the power switch to Movie mode ('🎥). When you're ready to start recording, press the Live View shooting mode button (🔲) on the back of your camera. If you are shooting family or casual events, handholding your camera and using the built-in microphones is fine (although an external mic is better). Try not to move your camera around too much. Fast movement and swings lead to what is called the *Jell-O effect*, which is unnatural-looking movement, or wobbly scenes or subjects. Also, too much movement tends to make your viewer seasick. When you are recording, you should always keep your camera horizontal because that is the orientation of televisions and monitors.

8.15 As you can see, this video outtake doesn't work as a vertical orientation. Your videos should be shot horizontally to match the orientation of TVs and monitors.

CAUTION Your camera's internal temperature increases when you record video for extended periods of time, especially on hot days. Keep an eye out for your camera's heat warning icons.

The Canon Rebel T4i/650D video files are limited to 4GB. Once your file reaches this limit, the camera automatically creates a new file. The camera also has a video shooting time limit of 29 minutes and 59 seconds. Once you reach this limit, the camera shuts off. To resume shooting, press the Record button (the Live View shooting button (🔲)) and the new recording is stored in a new file. Once you reach 20 minutes, keep an eye out for a good break in the action so that you can stop and restart your recording. It's much better than having the camera stop automatically during a peak moment.

NOTE A 16GB memory card can easily hold a full 29 minutes and 59 seconds of recording time.

In the creative zone modes, both Aperture–priority AE (**Av**) and Shutter–priority AE (**Tv**) work the same as the Program mode (**P**). Manual mode (**M**) gives you control over the shutter speed, aperture, and ISO settings. All basic zone modes use the Scene Intelligent Auto mode (⊞). In the creative zone modes, you can use the Auto Exposure Lock button (✳) to lock your exposures. This is helpful to fix your exposure during recording. When shooting, use the basic zone exposure setting. An icon appears in the upper-left corner of your screen representing the exposure mode it is using.

When you are not recording, you can press the Quick Control/Print button (▣) to change standard features, such as the frame rate, AF method, image quality, and so on, but you cannot use it while recording. You can make a few adjustments (depending on the mode you are using), such as turning Movie servo AF (▣) on or off, or adjusting the shutter speed, aperture, and ISO settings via the touch controls at the bottom of the LCD screen. If you don't see the options, press the Info button (**INFO.**). Maintaining consistency is important while you are recording. Make sure that you leave room for editing, keep your movements slow and smooth, and avoid making adjustments during recording. Professionals recommend that you use the Manual settings; changing options while shooting distracts the viewer, and makes your video look inconsistent and unprofessional.

While shooting video, you can still take photographs by pressing the shutter button. It is important to note that if you are using your camera's internal microphones, camera noise will be picked up. When you take a photograph, the Live View shooting mode (▣) is turned off and the video is delayed or interrupted for up to 1 second. Once you see the Live View screen again, the camera has resumed shooting video. The video and photo are saved as separate files. When it comes to focusing during a video shoot, it is important to check and recheck. This is especially true when you shoot in Manual or with a shallow depth of field, because you never know if your subject is moving out of your focal range.

Your camera also has the ability to capture short video clips for 2-, 4-, and 8-second sessions, and then place them in a video snapshot album. Ultimately, all of the clips you record are combined into one longer clip (a single movie file). When you play the album,

8.16 The Video snapshot Save options.

the clips play in the order of creation. This is a nice option when you are photographing events. You should note, however, that there are a number of limitations when using

this option. For example, you can only combine video clips of the same length. If you turn your camera off, a new file is created and starts a new album, so plan accordingly. You can review a clip before deciding to keep or delete it from your album.

To create an album while in Movie shooting mode ('🎥), look in Movie shooting menu 2 (▥) and select Enable. You then have two additional options: Use the current album file or create a new one. The next option is to determine how long you want your clips to be. Once you engage this option, all of the videos you shoot are limited to the time selected. A blue bar is placed on the screen, and it counts down how many seconds you have left. When you finish using this mode, disable it to return to the standard recording functions.

> **NOTE** Once you create a new video snapshot album, you cannot add new video clips to previous albums in the camera.

Equipment

To turn your still camera into a serious video camera, extra video equipment is neces-sary, such as lights, lenses, microphones, headphones, a tripod, and focusing aids. The following is a list of recommended equipment if you plan to shoot some serious video:

▶ **Color meter.** This is a useful tool when you are shooting different scenes in various lighting conditions. It measures the Kelvin temperature of the light in your scene so that you can accurately correct the white balance. It also helps flow each scene together by preventing obvious color shifts that may distract the viewer.

▶ **Microphone.** As covered earlier in this chapter, microphones are an important investment when it comes to video. The type that you purchase depends on your needs. An omnidirectional microphone captures the sound all around it, while a unidirectional mic focuses where it picks up sound.

▶ **Neutral density (ND) filters.** If you want to take advantage of slow shutter speeds and shallow depth of field, you can achieve this with neutral density (ND) filters. They limit the amount of light coming into your camera, which helps maintain the desired exposure in bright environments that would otherwise require faster shutter speeds and larger aperture settings.

▶ **Lenses.** If you are interested in a lens designed specifically for video, Canon offers the STM series. They are quieter than traditional lenses, reducing the amount of camera noise picked up by the internal microphones. Lenses with stabilization features are also worth your consideration because they can add a shutter speed the equivalent of up to 4 stops faster and prevent any unwanted camera shake.

▶ **Lights.** LEDs are popular with dSLR photographers shooting at close range. White fluorescents are also a good, all-purpose solution. HMI lights are ideal when you need powerful lights.

▶ **Loupe.** This can help you check the camera's focus, and it is important that you continuously do so, especially if you are using the Manual option. A full LCD screen cover loupe or viewfinder is also helpful outdoors because bright sunlight often makes it tough to see the LCD screen clearly. You can also use the Magnify button (🔍) to see details of your scene or image without a loupe.

▶ **Recorder.** A secondary audio recorder is highly recommended if you need high-quality sound. Make sure that you have a good set of headphones, too.

▶ **Support.** When you hand hold your camera, keeping it steady is important. Many companies make different types of brackets or support rigs that attach to you to keep the camera steady, even while you are moving.

▶ **Tripod.** A good tripod is one of the most important pieces of equipment you can buy for your camera and, especially, for shooting video. The head should be fluid and flow without jerking motions.

▶ **Bag.** Consider purchasing a good utility bag or belt to keep everything handy when you are on the move.

Make sure that you have extra batteries and memory cards. The Movie mode ('🎥) uses a lot of power and drains batteries quicker than still photography. Video also takes up a lot of space on memory cards. I recommend purchasing at least one high-quality, class 6 (fast) 16GB memory card.

Types of video

What type of video are you going to shoot? There are many ways to approach creating a video. Some are as simple as using your camera to capture family events. If you want, you can keep everything on automatic and, as you become more comfortable with your camera, you may decide to use more manual options.

The following is a list of a few types of videos you can shoot:

▶ **Testimonials.** Let your clients do the talking. Businesses upload videos of clients singing their praises to YouTube or Vimeo to be shared on websites or social media. These videos are rarely more than 2 minutes long and, in most cases, less than a minute is ideal. Make sure that you use a tripod and flattering lighting. You don't want to make your good client look bad. Ask your clients to share who they are and why they like working with you. Record the testimonial a few times until you are both satisfied with the results.

▶ **Business videos.** In general, these videos tell a company's story. You need to let people know what the business is and why they should use it. A person standing in front of the camera talking for 15 minutes doesn't accomplish this very well. Show people what the president of the company is talking about. This involves capturing and editing in some b-roll detail segments of the company. *B-roll* is additional video that supports the main video with details, behind the scenes shots, or examples of what the subject is talking about. Successful business videos are often entertaining and funny.

▶ **Demonstrations.** Sometimes, it's easier to *show* people how to do something rather than tell them. Video is a great way to share your knowledge and expertise.

8.17 A sample frame from a demonstration video created with the Canon Rebel T4i/650D.

▶ **Sports and action.** This type of photography requires longer lenses, faster shutter speeds, a great eye, and timing. You must anticipate what is going to happen, which requires a deep understanding of your subject.

▶ **Documentary.** This type of moviemaking has been helped greatly by dSLRs with video. It has made recording video available to people of all skill levels, giving many a voice to tell a story. Some are personal, and others are related to a cause they want to share with the world. When creating your documentary, it is important to follow the professional rules of good moviemaking. Use the manual settings, and make sure that your camera is steady and that you have good audio.

Helpful Hints for Shooting Video

The following is a list of documentary photographer Gail Mooney's tips for shooting video with a dSLR:

▶ **Tell a story.** Don't just string various video clips together in a timeline and assume it tells a story.

▶ **Shoot in sequences (many different shots).** Long video clips are a sure sign of an amateur. If you're shooting a birthday party, take separate shots of the cake, different people present at the party, gift opening, and so on, and then put them together in an editing program. Don't just zoom and pan to these items in one long clip.

▶ **Use a tripod.** There is nothing worse than shaky video; use a tripod to keep the camera still.

▶ **Don't use automatic settings (such as autofocus, auto exposure, and so on).** Video is time in motion, not a moment in time like a still image. That means when you shoot in an auto mode, the exposure and/or focus change during your shot, which is a big no-no in a video.

▶ **Don't use music illegally.** Music is copyrighted. If you don't have permission or secured licensing rights to use it, then don't.

▶ **Let the motion happen in front of your camera.** You don't always have to move the camera. Minimize pans and tilts (vertical panning), which are also the signs of an amateur at work.

▶ **Don't change your shutter speed to adjust exposure.** Your shutter speed should be 2 times your frame rate. So, if you are shooting 24 frames per second, your shutter speed should be 1/48 second, or whatever setting is closest to that for your camera.

▶ **Audio is more important than visual.** If you stand in the back of a room for a concert with a microphone on your camera, you'll pick up the sound of the people in front of you instead of the orchestra.

▶ **Remember to shoot horizontally.** Have you ever seen a vertical TV set? No, and this is why you should always shoot video in the horizontal orientation.

▶ **Watch TV commercials without the sound.** This will help you see how stories are told in sequences.

Gail Mooney has been shooting feature stories for publications for 30 years. Her work has been featured in National Geographic Traveler and Smithsonian Magazine. She has been shooting video for 15 years, and recently finished her first feature film, Opening Our Eyes. To watch the trailer, visit www.openingoureyesmovie.com.

Viewing, Editing, and Sharing Your Images

By now, your camera is probably full of great photographs and videos. The next step is to review, edit, and share them. Your camera offers some helpful playback and review functions, such as the LCD touch screen. Postproduction editing can sometimes be complex, but if you only want to make a few adjustments, you can do so on your camera. After you adjust your photos, it's time to share them. This chapter covers the playback and editing options available on the Canon T4i/650D, as well as how you can store and share your images.

Here, the Canon T4i is connected to a laptop computer.

Viewing your Images

Viewing images is as much fun as taking them. The LCD screen makes it easy to review your photos quickly. The instant feedback—such as the lighting and composition—helps you become a better photographer. There are a few ways that you can review your images beyond the LCD screen, but let's start there.

Viewing images or videos on the camera

In most cases, the first place that you see your photographs and videos is on the LCD screen on the back of your camera. I highly recommend that you protect the LCD screen from scratches by closing it when it's not in use. To close the screen, turn it around to face the camera. The LCD touch screen is one of the top features Canon has added to the T4i/650D. It's fun, easy to use, and adds a new dimension to viewing pictures. I'm sure that it's soon to become a standard feature on Canon cameras.

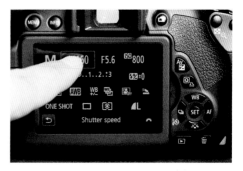

9.1 The LCD touch screen on the back of the camera.

Playback

To review your photos or videos, press the Playback button (▶). To scroll through your images, use the Cross keys, or swipe your finger across the LCD screen. To magnify an image, place two fingers (generally the thumb and index finger) on the LCD screen and spread them apart in a swiping motion across the LCD screen. To zoom out, create a pitching motion bringing your fingers together across the LCD screen. If the image on your screen is a video, you see a large Playback icon (▶) in the middle of the screen; press it to start the video. To stop a video, tap the LCD screen with your finger or press the Set button (⊛). If you see the Movie Set icon (SET 🎞) in the upper-left side of the LCD screen, this means that the video is part of a video snapshot album.

CROSS REF For more information about video snapshot albums, see Chapter 8.

To control a video, use the other icons along the bottom of the screen. The Slow motion playback button (I▶) is next to the Play button (▶). Use the Cross keys to change the playback speed rate. The next icon, First Frame playback mode (◄◄), takes you back to the first frame. Next to that is the Previous Frame playback button (◄II), and then the Next Frame playback button (II▶).

On the far right is the Last Frame playback button (▶▶), and then the very last icon is used to turn music on or off. Above the music icon is the Edit mode button (✂). You also can use the Magnify (🔍) and Reduce (🔍) buttons on the upper-right side of your camera to zoom in or out on a video or image. The Delete button (🗑) erases your images.

If you want to hear the sound of your recording, the speaker is on the back of the camera. I recommend downloading the video to your computer and listening to it with a good set of headphones.

The Quick Control/Print and Info buttons

There are additional viewing and editing options available via the Quick Control/Print button (🖼). On the left side of the LCD screen, you see the following list of helpful features:

▶ **Protect images (🔒).** This option protects important images from being accidentally deleted. Once protected, locked images cannot be erased until you unlock them or clear all information by formatting the memory card.

▶ **Rotate image (🔄).** You can rotate images 90 degrees to the left or right, or rotate them to be horizontal. If you need to flip or turn your photograph upside down, you have to do so with photo-editing software.

▶ **Rating (RATE).** For better organization of your photographs, you can rate them based on how much you like each one using a 1-5 star rating system.

▶ **Creative filters.** You can add creative filters to your photographs in-camera. You have the following options: Grainy B/W, Soft focus, Fish-eye effect, Art Bold Effect, Water Painting Effect, Toy Camera effect and Miniature effect. All options are saved as a new file on your memory card.

▶ **Resize.** If you want to save your file in a smaller size, use this option. You can resize an image to any size smaller than its current size. For example, you can resize a Large fine image (◢ L) to the Small 3 size (S3). You cannot increase the size of any image. Once you resize an image, it is saved as a new file.

When you press the Info button (**INFO.**), you get one of four display options in which you can review image data, such as the aperture, shutter speed, and ISO settings. Other options let you review histogram data, including brightness and RGB.

Viewing images on a TV or smart device

The following list includes a few of the other ways (beyond the camera and your computer) in which you can view your photos and videos:

▶ **Viewing images on a standard TV.** Connecting your camera to a non-HDTV requires a stereo AV cable (the AVC DC400ST is available from Canon). Insert the plug into the AV Out terminal on the left side of your camera. Connect the three split connects to the TV's right audio (red), left audio (white), and video (yellow) ports. Turn on the TV and select the TV's video input option. Turn on your camera and press the Playback button (▶). You should then see the camera screen on your TV.

▶ **Viewing images on an HDMI HDTV.** To connect your camera to a high-definition TV (HDTV), you need an HDMI cable (HTC-100) compatible with the HDMI terminal on the left side of your camera. Connect the cable to your camera's HDMI Out port and the other end to the TV's In port. Turn on the camera and press the Playback button (▶). The image only appears on your camera's LCD screen—you must press the Info button (**INFO.**) to change the view settings.

▶ **Viewing images on a smart device.** You can connect your camera to some smart devices using downloadable apps. Some require that you connect to a Wi-Fi-enabled computer first or use an Eye-Fi card with workarounds, which I do not recommend. Workarounds can get complicated and even void your device warranty. Apple has an iPad camera connection kit available that allows you to connect your device via a USB cable to view photos and video. This area is continually evolving, and worth searching the Internet once in a while to check out the latest updates.

Downloading and storing your images

There are three main methods of downloading images to your computer. You can connect your camera to your computer via a USB cord. If your computer is equipped, you can insert the memory card into a built-in reader, or you can take the memory card out of the camera and use a memory card reader. If you prefer to use software programs,

such as iPhoto, Image Browser EX (which came with your camera), or Lightroom, you can easily import your photos.

Another option is to use an Eye-Fi card, which transfers your photos wirelessly. Your camera has Eye-Fi card settings in the Setup menu 1 (**?**). Once you are connected or have transferred your photographs to your computer, you can open them in your favorite editing program. I recommend that you tweak and adjust your photographs before sharing them. I cover how to use your Digital Photo Professional software later in this chapter.

9.2 Some photographers prefer to use an external memory card reader to download their images.

9

Storage

You have many choices when it comes to storing your photographs. Many casual photographers just leave photos on memory cards, and buy new ones or erase old images on them when they run out of room. If this is your method of storage, I recommend that you consider using one of the following options instead. Your computer hard drive is a good starting point. If you take a lot of photos and videos, your computer's hard drive will fill up fast. Consider purchasing an external hard drive on which to store all of your photos and videos.

Optical storage devices, such as CDs, DVDs, and Blu-ray discs, are another storage option. Optical storage uses light (such as lasers) to read data. They are easy to use and are a good short-term option or for use as part of an overall storage plan. I don't recommend optical storage for the long term, though, because they can degrade over time if not stored in a cool, dry location.

If you are concerned about backup and generate a lot of images, consider purchasing something like a RAID (redundant array of independent disks) system or Drobo hard drive. These are designed to be redundant and prevent data from being lost by using multiple hard drives. If one drive crashes, it can be replaced without the worry of losing information, like your photographs.

The cloud is another storage option to consider. Storing your images on *the cloud* means that your photographs are saved on a company server via the Internet. Even if you already keep your photos on free storage sites, such as Google, Amazon, or Dropbox, the cloud is one more place that can keep your files safe. There are many locations online that give you even more storage space for a price, so make sure that you compare costs. I wouldn't recommend storing all of your photographs online because it can get expensive very quickly, especially if you shoot video. It also takes a lot of time to upload an entire vacation's worth of photos and videos. However, consider storing at least some of your prize photographs, such as important memories and portfolio-worthy images, online.

You should definitely take the time to organize your photographs. Give them filenames that make it easy for you to find them later. You have a numbering system available on your camera in the Setup menu 1 (⚙). There are three options: Continuous, Auto reset, and Manual reset. Continuous keeps the name of your files in order from 0001 to 9999, and then resets. Auto reset restores the file number to 0001 each time the memory card is replaced or when you create a new folder. Manual reset lets you reset the numbers at any point in time.

Photograph files start with IMG_ and video files begin with MVI_. This may not be the best way to store your files for the long term. Creating folders with descriptive names is a good way to store your images. A better way is to use software, such as Lightroom or Digital Photo Professional Batch, to rename your images so that they can easily be found through the search function. I explain this in more detail later in this chapter.

The 3-2-1 rule

When storing your photographs, it is important to follow the 3-2-1 rule. My friend Peter Krogh, who is an expert in digital asset management, taught me this rule. He suggests having three copies of your photographs on two types of media, including one off-site. Saving three copies of all of your files could mean putting them on different hard drives, DVDs, or Blu-ray discs. The idea is that you don't keep all of your images in one location where you could lose everything in a matter of seconds—this includes storing all of your photographs on your camera.

The rule to save your files on two different media forms is a safety net in the event that one type fails or becomes obsolete. Remember Zip drives and floppy disks? If you had data saved on any of those mediums, you would have trouble retrieving it. Storage methods are changing all of the time and you should be prepared. It has been said that a CD will last 100 years, and some might, but I'm sure many CDs from just 10 years ago are not being stored at their optimal temperature and humidity levels. Many people have lost data that they thought was secure on CDs and DVDs. Make sure that you increase the odds in your favor by using multiple technologies.

Finally, make sure that one of your storage devices is off-site. This could be at your office, in a safety deposit box, or on the cloud. The bottom line is if all of your data is stored in the same place, and that place burns in a fire or is swept away by a flood, it really doesn't matter if you kept your files on three different devices.

Editing Images and Videos on the Camera

Your camera has many editing options, the easiest of which is deleting unwanted photographs. However, I do not recommend deleting images on your camera because you never know what you might want to use later. It's also hard to make a clear judgment of what a photo looks like on a small screen. Sometimes, though, you have to delete images to make room on the memory card, which is why having backup memory cards is important—it prevents you from having to delete good images. Also, if it's obvious that an image is out of focus or underexposed, you want to delete those to make room for usable images.

Other editing options in your camera include resizing and creative filters, all of which are found under Playback menu 1 (⬛). Resizing allows you to decrease your images to all sizes smaller than its original size. The creative filters give you seven options to enhance or experiment with your photographs. The options include Grainy B/W, Soft focus, Fish-eye effect, Art Bold Effect, Water Painting Effect, Toy camera effect and Miniature effect.

9.3 The Canon T4i/650D has creative filters, such as the Water Painting Effect, which can enhance your photos. (ISO 100, f/10,1/200 second)

You can use the Picture Style editor to adjust RAW photographs on your camera. If you don't like the results of the auto setting or the Picture Style setting you chose in your camera, you can adjust or change it. You can also customize a photo with a new style using the available tools under the advanced menu. Use the side-by-side windows option to see how your adjustments affect the original image.

If you like the Picture Style you have created using this utility, you can save it to your camera as one of the user-defined options. To do this, click the File menu in the Picture Style editor and save as a Picture Style file. If you don't want anyone to make additional adjustments to your file, select the Disable subsequent editing check box. If you do this, though, note that you can't reload the file in the Picture Style Editor for use or additional adjustments.

To load your Picture Style onto your camera, connect the camera to your computer and launch the EOS Utility. Click on Camera settings/Remote shooting, and then click the red camera icon in the middle of the screen. Next, select Register User Defined

style. To the right of the current listed Picture Style is an open folder icon that opens a browser to your computer files so that you can search for your Picture Style file (called a PF2 file). Select the file, and then click OK, and the computer and camera do the rest. Now you can use your Picture Style with the remote utility and on your camera.

You can also perform some basic editing functions on your videos on the camera. Press the Edit mode button (✂) to go to the Editing screen. You can delete the first or last 1 second of your video. This option is not available for video clips in albums. You do have the option to save your edited video as a new file or overwrite the old file.

TIP You can download additional Picture Styles from Canon here: http://web. canon.jp/imaging/picturestyle/file/index.html.

Sharing your Photos

For many photographers, the great reactions and compliments they receive when sharing their images is a wonderful reward for their work. This section covers how and where you can share you photographs with friends and family.

9.4 Google+ is just one of the online options available for sharing photos.

215

E-mailing

You can use the Image Browser EX software that came with your camera to e-mail your photos. The e-mail option is under the Share menu, and it downsizes the file for you before launching your e-mail program. You can also download and attach an image in your e-mail program. If you need to downsize your image for e-mailing purposes, it can be done on your camera. Press the Playback button (▶) and use the Cross keys to find the image you want. Then, press the Quick Control/Print button (🖳) and select the Resize option. You can also select Resize in Playback menu 1 (🗐). Small 2 (**S2**) or Small 3 (**S3**) are good file sizes for e-mail.

Printing

You can print directly from your camera. To do so, turn off the camera and connect it to your printer via the provided USB cable. Set up your printer to communicate with your camera (you may have to consult your printer manual to do this). Turn on the printer—it may beep to let you know that it is connected to the camera. Next, press the Playback button (▶) and use the Cross keys to find the image you want to print. Press the Set button (⑤), and then follow the directions on the back of your camera.

If your camera and printer are not compatible, you can try placing your memory card directly into the printer, if that option is available. You can also use the Image Browser EX software to print your images from your computer.

Uploading images to a website

When you upload a photograph to a website or a blog, you don't want to upload the original file because it's too big. In most cases, website images only need to be less than 800 pixels wide (often, they are even smaller than that). Your camera's RAW and large files produce images with more than 5000 pixels, which are too large and take too long to upload. This means that you need to reduce the size of your images in editing software. If your original file is still on the memory card, you can use your camera to downsize your photographs. This option is found under Playback menu 1 (🗐).

The following are just a few of the many ways in which you can upload images to the Internet:

▶ **FTP (File Transfer Protocol).** If you need to upload your photos to a website or for storage on the web, this is generally the way to do it. There are many FTP programs, such as Filezilla (http://filezilla-project.org/), available for Windows

users. Some cloud storage websites have their own FTP sites available for cus-tomers to transfer files. I use the FTP client Transmit For my Mac (http://panic. com/transmit/). It has two windows: One displays my computer files and the other is where they are uploaded or downloaded. I like this program because you can easily drag and drop files onto the server folder.

▶ **WordPress.** This is a popular website and blogging platform. It certainly isn't the only one, but if you know how to use WordPress, the others will be easier to navigate. Under the title box on your post or page, there is an icon that looks like a camera. This is a common icon in social media, and when you click it, it opens a new window with multiple options. Select an image from your computer using a browser window, or drag and drop it. There is also an option for sharing an image via a URL, which is a link to a photograph that is already posted on the Internet. The final option is to use images already uploaded and stored in the WordPress gallery.

9.5 You can drag and drop files to upload to WordPress.

Sharing photos via social media

Social media is a great way to share your story with friends, family, and associates around the world. Your photos and videos tell your story and keep you connected. Websites such as Google+ and Facebook have nice gallery options to display your photos in groups. Although you can store a lot of photographs online through these services, I would not recommend using them as permanent or archival locations for your photographs.

When sharing your photographs on social websites, you should always read the terms of service, and make sure that you understand how they apply to photographs and video. Often the terms indicate that the owners of the website can do anything they want with your files, so you'll have to weigh the options.

The following are a few of the social media websites on which you can share you photos and videos:

▶ **Google+.** Adding a photograph to Google+ is easy. All you need to do is click the camera icon below the status update icon. You are then given three choices: Add a single photograph, Create an album with multiple photographs (this option offers a convenient drag-and-drop method if you have a lot of images to share), or Automatically upload through your smartphone. Next to the camera icon is the video icon, which also gives you three options: Upload from your computer, Share a video from YouTube, or Retrieve images from your instant upload archive.

9.6 Click the camera icon on Google+ to upload photographs.

▶ **Facebook.** To attach a photograph to your Facebook status update, click the Add photo/video button above where you place status updates at the top of the page. Three options appear: Upload photo/video, Use webcam, or Create photo album.

9.7 Click Upload photo/video to share your images with friends on Facebook.

▶ **Twitter.** To add a photograph to Twitter, click the camera icon in the lower-left corner of the Tweet message box. The browser screen appears so you can search your computer and upload your image.

▶ **Pinterest.** To upload a photograph to Pinterest, click the Add button (+) and a new screen appears with three options: Add a Pin, Upload a Pin, and Create a Board. The first option adds a web address (URL). The second option is for uploading photos from your computer. When you select it, a browser window opens so you can find an image on your computer. The third option creates a new board to which you can pin your photographs.

9.8 Click the camera icon to upload a photograph to Twitter.

9.9 Click the Add button (+) on the front page of Pinterest, and then click Upload a Pin to share photographs from your computer.

These days, social media can be an incredibly useful tool for getting your work to the masses. C.C. Chapman is a well-known social media marketing consultant and photographer. The following are some of his tips for sharing and marketing your work via social media:

▶ **Your domain is the most important space.** Having your own website is more important than ever. Make sure that it looks great in all browsers, including those on tablets and phones. Have your contact information front and center so that no one ever has to search for it. Use social media sites and tools to drive traffic to your main site.

▶ **Don't share and forget.** Be interactive and conversational. Too many people assume that if they tweet, pin, update, and share, they will magically find success with social media. This couldn't be further from the truth. If you want to be successful, you need to share and interact with the people you meet. Comment on sites and share other interesting things that you find. Don't make all of your social media content about yourself and your work.

▶ **Find out where other photographers are sharing their work.** A team of pho-
tographers built 500px.com and they've created a great community of passion-
ate photographers. Google+ has also become more popular in the photography
community.

▶ **If you must watermark, make it useful.** There is an ongoing debate between
those who watermark their images and those who don't. I personally fall into the
don't-do-it camp. If you must do it, make it useful. Watermark with your name
and URL so that every image turns into a virtual business card for you.

▶ **Choose the content that you share carefully.** If you are looking for profes-
sional work, make sure that you are only sharing your best work. If you are a
more casual photographer, figure out how you want to leverage social channels,
and then share the type of photos you want to be known for. Don't be afraid to
use moment-sharing apps, like Instagram, to share more casual snapshots.

*C.C. Chapman is an entrepreneur, author, speaker, and storyteller. His photos and
words have appeared in Rolling Stone, The Wall Street Journal, The Boston Globe,
and on CNN. He is the coauthor of the best-selling book, Content Rules, and is the
host of Passion Hit TV. You can find him on the web at: www.cc-chapman.com.*

Postproduction

With the advent of digital technology, once you press the shutter button, you have completed half the job. Next, you need to edit your photographs and decide which of them you want to share. Chances are you will make some adjustments before your images are uploaded, e-mailed, printed, or shared via the Internet or social media. Sometimes, only a few basic adjustments are necessary, such as cropping, lightening, or sharpening. Other times, you may want to create a work of art from your image. A successful video also relies on postproduction. After shooting it, you have to combine the different elements of a video to tell a story. Entire books have been written about many of the editing programs covered here, and you should refer to those if you need more detailed instructions; this Appendix is intended to be an introduction.

AA.1 Family vacation photos can take as much time in postproduction as a professional assignment. (135mm lens, ISO 400, f/8.0, 1/1000 second)

Photo-editing Software

Editing your photographs is as important as taking them, and selecting the best of a batch is not usually an easy task. Photographers put a lot of emotional energy into their work, but often select images to share based on the wrong reasons. The reason for the selection is sometimes linked to a backstory that is not represented in the photograph. For example, maybe you had to overcome some major obstacles to capture an image, but the result wasn't all that spectacular. It takes practice to pick your best shots based on technical and aesthetic concepts. Once you select your photos, you need to make additional adjustments. You have many options available on your camera when you are shooting your images, such as Picture Styles or adding filters. However, after shooting is complete, there are numerous photo-editing programs that can help you enhance your images. Canon includes some helpful software with your camera, such as Digital Photo Professional. This section examines some of the editing software options available and their features.

Each program handles tools differently, but the basic functions are the same. I cover additional features that are specific to each program later in this appendix. The following basic functions are found in nearly every photo-editing program:

▶ **Color balance.** Sometimes your photographs look too red, too green, or too blue (among other possible shades), and need to be corrected. Often, the goal is to neutralize a color that is tinting your entire photograph away from the natural color. Color balance is generally presented in the form of a slider or curves tool (a grid with a diagonal line). A curves tool is designed to be more precise than a slider, although sliders are easier to use.

▶ **Cropping.** If you don't like all of the elements in your image, you can cut them out with a cropping tool. Some tools allow you to crop any way that you want, while others offer ratio guides so that you don't crop at odd dimensions. If your final crop is not in line with a standard ratio, it makes it difficult to print using traditional paper sizes.

▶ **Dodge and burn.** If you want to lighten an area of a photograph, select the dodge tool. When you wish to darken an area, pick the burn tool.

▶ **Exposure.** This option makes your photograph either lighter or darker.

▶ **Fill light.** The idea behind this tool is to lighten your subject as a fill flash would so that you can see more detail in the subject.

► **Filter effects.** Each program has its own suite of filter tools. These effects can range from turning a color shot into a black-and–white, to softening or posterizing (that is, changing the entire color scheme).

► **Red-eye correction.** When you use flash in a dark environment, the subject's eyes can reflect light back to the camera lens, making them appear red. This is called red-eye and these tools make adjustments to minimize the effect.

► **Resize.** Sometimes you need a large image resized for the web or e-mail. Although you can accomplish this in your camera, it may not be necessary at the time. There are free photo resizing tools available online, such as www.picresize.com.

► **Rotate.** When you want to turn your image to the left or right, use the rotate option.

► **Saturation.** When you want to intensify the colors in your image, use this option. A little saturation is helpful for most images, but too much makes the photographs look unnatural.

► **Sharpening.** Sometimes your image is not as sharp as you would like. Sharpening tools are helpful, but don't expect miracles, especially from online editing software. Higher-end programs, such as Photoshop, do a good job depending on the degree of blur. There is a point, however, at which sharpening tools cannot sharpen your photographs.

► **Touching up/healing.** These tools are good for small imperfections in the photograph, such as dust or blemishes on skin. They do a good job in most cases. The larger the area, the better the software needs to be to correct it.

There are many photo-editing software programs available. Some are available on your computer when you buy it, such as Apple's iPhoto or Photo Gallery for Windows. Others are open source and can be downloaded from the Internet. If you want to take your photographs to a professional level, you can purchase premium software with deep features and more control.

The following sections offer an introduction to some of the photo-editing options available to you. The secret to using editing software is to avoid overdoing it. Although heavy effects, such as high-contrast and saturation filters, are popular, it is good to start small and work your way up. Not every technique or filter works for every image. Don't use more than one or two effects on an image unless you have a well thought-out plan. Too many styles in one photograph usually do not work. As I tell my students, if the first thing people think when they see your image is that you used Photoshop, you need to rethink your process.

Digital Photo Professional

This software is included with your camera, so I cover it more extensively than the other programs in this appendix. If you don't have a software option like Photoshop available to you, this program works with your RAW images, although JPEGs and TIFFs work just fine with this software, too. When you launch Digital Photo Professional, the main window appears with a row of options at the top. You see the photograph available from the folder you have selected. If you don't see the folder options from your computer, click the Folder view button. You may select a photograph and work on it in the thumbnail view, or you can click on it to make adjustments in a larger format.

AA.2 The main window of the Digital Photo Professional software that comes with your camera.

The following tools are available in the main window of the Digital Photo Professional software:

▶ **Edit image window.** This option takes you to the editing window where you can select the images you want to work on in the main window.

▶ **Folder view.** To select images to work on, you need to see the folders on your computer. This option lets you display or hide the window showing your files.

▶ **Tool palette.** You can use this palette to make color corrections with curves, or to sharpen, increase saturation, or adjust contrast and brightness on both RAW and JPEG files.

▶ **Info.** To see the photograph's shooting information, select this option to view items such as shutter speed, aperture, ISO, and image size.

▶ **Select all.** Use this option to select all of the images available in a file. You can then adjust the entire collection simultaneously.

▶ **Clear all.** To deselect all selected images, click this button.

▶ **Rotate left/Rotate right.** Use these buttons to rotate your photos left or right.

▶ **Quick check.** This option is for a quick review of metadata, or rating and rotating your images.

▶ **Stamp.** This tool can replace part of your image with a similar section to repair it. If you are using the Dust data collection option, found in Shooting menu 3 (⬛) on your camera, you can also process it in this window.

▶ **Trimming Angle.** This cropping tool allows you to make crop adjustments by rotating your image.

▶ **Batch process.** Use this option when you need to resize or rename multiple files.

AA.3 You can batch process to resize or rename multiple photographs.

When you click the Edit image window button, a new screen appears with a different set of icons. Some of these are the same as the main window, such as the Tool palette, Info, and Batch process. If your photograph needs a lot of work, this is the window you want. You also have access to the Tool menu at the top of the screen.

AA.4 The options available in the Edit image window.

The following options are available in the Edit image window:

▶ **Main window.** This option returns you to the Main window.

▶ **Thumbnails.** This displays the images selected in the Main window as thumbnails.

▶ **Tool palette.** This is the same palette found on the Main widow. You can use it to adjust curves, sharpen, increase saturation, or adjust contrast and brightness on both RAW and JPEG files.

▶ **Info.** Click this button to review shooting and metadata.

▶ **Grid.** Clicking this places a grid across the image to balance and square up your scene. There is only one grid option.

▶ **Fit to window**. If you magnify or reduce your photograph, use this to resize it to the original viewing size that fits the screen.

▶ **50, 100, and 200 percent view.** These buttons magnify or reduce your images for viewing purposes.

▶ **Previous image/Next image.** These buttons take you to the next or previous photograph within your selected group.

▶ **Rotate left/Rotate right.** Use these buttons to rotate your photos to the left or right.

▶ **Stamp.** This is the same tool that is in the Main window. You can use it to replace part of an image with a similar-looking section to repair it. If you are using the Dust data collection option, found in Shooting menu 3 (🖻) on your camera, you apply that information and process it here.

▶ **Trimming Angle.** This is the same tool that is in the Main window. You can use it to crop your photos by rotating them.

▶ **Batch process.** This is the same option as that in the Main window. Use it when you want to resize or rename multiple files.

To reduce noise in RAW, TIFF, or JPEG images, select the NR/ALO option on top of the Tool palette and adjust the noise reduction sliders as needed. The CD included with your camera also contains a photography management program called Image Browser EX.

Image Browser EX

For quick browsing, importing, and management of your photographs, Canon gives you Image Browser EX on the CD that comes with your camera. You can use this software to import your photographs for review. You have three options to view your image: Thumbnails, preview, and full screen. If you want to make adjustments, the software pops up a new window specifically for that adjustment. I find the pop-up window a little awkward, but the adjustments are available when needed. If you have a lot of work to do on your photographs, I recommend using the Digital Photo Professional software that comes with your camera or your favorite photo-editing software.

Lightroom

Lightroom is a photo-management and editing software package made by Adobe, the same company that owns Photoshop. It makes it much easier to work with a lot of photos because you can make adjustments to multiple images, such as sharpening, contrast, color, and saturation. When you have major enhancement or repair work to do on a photograph, you can also switch to Photoshop to complete that task. Like Photoshop, you can create and download actions in Lightroom. An *action* is a recorded series of commands that create a specific effect and can later be applied to other photographs.

AA.5 Adobe Lightroom 4.1 is a powerful photography-management tool.

Lightroom features the following seven modules to help you manage and share your photos:

▶ **Library.** The Library module helps you organize your photography collections. Here, you can import, export, rank, and review images. You can also add keywords, apply presets (programs that adjust or add specific settings to your images), or publish your photographs to Facebook and Flickr.

▶ **Develop.** You adjust your photographs in this module. All of the basic options, such as cropping, exposure, contrast, and color correction are available. Presets are also available under this module. *Presets* are like actions—they allow you to run a series of adjustments on a photograph at the press of a button.

▶ **Map.** If you geotag your photographs, this map displays the location at which the image was shot. You can also add location information to your photos in this module.

▶ **Book.** This module allows you to lay out a photo book that can be uploaded to the book publishing service Blurb. A Blurb account is required to use this feature.

▶ **Slideshow.** In this module, you can create a slide show of your favorite images. It features useful options, such as adding text, sound, background images, and transitions. You can also export your slide show as a PDF or movie.

▶ **Print.** Use the Print module to send your files to a selected printer.

▶ **Web.** This option helps you create a website gallery to display your images online. It is also helpful as a preview site creator for friends or clients. You can save your gallery to your desktop or upload it from Lightroom.

iPhoto

This software is available for Mac users. It comes preloaded on some computers or it can be added as part of Apple's iLife software package. It is more of a photo-management tool than editing software. It does have basic adjustments available, such as lighten, darken, saturation, and creative filters. I often use iPhoto for slide shows and presentations.

AA.6 iPhoto is a good photo-management tool for the Mac platform.

iPhoto has a few options worth noting. You have three tool sections found under the Edit button called Quick Fixes, Effects, and Adjust. Quick Fixes is convenient when you have a few minor adjustments. Here, you can Rotate, Enhance (increases saturation), Fix Red-Eye, Straighten, Crop, and Retouch. Effects includes the following exposure adjustments: Lighten, Darken, Contrast, Warmer, Cooler, and Saturate. Effects also has nine style options, including B&W, sepia, and vignette. Adjust gives you more manual control with the use of sliders to change image exposure and color.

Photoshop

Photoshop is the standard software for professional photographers. If you have heavy-duty work to do on your photographs, then this is the program you need. It has very powerful filters, and the Layers feature is better than any other program, in my opinion. It has tools like the Content-Aware Patch, which allows you to move subjects from one area to another within an image, the Adaptive Wide Angle tool which corrects camera distortion, and numerous other enhancement tools. However, it's important that you learn the basics before you dive too deeply into the more complex options.

AA.7 Photoshop is the program to use for heavy-duty editing projects.

The following list covers some of the basic tools in Photoshop, as well as a few of the more advanced options:

▶ **Actions.** This feature helps you complete a series of tasks at the click of a button. If you regularly perform the same adjustments on multiple photographs, create an *action* (a mini program) rather than performing repetitive clicks. To create an action, open a photograph, and then click the Actions tab (next to History). Use the Record, Stop, and Play buttons at the bottom of the window as you would any recorder. The next time that you need to apply the same steps, click Play and the action adjusts one image or a folder full of them.

▶ **Burn tool.** There are many uses for both the Dodge (lighten) and Burn (darken) tools, and you should learn to use both well. One common use is to darken distracting backgrounds or create a vignette around the edges of your photograph.

▶ **Color dodge**. Try the Color dodge tool rather than using the standard Dodge tool to lighten an area of your photograph. Select the Brush tool, click the Mode menu, and then select Color dodge. Use the Eyedropper tool to select the color you want to use as part of the dodge function. Make sure that you use this option at a low opacity (15-25 percent). I apply this technique to create a sunlight effect on the front of a building or to add a glow of light through a window.

▶ **Erase.** This tool's use may seem simple and obvious, but it's also an excellent blending tool when used with layers. If you erase portions of an upper layer, you see the layer below it. In some cases, the best option is to set the eraser at a lower opacity, and then gradually erase the top layer until the front and back layers are blended to your satisfaction. Click the eye icons next to the layers to review what sections have been erased.

▶ **Layers.** Learn to use *layers* (multiple images stacked on top of each other) well. They are helpful when making adjustments, adding effects, or blending objects and scenes.

▶ **Liquify.** This tool is so much fun to use, it's easy to overdo it. Liquify (found under the Filter menu) allows you to push, pull, and move sections of your image as if it were liquid. It is common to use this option to exaggerate your subject's features. A more practical use is to make small adjustments to your scene or subject. For example, photographers use Liquify to make their subjects look thinner.

▶ **Patch tool.** This is a freehand healing tool (and my personal favorite) that blends areas of any shape, making it easy to remove scratches, blemishes, or dents from your subject. The Content Aware Patch tool allows you to remove or move a subject from one part of the image to another.

▶ **Transform.** This option is found under the Edit menu. Select a portion of your photograph or your entire image to straighten lines in scenes or buildings. Other options under Transform are Scale (use this to increase or decrease the size of a layer image, object, or the entire image itself), rotate, distort, adjust perspective, and warp your image.

Experiment with each of these options to find the ones that suit your needs. One tip for using Photoshop is not to use every tool at 100 percent—a little goes a long way, and that includes filters. Learn to use the basic tools, such as cropping, healing, the eyedropper, paintbrush, dodge, and burn to develop your own style. There are excellent books on the topic of Photoshop that can guide you through this feature-rich program.

Video-editing Software

Your goal when editing a video is to tell a story. Unlike still photography, the story is not told in one moment of time, but in moments of time. Editing takes a lot of work, and organization is one of the editor's best friends. If your video has a lot of sections, take the time to plan out the end result. When shooting your video, think about what you might need during editing, such as *b-roll* (that is, extra video elements and details), ambient sound recordings, and extra footage before or after a scene. In other words, don't be too quick on the trigger—keep the camera rolling a little longer. In this section on video editing, I introduce different types of software you can use for video editing.

The following are some of the basic features found in most of these software packages:

▶ **Edit clips.** To tell your story, you need to trim and combine different video clips.

▶ **Sound.** Sound is a very important part of your video. Some editors have multiple tracks so you can add or replace the sound on your video.

▶ **Timeline.** This displays your video and audio in chronological order within the software. Some programs also call it a storyboard.

▶ **Track.** A track contains video media data within different points of the video timeline. Editors like to have a lot of tracks for complex videos. Some editing programs limit the number of tracks available.

▶ **Transitions.** Rather than having hard cuts between clips, you have the option of adding transitions. These make the ending of one clip and the beginning of another more natural, exciting, or dynamic. Professionals use transitions, but tend to keep them simple. Some transitions dissolve, some swirl, and others fade between clips. Also, once you select a transition, use the same one throughout the movie to keep your presentation looking professional rather than gimmicky.

▶ **Text.** Usually, you will want to add text as an introduction or title for your video. You may also want to display information, such as the name of your subject, or list credits at the end of your video.

▶ **User Interface.** If a program is difficult to navigate, or you can't figure out where some features are or how to use them, you are not going to be able to create the best possible video. Don't settle for the first editor that you try. Test and download free trials to see which option works best for you.

When it comes to free software, iMovie for Mac and Windows Movie Maker are two of the better choices available. Image Browser EX comes with your camera and is easy to use as part of your workflow. If you want to create more complex videos, consider some of the more professional software, such as Adobe Premiere Pro or Final Cut Pro.

AA.8 Adobe Premiere Pro is used by advanced amateurs and professionals for video editing.

Image Browser EX

This is the browser that comes with your camera. It is relatively easy to use and has some basic editing features, such as Transitions, Filter effects, and Text. You can also add external audio. I find the image Extraction tool very useful. If you want to use a single frame as a still image for another use, this tool makes it easy to do. The browser also has a basic tool for editing video snapshot albums created in your camera.

To add videos to the Edit module, highlight the file in the main photo window in your Browser EX software. Under Edit, select Edit Movie to open a new pop-up window containing the video(s) you selected and the available editing options. The Edit module has four tabs: Arrange, Effect, Audio, and Save. Click Arrange to combine clips by dragging and dropping them into the desired timeline position. Effect contains the transitions, text, and filter effects. You can add seven transitions and 15 text options to your video here. Filter Effects has three options: RGB adjustment, Sepia, and Monochrome. RGB adjustment is helpful for correcting color when your video scene environment colors do not match. Audio allows you to add audio files from external recorders or music from your computer. Save gives you export options, such as File size, Type of file, and Sound quality.

iMovie

This software is available on all Macs and is easy to use (it's also available at the App Store). It can handle most basic editing needs, and I often use it to edit testimonial or demonstration videos. It also interacts with iTunes and iPhones, so you can add music and photographs easily. It's also easy to add text and transitions. If you want to export to online video-sharing platforms, such as YouTube and Vimeo, it is easy to do from iMovie.

Editing is as simple as highlighting your desired scene, then copying and pasting it into your timeline. You don't have to highlight an entire scene; you can select portions of a file down to a fraction of a second. You can rearrange the timeline by dragging and dropping scene files. Transition times may be time adjusted, and audio levels are raised and lowered by highlighting the audio section found below the video file. Once you complete your video, you can upload it to YouTube, Vimeo, or render it to your computer.

AA.9 iMovie is a good basic editor that comes with Mac computers.

Windows Live Movie Maker

Microsoft offers free editing software for those using Windows Vista or Windows 7. It is bundled with Windows Live Essential. You can download it at the Microsoft Windows website in the Downloads section. It is similar in design to iMovie, but with fewer windows. It has standard features, such as Titles, Transitions, and Auto track. It also has nonstandard features, such as animated titles. Editing is easy: First, import your video and photos by browsing your hard drive or dragging and dropping them to your storyboard window. You can rearrange your files as desired. If you click the Auto Movie button, the software adds titles, transitions, and zoom and panning effects for you. You will be asked to add an audio file from your computer during the process.

The auto feature is most effective for slide show presentations. If you don't like the results of the Auto Movie feature, you can always tweak it. It's a good tool to help you quickly create movies. You can also share your movies directly to Facebook and YouTube. When you save videos to your desktop, the files are saved with the WMV (Windows Media Video) file extension. If you have a version of Windows before Vista, you can use Windows Movie Maker.

Other video-editing software

The following programs are powerful video-editing tools, and have features most amateur and semi-professional film makers and video producers need:

► **Adobe Premiere Pro.** This is a professional-based video-editing tool. It gives you more flexibility for the finer details of editing. Available plug-ins and applying options from Adobe After Effects make this level of editing very deep. It has multicamera editing, adjustment layers, and a nice stabilizing feature for shaky clips. Even the layout allows you to customize available buttons and options. Good transitions (21 available) and filters, such as colorize, give you options you don't have in basic editing software. Another advantage this software offers is that it is compatible with other Adobe products.

► **Final Cut Pro X.** This video-editing software is created by Apple and is the preferred platform by many advanced amateurs and professionals. It's well organized, similar to iMovie, has a good drag-and-drop editing interface, and has become faster with recent upgrades. Final Cut has all of the basic editing features you would expect, including a large number of transitions and effects, plus third-party plug-ins to expand its capabilities. If you find that iMovie is not giving you the flexibility or advanced edits that you need, consider upgrading to this program.

Accessories

When it comes to cameras and photography, the list of accessories is long. Where do you want to take your photography? If you are serious about investing in ways to improve your images, new lenses are a good starting point. If you plan to produce serious videos, then you'll require some support accessories. Lights, microphones, and products to keep the camera steady are important. A tripod is a must for video or if you plan on shooting long exposures. I purchase grips for all of my cameras because it makes them feel more solid, and the camera seems to fit better in my hand. Finally, consider the basics, such as extra batteries.

Grips and Remotes

A grip fits on the bottom of your camera and stores two batteries. It also adds weight to your camera, which some photographers consider a benefit because it makes it easier to balance. Remotes give you the ability to take long exposures (beyond the 30-second limit) with your camera. An intervalometer is a more advanced remote control that can be programmed to take multiple photographs over specific periods of time.

The Canon grip for your T4i/650D is the BG-E8. It is useful for several reasons. First, you can shoot more comfortably holding the camera vertically. The grip also holds two batteries, giving you longer battery power in the field. It also offers additional balance when handling your camera.

To install a grip, you need to remove the battery door cover, as shown in Figure AB.1. Because the grip holds two batteries, you must purchase an additional LP-E8 battery pack.

Image courtesy of Canon

AB.1 This is the BG-E8 grip designed for Canon Rebel T series cameras.

NOTE You can also use the BG-E8 grip on the Canon T2i and T3i.

Your camera is limited to a 30-second exposure time. For some situations, you can use your camera's timer to take up to 10 images in a row, and then combine them in a program, such as Photoshop. However, this does not change the fact that you can't have an exposure time of more than 30 seconds.

Remotes are very helpful when shooting long exposures. The Canon RS-60ES remote connects directly to the remote port on the left side of your camera. This is like having an external shutter button. Remotes—also known as cable releases—are also helpful for macro and night photography to prevent camera shake while taking long exposures.

The RC-6 is a small, infrared wireless remote used to avoid camera shake when shooting long exposures. Another benefit is that you can be in the photograph, and wait until everyone in the group is ready before you take the picture. You have the choice of a 2-second delay or the camera taking the photograph instantly. The delay gives you time to prepare yourself or quickly put the remote in a pocket. You can also easily stand up to 15 feet away from your camera to take a photograph. It's a nice, inexpensive accessory to have in your bag.

Image courtesy of Canon

AB.2 Use the RS-60ES remote to keep your shutter open for long exposures.

Image courtesy of Canon

AB.3 The RC-6 is a small, infrared wireless remote for Canon cameras.

Video Accessories

Video accessories make creating movies easier and, in many cases, can make your video look more professional.

The following list of accessories can help you create better videos:

▶ **A steady camera.** Keeping your camera steady is one of the tricks of creating good video. Begin with a tripod. When you need to be on the move, there are many options to hand hold your camera. Some of these options, such as the Merlin Steadicam, shown in Figure AB.4, are simple, handheld devices. Others require two hands, or rest on your shoulders or your body. There are also rigs with monitor holders.

▶ **Loupe.** A loupe magnifies the pixels on the LCD screen. Some of the more sophisticated models are found on lens hoods, and the best also have a diopter to help you see more clearly.

Image courtesy of Tiffen

AB.4 Tiffen's Merlin Steadicam is designed to be handheld for the photographer on the move.

▶ **Lights.** Lighting is covered extensively in Chapter 6, but it is important to reinforce the idea that good lighting accessories can drastically improve your videos. You have many choices, such as LEDs, fluorescents, and HMIs (Hydrargyrum medium-arc iodide), to name a few. LEDs, like the Manfrotto 24 LED light with a color temperature of 5600K, are good for short distances. They are a popular light source and usually fit in your camera's hot shoe. LED lighting

kits often come with filters to match different lighting situations. HMI lights are much more powerful than LEDs, and are commonly used in movie and video production. However, if you like to use light boxes and umbrellas, I recommend using a fluorescent lighting kit.

▶ **LCD screen hood/shade.** Your LCD screen is great until it meets bright sunlight; then it disappears. If you are shooting stills, you can use the camera's viewfinder to overcome this problem. If you are shooting video, however, you need a way to turn the back of your camera into a viewfinder so you can see your screen clearly. A screen hood blocks the sunlight so you can clearly see the camera's LCD screen.

Image courtesy of Lowel

AB.5 This Lowel LED light can be used for video or still photography.

Microphones

For the casual user, your camera's built-in microphone might do the trick. But, as mentioned previously, one of the most important elements of a good video is good audio. I recommend that you invest in an external microphone. In-camera microphones don't deliver the high-quality sound needed for quality video production. Your camera's microphone and software are better than many, and they allow you to make some adjustments in-camera. However, when high-quality sound is needed, an external microphone is the answer.

There are a number of models on the market, and most fall under one of the following three categories: Omnidirectional, bidirectional, or unidirectional. Each type has its advantages, depending on your needs. *Omnidirectional microphones* capture sound from all directions. This type of microphone also easily records ambient noise in the background (wanted or unwanted). A *bidirectional microphone* captures sound from two directions, and the *unidirectional microphone* records sound from one direction. Unidirectional mics come in multiple styles and are used for different purposes, each covering different angles or focus areas of sound capture.

Image courtesy of Rode

AB.6 Rode makes a series of microphones, some of which are designed to fit in your camera's hot shoe.

A *shotgun microphone* is a common, all-purpose unidirectional microphone for subjects that are relatively close to the front of your camera. Many companies make shotgun microphones that connect to your camera's hot shoe. For interviews, a handheld microphone is a good option for the photographer on the move. A *lavalier microphone* clips to the subject's clothing, and is often used for more static or formal interviews.

If you want to achieve the best audio possible, you should consider using an external recording device in addition to a microphone. The combination of microphones and recording devices necessary depends on your goal. The downside of using an external recording device is that you must align the sound and video in the editing process. This is why you see clappers being used on movie sets—it's to help match the sound with the scene in editing. Many microphone manufacturers, like Zoom, make it easy to attach microphones to dSLR cameras.

Image courtesy of Zoom

AB.7 The Zoom H1 handy recorder fits on your camera using the HS-1 Hot Shoe (also available from Zoom).

Tripods

When it comes to tripods, you often get what you pay for. They come in many shapes and sizes; some are heavy and sturdy, while others are small and portable. When trying to figure out what you need, consider how and where you will use your tripod. A good tripod keeps your camera steady, while still offering the flexibility of smooth motion for actions, like *panning* (following a moving object).

How high your tripod should be is also an important consideration. All of this depends on what you plan to photograph. The heavier the tripod is, the steadier it will keep your camera. Heavy tripods and tripods made of higher quality materials, such as carbon fiber, tend to cost more money, though. Less-expensive tripods are usually made of aluminum, come in one piece, and have a tilt-and-pan-style head. These heads are not as flexible as the more versatile ball heads found on higher-quality tripods.

Image courtesy of Canon

AB.8 The Canon Deluxe Tripod 300 is good for casual use.

Usually, tripod companies require you to select a head separately. When selecting a head, make sure it has all of the features that you need. Some things to consider include smooth movement, ease of adjustment, and a quality plate that is easy to connect to your camera and tripod. If you are a photographer on the go, such as a sports photographer, consider using a monopod. A *monopod* has only one leg, and allows you to be mobile while offering the support necessary for long lenses.

Once in a while, you may not have a tripod available. In these situations, a handbag, backpack, or clothing can support your camera on top of a wall, fence, or a rock. Sometimes a small, flexible tripod, such as a Gorillapod, shown in Figure AB.9, is good to keep in your bag when you don't have a full size tripod available. I have had many tripods throughout my career, and those that I invested some money in are still in great working order.

Image courtesy of Joby

AB.9 Gorillapods are light, flexible, and ideal when you don't want to carry a lot of equipment.

Bags

Make sure that you have a good bag, pack, or case to protect and carry your gear. It is nice to have a lot of pockets, but my biggest concern is ease of use. How easily and quickly can you grab equipment when you need it? Also, consider whether the bag is weatherproof and durable. Is it designed for the type of photography you are going to be doing? A photojournalist needs a different bag than a commercial photographer working in the studio.

Commerical photographers often use hard cases to protect their equipment in storage and transit. Standard shoulder bags have a lot of pockets and are good for the photographer on the move who needs multiple lenses, filters, and small support tools. Messenger bags, with their simple design and ease of use, are popular for photographers. If you are a travel, nature, or wildlife photographer, you might want to consider a backpack-style bag, like the one shown in Figure AB.10.

Image courtesy of Naneu
AB.10 A backpack-style bag by Naneu.

How to Use the Gray Card and Color Checker

Have you ever wondered how some photographers are able to consistently produce photos with such accurate color and exposure? It's often because they use gray cards and color checkers. Knowing how to use these tools helps you take some of the guesswork out of capturing photos with great color and correct exposures every time.

The Gray Card

Because the color of light changes depending on the light source, what you might decide is neutral in your photograph, isn't neutral at all. This is where a gray card comes in very handy. A gray card is designed to reflect the color spectrum neutrally in all sorts of lighting conditions, providing a standard from which to measure for later color corrections or to set a Custom white balance.

By taking a test shot that includes the gray card, you guarantee that you have a neutral item to adjust colors against later if you need to. Make sure that the card is placed in the same light that the subject is for the first photo, and then remove the gray card and continue shooting.

> **TIP** When taking a photo of a gray card, de-focus your lens a little; this ensures that you capture a more even color.

Because many software programs enable you to address color correction issues by choosing something that should be white or neutral in an image, having the gray card in the first of a series of photos allows you to select the gray card as the neutral point. Your software resets red, green, and blue to be the same value, creating a neutral midtone. Depending on the capabilities of your software, you might be able to save the adjustment you've made and apply it to all other photos shot in the same series.

If you'd prefer to made adjustments on the spot, for example, and if the lighting conditions will remain mostly consistent while you shoot a large number of images, it is

advisable to use the gray card to set a Custom white balance in your camera. You can do this by taking a photo of the gray card filling as much of the frame as possible. Then, use that photo to set the Custom white balance.

The Color Checker

A color checker contains 24 swatches which represent colors found in everyday scenes, including skin tones, sky, foliage, etc. It also contains red, green, blue, cyan, magenta, and yellow, which are used in all printing devices. Finally, and perhaps most importantly, it has six shades of gray.

Using a color checker is a very similar process to using a gray card. You place it in the scene so that it is illuminated in the same way as the subject. Photograph the scene once with the reference in place, then remove it and continue shooting. You should create a reference photo each time you shoot in a new lighting environment.

Later on in software, open the image containing the color checker. Measure the values of the gray, black, and white swatches. The red, green, and blue values in the gray swatch should each measure around 128, in the black swatch around 10, and in the white swatch around 245. If your camera's white balance was set correctly for the scene, your measurements should fall into the range (and deviate by no more than 7 either way) and you can rest easy knowing your colors are true.

If your readings are more than 7 points out of range either way, use software to correct it. But now you also have black and white reference points to help. Use the levels adjustment tool to bring the known values back to where they should be measuring (gray around 128, black around 10, and white around 245).

If your camera offers any kind of custom styles, you can also use the color checker to set or adjust any of the custom styles by taking a sample photo and evaluating it using the on-screen histogram, preferably the RGB histogram if your camera offers one. You can then choose that custom style for your shoot, perhaps even adjusting that custom style to better match your expectations for color.

Glossary

Adobe RGB A common color space often used by printers.

AI Servo Focusing mode A focusing mode that follows the subject's movement until the shutter button is pressed completely to expose the image.

ambient light Available natural or existing light that is not created by the photographer.

angle of view The amount of area seen through the viewfinder and measured in degrees. For example, telephoto lenses have a narrow angle of view.

aperture The opening in the lens that allows light into the camera.

Aperture-priority AE An exposure mode in which the photographer controls the aperture and the camera controls the shutter to create a proper exposure based on the camera's metering system.

artificial light Light from a manmade source, such as a light bulb or flash.

aspect ratio The proportional relationship of a shape's width compared to its height.

Autofocus (AF) Focusing mode in which the camera focuses on the subject using select points.

Automatic Exposure (AE) The camera selects all of the elements for proper exposure or the photographer selects some of them, and the camera selects the rest. For example, in Shutter-priority AE mode, the photographer selects the shutter speed and the camera selects the aperture.

Automatic Exposure Lock A button on the camera that locks the exposure setting so that the photographer can recompose the image, or point the camera in a different direction using the locked exposure.

backlighting When the subject is standing between a light source and the lens.

barrel distortion A distortion created by zoom, wide-angle, and fisheye lenses in which straight lines are bowed.

bounce light Reflected light that is bounced off a wall, ceiling, or reflector, or any light that does not come directly from the original source.

bracketing Taking a series of underexposed, overexposed, and correctly exposed images. This technique is often used when photographers are unsure of the proper exposure, or want backup options.

brightness The lightness of an image.

broad light Lighting that illuminates the side of the subject that is facing the camera.

buffer A temporary storage location for digital data. Your camera uses a buffer to store bursts of generated images before they can be processed.

built-in flash A flash hardwired into the camera. It is usually located on top of the camera above the viewfinder.

Bulb An exposure mode that allows the shutter to remain open as long as the shutter button is pressed or the cable release (remote) is engaged.

cable release A tool used to manually trigger or keep the shutter of a camera open without the photographer touching the camera.

camera shake A condition caused by the movement of the camera, usually while using a slower shutter speed, which results in blurry photographs.

candid A photograph taken when the subject is ignoring or unaware of the camera.

Center-weighted metering A metering system that emphasizes and gives more weight to the center of a scene when calculating the correct exposure.

chromatic aberration A condition caused by light rays of different wavelengths coming into focus at different distances and causing a fringing look.

close-up A tight photograph often taken within just a few feet of the subject.

CMOS (Complementary Metal-Oxide Semiconductor) The type of imaging sensor found in the Canon T4i/650D.

color balance How the camera reproduces colors in comparison to the original scene.

color space A model in which colors are represented. Different color spaces have large and small ranges.

color temperature The representation of light based on Kelvin temperature. See also *Kelvin*.

composition How a photograph is framed.

compression Reduces the size of a file. Unless lossless compression is used, some of the file information may be permanently lost.

contrast The range between light and dark. The fewer shades there are, the more contrast there will be. The more shades there are, the less contrast.

crop Removing or only printing a section of an image. This is done when the photographer does not want part of the frame to be in the final image presentation.

daylight balance A white balance adjustment designed to correct light to equal the color temperature of the midday sun.

dedicated flash A flash designed for a particular camera brand.

depth of field The amount of focus in front of and behind the subject of a photo.

diaphragm The adjustable opening (aperture) inside the lens that works like the iris of the eye allowing the aperture of the lens to increase and decrease in size.

diffused light Indirect light that is usually shot through a material that disperses it, making it softer and flatter.

DPI (dots per inch) The number of dots printed per inch by output sources, such as printers.

exposure The result of the combination of the amount of light reaching light-sensitive material and the sensitivity of that material.

fill flash Using flash, often outdoors, to fill in deep shadows caused by the sun or a strong light source.

filter A transparent material (often glass) used to change the way the camera sees the scene through the lens. Filters are often placed on the lens. dSLR cameras have a digital version programmed into the camera.

flare Unwanted light in a camera lens.

flat A low-contrast photograph with a lot of middle tones.

f-number The number that indicates the size of the opening in the lens aperture. A smaller number equates to larger openings, and larger numbers equate to smaller openings.

focal length The length of the camera lens represented in millimeters. A larger number indicates a longer focal length or more telephoto, while a lower number indicates a shorter focal length or wider angle.

frame The boundaries containing the subject of a photograph.

frames per second (FPS) The number of frames produced by a video camera within a second.

frontlighting Light shining in the same direction that the camera is facing.

f-stop See *f-number*.

ghosting A ghost-like look created by the combination of flash, movement, and a slow shutter speed.

gray card A card made out of middle gray that is used with a reflective light meter to find a proper exposure.

grayscale A scale that shows the progression between black and white.

highlights The bright areas of a photograph that are often white.

histogram A graphical representation of the tone distribution in a photo between white and black, or the Red, Green, and Blue channels.

hot shoe The location where the flash is attached to an SLR camera.

ISO (International Organization for Standardization) A setting that represents a camera's digital sensitivity.

JPEG (Joint Photographic Experts Group) An image file type that uses lossy compression. It is one of the most common digital image file types.

Kelvin A unit of measurement for the color temperature of light. For photographers, the goal is to balance light to approximately 5500 degrees Kelvin for the equivalent of midday sun. See also *color temperature*.

LCD (liquid crystal display) Commonly used for flat-screen televisions, computer monitors, and the back panel of the Canon T4i/650D.

GL

lens One or more pieces of optical glass designed to focus and create an image within a camera body. An image is created by the light coming through the lens and reaching the photo sensor in a camera.

lossless A compression method that allows the exact original data to be reconstructed from the compressed data.

macro lens A lens designed to take extreme 1:1 or closer photographs.

Manual exposure An exposure setting in which the photographer sets both the shutter speed and aperture to expose an image.

megapixel 1 million pixels.

memory card The electronic card used to record photographs in a dSLR camera.

metadata Information about a file stored or embedded within it.

midtone The point between white and black.

monochromatic An image that uses different shades, tones, and tints of the same color.

noise Visible artifacts (similar to grain in film) found in underexposed images, or images taken with high ISO settings or long exposures.

overexposed An image that receives too much light.

panning Following a moving subject with your camera, resulting in an image in which the subject is in focus and the background is blurry.

pincushion distortion Lines in a photograph bow inward toward the center of the frame. This is the opposite of barrel distortion.

pixel The smallest picture element that can be manipulated to change tone and color.

polarizing filter A filter designed to minimize reflections and glare.

Program AE An exposure mode in which the camera is in full control of the aperture and shutter speed.

RAW An image file that has not been run through compression software and can be adjusted without loss of information.

reflective light meter A light meter that bases exposure on reflective light. This is the type of meter found on the Canon Rebel T4i/650D.

reflector Anything used to reflect light back on the subject. Photographers often use white, gold, and silver surfaces to reflect light onto their subjects.

RGB Red, Green, and Blue color channels. The mixing or adding of these three colors combine to create a given color. This additive color model is used in televisions and computer monitors.

self-timer A device used to set and count down the seconds before it releases the camera shutter.

sharp The point at which an image is well-defined or considered in focus.

shutter A curtain or moving cover that opens and closes to let light into the camera in a matter of seconds, or fractions of seconds.

sidelighting Light hitting the subject from the side.

slave Flash unit that is triggered by another flash unit.

Spot metering mode A metering mode in which the camera uses a small segment (1 to 5 percent) of the frame area or scene to calculate exposure.

sRGB A color space best used for images meant to be displayed on computer monitors and the Internet.

telephoto A longer lens that makes the subject appear closer.

Through-the-Lens (TTL) A type of flash metering system that reads the information from the camera sensor to make exposure calculations. This is the type of flash metering used on most dSLR cameras.

TIFF (Tagged Image File Format) A high-quality and commonly used image file format that uses lossless compression.

tonal range The range of light to dark within a photograph.

tungsten light Type of light that often comes from incandescent bulbs. It produces light that is low on the Kelvin scale and often produces a yellow cast.

underexposed An image that did not receive enough light.

viewfinder What the photographer looks through to see the scene in front of the lens.

vignetting A darkening of the edges of a photograph. It is considered a sign of a poor or defective lens, although it can also be used for photographic enhancement.

GL

white balance Adjustments made in the camera or image-editing software to establish neutral color based on white light or daylight.

wide-angle lens A short focal-length lens that offers a wide-range view.

Index

Guides to go.

Digital Field Guides are packed with essential information about your camera, plus great techniques for everyday shooting. Colorful and easily portable, they go where you go.

978-0-470-63352-6

978-0-470-64864-3

978-1-118-02223-8

978-0-470-64861-2

978-1-118-11289-2

978-0-470-64862-9

Available in print and e-book formats

WILEY
Now you know.